Holly

Holly

Evergreen Oak

Hornbeam

GOLF

IMPLEMENTS AND MEMORABILIA

GOLF
IMPLEMENTS AND MEMORABILIA

Eighteen Holes of Golf History
with Kevin McGimpsey & David Neech

Philip Wilson Publishers

First published in 1999 by
Philip Wilson Publishers Ltd
143–149 Great Portland Street
London W1N 5FB

Distributed in the USA and Canada by
Antique Collectors' Club
91 Market Street Industrial Park
Wappingers' Falls
New York 12590

ISBN 0 85667 507 5

Designed by Andrew Schoolbred
Edited by Antony Wood & Helen Robertson

Printed and bound in Italy by
Società Editoriale Lloyd, Srl, Trieste

Contents

Foreword

One only has to look at the 1,626 entries on the R&A's list of conforming golf balls to appreciate how confusing it is in 1999 for a golfer to select a golf ball that is best suited to his game. Bearing in mind that, for nearly 400 years, a small number of craftsmen could only probably produce a maximum between them of 50 balls a day, you can appreciate that a golf ball was indeed a precious object and to lose one was disastrous, as well as being extremely expensive.

Once the hand-made feathery ball gave way to the gutty, which in turn was replaced by the rubber-cored ball, so the popularity of the game was able to leap forward due to the fact that not only was it possible to produce many, many more golf balls in a year, but also the cost of them reduced dramatically. When I started golf, just after the 1939–45 war, golf balls were still very scarce and, as a young boy, I would spend many hours raking through bushes, thick gorse and heavy rough with the hope and expectancy of a prospector for gold or diamonds. Would this be my lucky day? Would I find an almost new ball? Or, if not, would I find enough reasonably preserved ones to justify sending them away for recovering at, what I seem to remember, was a cost of sixpence in old money.

The recovered balls came back under the name of 'Spitfire' or 'Bambi' and sometimes, if you were lucky, you found that you had a really exceptional ball, whereas in the same box you might also have a complete dud. This was all part of the excitement. However, it did make me appreciate their value and even to this day I tend to hoard used golf balls in the same way a squirrel puts aside his store of nuts for harder days.

Once new golf balls started to be manufactured again and became more available, I remember that I was probably more influenced by the colour and pattern of the markings or by the paper in which each ball was wrapped, than I was by the claims made for the performance of the ball by the manufacturer. I tried them all: KRO FLITE, TOP FLITE, NORTH BRITISH, PATENTED PENFOLD, SILVER KING, and, of course, the DUNLOP 65, individually wrapped in black shiny paper with its distinctive red and gold label.

As I became more proficient at the game, so my choice of ball, having tried

them all, reduced to an option of maybe two makes. I cannot imagine how I would have coped with the present day choice of over 1,600.

Many years later, having joined the R&A, I was asked to become a member of the Uniform Ball Committee which had been set up with the specific purpose of finding a size of golf ball that would be acceptable worldwide and so provide harmony between the Rules of Golf on both sides of the Atlantic. We tried golf balls of all sizes: 1.63, 1.65 and 1.66, none of which felt as good as the UK-made 1.62 or the USA manufactured 1.68. Happily, as is now history, the adoption worldwide of the larger sized ball ensured that the problem of whether to play the small or large ball was resolved and now we happily play the one size.

Now all we have to worry about is whether we choose a ball which gives a low flight or high one, a ball to give us added distance, or one that stops quickly. Do we need a high compression or a low one? We can have them in a variety of colours and with a varying number of dimples. Our choice is endless. On the other hand, maybe I will revert to my early golf years and go out on the course to find a few old balls which I can send away to have re-covered. Life was so much simpler then!

The story of the golf ball is a fascinating subject which, until now, has never been properly told. I am sure that this book by David Neech and Kevin McGimpsey will answer many of the questions about the development of the ball and how, over the years, it has been perfected to add to the enjoyment of the game.

In addition, the authors also give some unusual and often detailed insights into the development of the golf club, demonstrating how often 'inventions' are re-invented in modified ways.

Finally the book has extensive coverage of the hobby of golf memorabilia collecting, covering the whole range of our wonderful game.

MICHAEL BONALLACK
St Andrews, May 1999

Acknowledgements

The authors and publishers gratefully acknowledge the use of material obtained from back issues of *The American Golfer, Golf, Golf Illustrated* and *Golf Monthly*. We ask the kind indulgence of any copyright-holder in quoted material whom we may have been unable to identify, and in any such case undertake to set the record straight in any future edition of this book. We also have many people to thank individually, as follows:

Archie Baird, Curator of the Heritage of Golf Museum at Gullane.

Lady Campbell, who provided photographs that belonged to her father-in-law, Major Guy Campbell.

Elinor Clark, Assistant Curator of The British Golf Museum, St Andrews.

Lorraine Cooper and Sotheby's for providing the vast majority of photographs from their published catalogues and photographing original material for this book.

Peter Crabtree for photographs and advice.

Rachel Doerr, Manager of Phillips, Chester, who provided several important photographs from various Phillips golf catalogues.

Jim Espinola, an American golf antiques collector, who supplied several of the golf ball advertisements.

Bill Francis, Secretary of the Royal Sydney Golf Club, who supplied information on the Robertson Golf Ball Collection.

Thomas Frick, the great Swedish collector, who provided some important photographs.

John Joinson (JJ), head of the Golf Department at Phillips, Chester until July 1999.

Dr Roy Jones at Loughborough University for help on technical aspects.

Peter Lewis, Director of the British Golf Museum, St Andrews.

Ronnie MacAskill, golf professional at Royal Aberdeen and collector of golf memorabilia.

Rachel McGimpsey, for the drawing of the Allan golf ball.

Roy Moore, Curator of the Royal Blackheath Golf Club Museum.

Alistair Morris, author of *Antiques from the Garden*, published by the Garden Art Press.

Roger Morton, golf professional and club maker.

Jenny Neech for unlimited help.

Edward Playfair of Sotheby's.

Nick Potter from his new gallery in Sackville Street, London.

Mark Roe, golf professional, European Tour player and collector of golf memorabilia

Rolls Fine Art for the photograph of Mowers at rest.

Paul Tatz, who provided photographs of the balls in the Royal Sydney Collection.

Hazel Taylor for patiently putting scribblings onto the computer.

T.T.L. Chitern at the Timber Research Station, High Wycombe, Buckinghamshire.

Chris Treacy of Diamond Golf.

Tommy Walker, a collector of golf memorabilia.

Brain Wall, for photography of the Display Points.

Brian Wallas MA, who unearthed golf in Sussex.

Bill Waugh, who provided some excellent artwork.

Preface
Golf is over 550 years old

At home I have a crested china golf ball, around the circumference of which is printed: *The Game of Golf was first played in 1448*. If this is the case, then golf reached its 550th anniversary in 1998. There is little doubt that the game of golf we know today was developed in Scotland, but theories abound as to precisely when it was first played there. I believe the date on my small china golf ball must be about right. James I of Scotland banned football in 1424 because its popularity was interfering with archery practice, which was vital to the nation's defence. James II of Scotland did the same in 1457, but he banned golf as well! QED, as I put pen to paper, golf is over 550 years old.

For many years Philip Wilson Publishers asked me to write a golf book, and of course Sotheby's like their experts (of which I'm one) to write books. However, until recently I have always resisted these overtures as I wanted to find a way of devising a different sort of golf book. Then I met Kevin McGimpsey.

Kevin's brother, Garth, has played golf for Britain and Ireland on many occasions in the Walker Cup against the mighty USA, and at the time of writing is in the British 1999 Walker Cup squad. It was, however, Kevin's own credentials that attracted me to enter into a joint literary venture with him. Kevin was a Captain in the 3rd Battalion of the Parachute Regiment in the Falklands War; he and his colleagues marched from one side of the East Island to the other and took Mt Longdon in a fierce battle. Kevin and the rest of the battalion were bombarded for three days by Argentinian missiles before hostilities were successfully concluded in late June 1982. An expert on one type of missile, Kevin also turned out to be an expert on a different kind of missile!

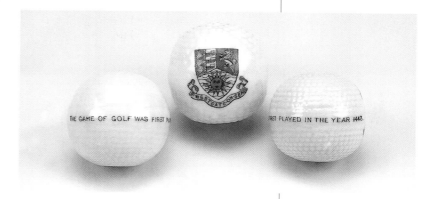

The big secret of golf lies in the golf ball. If it were not for this quaint little pimpled, dimpled, squared and marked object, golf would be just another minority sport like real tennis, fives, handball or marbles. This extraordinary little ball gets you where you want – or sometimes where you don't want – on the golf course, and it has certainly got the game to where it is today.

It is said that the first golf balls were wooden, probably made of box wood. (Box Hill in Surrey takes its name from the box trees that proliferate there.) By the year 1500 golfers were using feather-filled leather balls, but these were very expensive. By 1700 feather balls cost four Scottish shillings, the equivalent of around £50 now. Golf used to be a rich man's game.

On 1 January 1848 all the golf ball makers in the world could have been squeezed into a telephone kiosk in Sauchihall Street. Less than 60 years later there were about 2,000 golf courses in England, Scotland and Wales, and 300,000 golfers using 15 million golf balls. Why? We hope you find some answers to this and perhaps further questions in the pages that follow.

DAVID NEECH

The rise and rise of golf
The uphill hole

If you stopped one hundred thousand golfers, or even a million, and asked them why they were playing this wonderful game, not one would reply: 'Because of the golf ball.' However, had it not been for the extraordinary evolution of the golf ball, none of them would have struck a shot. We should never have heard of famous players like Nicklaus, Faldo, Norman, Ballesteros or Els. They would never have graced our fairways. In fact, it is doubtful whether there would have been any fairways to grace!

The great sports goods manufacturers would have had to look elsewhere; A.G. Spalding would have had to rely for their income on baseball bats, Wilson on meat packing and Dunlop on tyres. The great fortunes made from golf would not have been made. And all of this entirely due to the golf ball.

After the first 50 years or so, when golf was played with a wooden ball, for the next 350 years it was played with a feather ball, which was hard to make. The small number of craftsmen who made these balls could produce only eight or nine a day, and ingestion of the dust from them shortened the makers' lives. On a wet day several (costing £50 each at today's prices) could be used up, what with losses and breakages; when wet, the ball became soggy and the stitches burst in play. This meant that only the wealthiest people could afford to play the game.

By the middle of the nineteenth century there were only a handful of feather ball makers. One of the most famous, Allan Robertson, made less than 3,000 balls in his last year.

At this time, barely 150 years ago, there were so few golfers in the world

A burst feather ball.

that all of them could have been packed tightly into the Big Room of the Royal & Ancient clubhouse at St Andrews. And with so few people playing the game, the number of golf club manufacturers was also minute. Wooden heads were mainly used, since they caused the least damage to the expensive ball; iron-headed clubs were kept to a minimum.

In order for golf to grow, something had to happen. That something was gutta-percha.

The arrival of gutta-percha

Gutta-percha is a gum that was collected from trees growing mainly in India and what is now Malaysia and other Far Eastern countries. The gum becomes soft when heated but sets rock-hard when cold. The story is told that a Rev. Robert Paterson, after receiving a Hindu statue packed in the substance, rolled chips of gutta into a ball, painted it white, and in April 1845 played golf with it. This is a most romantic idea of how gutta arrived, but however it did so, it totally transformed the game.

The first gutta balls were made smooth, like table-tennis balls, but they did not fly properly. They ducked and dived until they became damaged in play, and then they flew better. Later they were marked intentionally by being hand-cut or hand-hammered before play.

Here was a ball that not only cost a fraction of the price of the feather ball but performed better when damaged! Bingo! Many more people could now afford to play golf, and it was even good news to damage the ball. What's more, the gutta could be re-pressed and re-cut.

The impact of the new gutta ball revolutionised clubs as well, and iron clubs began to proliferate alongside the wooden ones. Some club manufacturers, such as Willie Park (1834–1903), produced both types, since the new balls created great demand not only for irons but also for woods. The gutta ball also led to changes in the materials from which clubs were made, but this will be discussed in a later chapter.

Thus the ball alone changed the game for ever. Golf dramatically increased in popularity from about 2,000 players in 1848 to the huge volume reported in 1906 in the following extract from an article by Henry Leach, one of the most celebrated of early twentieth-century writers on golf, in *C.B. Fry's Magazine*:

The Golfer and His Millions

Another year of golf has gone, and they are saying that it has been the greatest year that

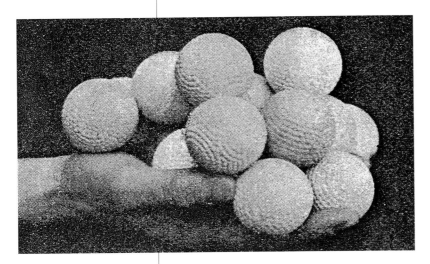

Sixteen bramble balls held in a hand.

ever was. There was abundant reason to believe that 1905 stood for a record in the popularity and increase of the game, and there is just as much reason to believe that 1906 has beaten it, and that in turn the figures of the last twelve months will be eclipsed by the next period. For the end of the 'boom' in golf is not yet.

Bespattered as Britain is with courses, there are still many virgin areas, and the population of the country is now only just awakening to the charms of the game and the countless delights and benefits that come to those who play it.

There are now about 2,000 golf clubs in Great Britain, and it is generally estimated that there are about 300,000 players. Yet the last census of the population showed that there were nearly 42,000,000 of people in these islands; and it seems ridiculous that only one in 140 patronises a game, or a pursuit, as it might be called, which is as indispensable to its followers as most other things in life.

Now we may proceed to discover some of the wonderful things that the golfer does with all these millions, apart from improving his health and increasing his capacity for work.

Consider the golf ball. Pretty little pimpled thing, isn't it? Stuffed full of delight! Full of promise for at least two hours' fine health-giving enjoyment! We used to think a half-pound tin of our favourite tobacco was the most heartening sight to see; but a box of new balls has it now. One ball is such a tiny little thing. See, we can hold sixteen of them in one hand! We have seen a man hold eighteen, and possibly that is a record. Giving a ball four rounds of life, two men could play together morning and afternoon for more than a

fortnight with the balls that are held in this hand. But just see how many are needed by the great world of golf!

To begin with, there are those 300,000 golfers in this Country. It has been reckoned that at the height of the summer golfing season, when the players are busy everywhere, not less than 500,000 balls are used up every week. This, indeed, seems to be a most reasonable estimate – less than two balls per man per week, with an enormous percentage of players out on the links four or five days a week. It was semi-officially stated in June that one firm of makers, and that not by any means the biggest, was working night and day, and turning out 100,000 balls a week. Decidedly our half million is well within the mark. Taking the whole year round, if you say one ball per golfer per week, that is surely a very modest reckoning. It is practically a certainty that it is an underestimate, but we will always be on the safe side in our calculations, so that no one shall complain of exaggeration. At that rate we have a grand total of 15,000,000 balls used up every year by the British golfers on British links. Fifteen millions!

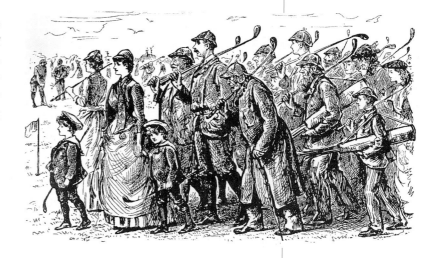

The golf stream c.1885.

In 1905 London's Ranelagh Golf Club alone (the biggest in Britain) had nearly the same number of members as there had been golfers in the whole world just 60 years earlier. There were also more people involved in the manufacture of golf equipment than there had been players that short time ago. By the first decade of the twentieth century golf had spread overseas. It had been transported, generally by the Scots in the British Army, to India, Hong Kong, Singapore, Australia, Canada and many other countries. The first course in Ireland was at the British Army base, The Curragh, which was both barracks and a venue for horse racing and golf. There are many examples of golf and horse racing sharing a common ground, of which Musselburgh, Yarmouth & Caister, Whittington Barracks (now Whittington Heath), Harpenden Common, Royal Liverpool, Buxton & High Peak and Northumberland are just a few.

So there we are! The golf ball has been all-important to golf. That is why the following pages are full of stories of the feather ball, the solid gutta-percha ball, the rubber-wound American ball with its almost modern construction – and today we are reverting to another type of solid ball. This book is 'driven' by the golf ball and in it you will find many instances of old ideas resurfacing as new.

The Scottish ball
1448 to 1848 – a long downhill hole

The early days

It is thought that the earliest 'golf bawis', first used in the fifteenth century, were made from box wood. However, by the 1450s Scotland and the Low Countries had established good commercial links and sailors brought home with them leather-covered balls made in Holland. Initially these leather balls were stuffed with 'flok', which was wool or hair. Almost immediately the wooden ball fell from favour; these new balls were more resilient and much more pleasant to play with.

It is unknown who first thought of filling the leather sac with feathers, or when, but the result was a ball that was round, firm and elastic – one that achieved pleasing distances when struck by a club on the links. It is believed that the earliest Scottish feather golf balls were made some time towards the end of the fifteenth century.

Records show that 'goiff' balls could be bought in 1452 for ten Scottish shillings each, the equivalent of ten pennies in England. In 1503 representatives of King James IV of Scotland bought for him 'golf clubbes and balles'. A dozen 'golf ballis to the King' cost four Scottish shillings each, which equated to four English pennies – at a time when a good-quality playing club cost twelve Scottish shillings (or twelve English pennies).

Although there are several references to golf balls in the sixteenth and seventeenth centuries, none mentions the feather golf ball as such. No one knows for sure which type of ball was being referred to; it could equally have been feather, wooden, or leather filled with hair, wool or even cotton!

A rare D. Marshall ball with ink-written weight of 27 dwt, stamped 'RHB'. The original ball's owner, Dr R.H. Blaikie, was a founder member of the Luffness Golf Club in East Lothian, Scotland. In July 1995 the ball was sold at auction at Phillips for £17,000.

This mid-18th-century woodcut shows a golf ball maker and a customer. The large size of these leather-covered balls suggest that they were made for the Dutch version of the game that was played on ice.

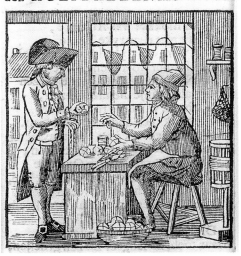

den KOLFBALLENMAAKER

However, on 9 November 1894 *Golf* magazine published the following item referring to golf balls from bygone days:

In the *Nineteenth Century* for October, is an article by Sir Herbert Maxwell, entitled 'A Scottish Vendetta', an account of family feuds in Ayrshire, about 1550: 'The laird of Bargany's neise was lech (nose flattened) by ane Goif ball on the hills of Ayr, in recklessness.' Sir Herbert says they were strong drivers, it would seem, the golfers of Queen Mary's reign, to break a man's nose with a ball made not like modern ones of hardened gutta percha, but of feathers pressed into a leather covering.

The year 1603 marked the union of the Scottish and English monarchies when King James VI of Scotland became James I of England. In 1618 – by which time considerable commercial rivalry had grown up between England and Holland – King James granted a golf ball monopoly to a certain James Melvill, who was, among other things, a business opportunist. Knowing that

the King needed more revenue, Melvill had argued that the realm's balance of payments would be healthier if golf balls were no longer imported from the Hollanders. He proposed the establishment of a cartel of ball makers in North Britain (Scotland), a percentage of whose sales revenues would be paid to the monarch. In addition, any impounded balls that had arrived from outside the realm were to be confiscated and sold, and the monies divided between Melvill and the crown. By such means Melvill obtained a monopoly for 21 years. He employed a ball maker called William Berwick to oversee the scheme; it was closely monitored and policed but proved impossible to control.

When King James died in 1624 he was succeeded by his golfing son, Charles I. Despite this, by 1629 Melvill's scheme had failed, although he still claimed that he had a monopoly on every golf ball made and was entitled to 'certain impost aff everie gowffe ballis made within this kingdom'. In 1642 a John Dickson, originally from Leith, was given a licence by the Aberdeen Burgh council 'to make gowff ballis within this burgh during the council's pleasure'. And during the period of conflict in the English Civil War south of the border, the golf ball industry in other Scottish towns, such as St Andrews, enjoyed dramatic growth. The monopoly on the making of golf balls was never again an issue. By the 1600s, although a range of different golf balls were available, the feather-filled type was regarded as the best.

Some of the first settlers in America played golf and as early as 1743 there is a report that the Dea family in Charleston, South Carolina took delivery of 432 golf balls; in 1779 an advertisement in the New York *Royal Gazette* offered 'Caledonian Balls' for sale.

Although at this time golf balls were mostly sold by ball makers or club makers with workshops on the links, there is at least one record of 'hard balls and golf clubs' being on sale in a hardware store in Edinburgh.

In 1838 the 'New Statistical Abstract of Scotland' census estimated that ball makers living in and around St Andrews were making 10,000 feather balls annually – even though most ball makers considered it good business if, on average, they sold three 'featheries' a day. Some 50 per cent of the balls made were for use by golfers from the St Andrews area; the rest were destined for other British clubs or for export to clubs elsewhere within the British Empire. Skilled ball makers would produce only between three and six balls per day, although a not-so-skilled maker might turn out many more! Allan Robertson's shop (where Tom Morris served his apprenticeship) made only 1,021 balls in 1840; in 1841 the number had risen to 1,392 and three years later the total was 2,456.

Who were the ball makers?

Before the 1800s ball makers were mostly shoemakers or cobblers who had learnt or were being trained to make shoes, bags, belts and other leather goods. Since they already possessed the skills to cut, shape and stitch leather, the making of balls for the local golfing gentry was seen as an obvious way of increasing turnover. Many lived in or around Leith, Musselburgh and the St Andrews area; by the middle of the eighteenth century a generic term for golf balls was 'St Andrews Balls'. It was only by the late nineteenth century that specialist leatherworkers emerged who were more interested in making feather balls than shoes.

A list of the better-known feather golf ball makers active from the early seventeenth century to the end of the nineteenth century can be found in Appendix 2.

How feather balls were made

The Goff, a poem written by Thomas Mathison in 1743, described for the first time how feather golf balls were made. His strong scatological imagery captures the physical strength needed to make them:

> The feathers harden and the leather
> swells;
> He crams and sweats, yet crams and
> urges more,
> Till scarce the turgid globe contains its
> store.

The ball maker cut out three pieces from a section of untanned bull's hide: two that were round, for the poles, and one a strip – on average a quarter of an inch (6.35 mm) wide – to make the middle area of the ball. The size and thickness of these three wet and pliable pieces of leather were determined by the anticipated weight of the finished ball.

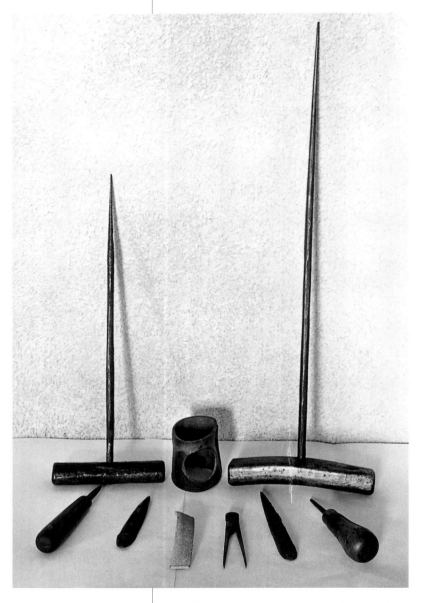

Some of the instruments used to make feather balls: two brogues with wooden chest braces, a leather ball-holder, two short awls, two wooden feather-stuffers, a calliper and a strip of leather.

left, through which the feathers would be stuffed, but first the small leather sac was turned inside out through it. This was a very difficult procedure and not every would-be maker mastered it. The thicker the leather, the harder it was to perform the task. With the stitches inside the ball, these potentially weak spots were afforded a small degree of protection from the striking golf club.

Meanwhile the goose or 'cocks and hens' chicken feathers were softened up in a mixture of alum and water until they were soggy. Tradition has it that the amount of feathers needed to make one ball was the same as would fill a top hat. In fact, a ball needed more feathers than this. The flaccid sac of leather was put into a supportive device such as a cup-shaped stand or a leather collar; the latter had an opening to enable the ball maker to get at the leather casing. The soggy feathers were then forcibly stuffed through the narrow slit with a small, sharply pointed tool. When the sack was nearly full the ball maker placed under his arm a long metal awl, called a brogue – a crutch-like implement. This enabled him to force even more feathers into the sac. The ball maker used callipers to determine the diameter and size of the ball and scales were employed to ensure that it was a popular weight. The finished ball was seldom round; it was more egg-shaped, and as such well suited to the rough and uneven texture of the putting surface. The slit was sewn up with a simple stitch and this was the only stitching visible. The ball maker then applied a liberal coat of

It was important that the leather was as non-porous as possible to prevent unwanted moisture getting into the ball during play. After the pieces had been shaped and softened, small holes were punched into the end flaps of the middle piece to make it easier to stitch this to the other pieces with waxed linen thread. A small hole was

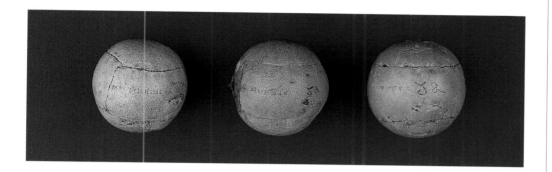

Three sought-after golf balls: (*left*) A fine W. & J. Gourlay; (*centre*) A ball made by Tom Morris – note that some feathers are exposed; (*right*) A good example of an Allan Robertson feathery.

well-ground pure white lead paint, sometimes using iron callipers with wooden handles to hold the ball in place. When the ball had dried, a second coat was applied. The maker's name and the weight were often hand-written or stamped onto the ball in dark blue or black ink. As the feathers dried out within the ball they expanded, while the leather casing contracted as it dried. The pressure on the stitches was intense, but the result was a hard leather ball whose tightly packed feathers gave it resilience and power.

Price, size and weight

The price of balls varied from century to century and early balls were priced in Scottish currency only; a Scottish shilling was the equivalent of an English penny. Ball makers with an established reputation could charge a higher price than their rivals. By the early 1500s a ball cost, in English currency, 1s 3d, and a hundred years later the price had more than trebled to four shillings. During the 1700s the price was sixpence, but this rose in the early 1800s to between tenpence and two shillings.

Contemporary bills of trading and sales invoices have proved good sources of information. Two such documents sold at auction in the UK involve John Cundell, an early nineteenth-century golfer who was an official at the Thistle Golf Club at Leven in Fife, Scotland. In one transaction, dated 1823, he bought from William Gourlay Sr '18 best golf balls at 1/9 each'. A few years earlier, in July 1817, Cundell – who probably retailed golf balls to his society members or used them as prizes – bought a very large quantity of balls from William Robertson of Leith: '18 Doz of Golf Balls £9'. These balls had cost Cundell only 10d each; Robertson was not as highly regarded as Gourlay.

In 1845 the price of a golf ball was an expensive four shillings, but with the popularity of the gutta-percha ball this fell to 2s 6d in the 1860s. Because the feather ball was such an expensive item, some players could only afford to use the ball makers' rejects – balls that had turned out too heavy or had inferior stitching, or those made by their apprentices, which they often sold off at a discounted price. Such balls were probably used by the gentry for practice as well as being the only option for less well-off golfers, who frequently had to make running repairs to their feather balls. If the stitching came

undone or part of the leather needed an overhaul, a souter or harness-maker was a good man to know. One of the many drawbacks to the 'feathery' – as it became known – was that it was not much good in wet weather. It tended to become heavier as the leather, and eventually even the feathers, absorbed the water, becoming soggy and soft and more prone to being split open. Balls could be regularly oiled to increase their water resistance, not necessarily by their owners but more probably by the caddies. Well-oiled feather balls even floated and were retrievable from water hazards.

This beautiful Tom Morris feathery was sold by Phillips in 1993 for a world record price of £17,825.

To reduce ownership disputes, since basically one feathery looked much like any other, some players applied coloured identification spots to the balls' poles, while others tended to mark their balls with a cross or some other symbol, or with their initials. The majority of feathery balls were painted white because white objects reflect the most light and appear larger than they actually are. However, in the winter months, when the fairways were covered in heavy frost, players had their balls painted red or even blue.

There were no regulations standardising the size or weight of the ball; instead, it was up to the ball maker to make a ball that players would enjoy using. Players chose balls of differing sizes and weights to suit the course being played or the weather conditions likely to be experienced. Thomas Kincaid, a medical student studying in Edinburgh, wrote in 1687: 'Your ball must be of middle size, neither too big nor too little, and then the heavier it is in respect of its biggness it is still the better...'

The ball's weight was shown by a two-digit number written or stamped on it in ink. Golf historians are still unsure which weight system was used. A common system for recording weight was the troy system, used primarily to weigh gold, in which one pennyweight (dwt) weighed 24 grains. (The 'd', used as an abbreviation for 'penny', comes from the Latin word *denarius*, denoting an ancient Roman silver coin.) It is likely that this was the system used by ball makers to record the weight of the ball. Sometimes makers referred to the unit of weight as a 'drop'. *Golf*, 3 February 1899: 'William Gourlay ... used no weights whatsoever, but simply placed the ball on one side of a pair of scales, and so many leaden pellets of shot on the other...'

Between 1750 and 1850 the diameter of the ball was reduced to an average of 1¾ in (4.45 cm); weights began at 24 dwt. To convert troy weights to the avoirdupois system (pounds and ounces), the pennyweight figure is divided by 18.23. The table shows some of the more commonly used weights:

dwt	oz
24	1.32
27	1.48
28	1.54
30	1.65
31	1.70
34	1.87

The effect of the feather ball on the game of golf

Up until the mid-1850s golf was a sport for 'well to-do men': rich and privileged members of the upper classes as well as wealthy merchants and others who had amassed 'new money'. As members of golf societies or clubs they played in a uniform unique to their particular organisation, which usually meant a distinctive red coat that contrasted well with the green of the turf and made members recognisable at long distances.

The feather ball only lasted – at best – one round (less if the conditions were wet), so the expense of buying the balls in itself ensured exclusivity in terms of those who could play. In addition, the caddie normally carried at least half a dozen balls, the majority of which could end up lost or damaged.

The effect of the feather ball on golf equipment

The clubs used to propel the feather ball were beautiful long-nosed, concave-faced woods. Although a small number of these were made of beech before 1800, the timbers most widely used to make quality clubs were hawthorn, apple or pear, since all three were light in weight and very hard. It was noticed that because the shaft was subjected to torque the club face opened slightly on the downswing. In order to neutralise this the face was made closed, with the toe of the club in advance of the heel. The player's stance was very closed or shut, with the right foot far behind the left.

A club had to be used in a sweeping, rather than a hitting, motion – an action that propelled the feather ball on average 180 yards (165 metres). There was little or no roll and so control was relatively easy. A badly struck shot tended to rupture the ball, which was why a sweeping-away action needed to be adopted. Iron-headed clubs were only used when the ball was lying so badly that the chances of breaking the wooden club were too great. Players had five or six wooden-headed clubs and two irons only, usually a cleek and a rut iron.

A sepia studio portrait of Allan Robertson with two of his clubs and golf balls, given to John Kerr by Tom Morris in 1895.

The effect of the feather ball on the rules of golf

The original thirteen rules of golf were drawn up in 1744 by the Company of Gentlemen Golfers (later the Honourable Company of Edinburgh Golfers). Rule 3 stated: 'You are not to change the Ball which you strike off the Tee.' Thus under these rules it was forbidden to change a feather ball for another one during the playing of a hole, even if the leather was ripped and the feathers exposed. However, in later years, after the demise of the feathery, the rules of golf were modified so as to allow a damaged ball to be replaced during play, even when the damage was minimal.

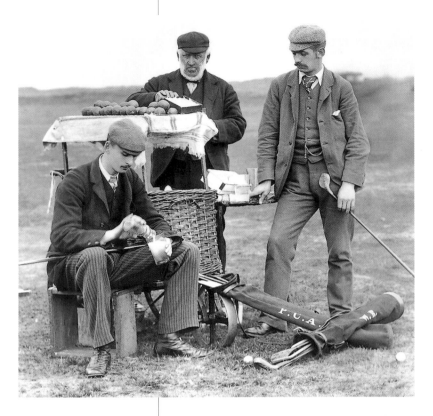

Thirsty golfers stopping at the Ginger Beer hole at St Andrews for a drink in the 1890s. Even then 'Old Daw' Anderson who ran the stall would have been able to offer replacement featheries to his customers. The large round objects on the stall are not featheries, however – probably fruit to make the cordials.

These balls were made in Scotland by such greats as Allan Robertson and Tom Morris. They are on display in the Royal Sydney Golf Club.

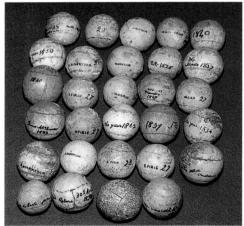

The end of an era

When John C. Gourlay first witnessed a gutta ball being struck, he realised that this was the ball of the future. The story goes that he immediately completed an outstanding order to supply 'Gourlays' to one of his best customers. Upon checking his inventory and finding that he had 72 featheries in stock he despatched them all, together with his bill, before the customer had time to learn of the new ball.

Although the feathery's popularity began to wane in 1846 with the arrival of the gutta-percha ball, it remained for many the only true missile to hit around the links. But progress could not be halted. In 1852 the Royal Burgess Club gave solid balls as prizes instead of Scottish ones. And in 1865 the Honourable Company of Edinburgh Golfers broke with tradition when a silver-plated replica of a gutta-percha ball was attached to their silver Club trophy. *Golf Illustrated*, 24 January 1908: 'The Silver clubs to which the captains of each year affix a ball have, from 1744 up to 1865–66, been the old feather ball, then for the next ten years, the hand-hammered gutta, and in 1878–9 the moulded gutta first appears.'

However, traditions died hard elsewhere. In 1859 Edward, the Prince of Wales, played his first game of golf at Royal Musselburgh and the ball he played with was a traditional feathery, not a gutta-percha ball.

3rd HOLE

Golfing art
A pretty hole with hazards

Beauty is in the eye of the beholder. Golf memorabilia can now be found in all corners of the antiques world, but anyone thinking of starting to collect golfing items should first decide exactly *what* to collect. Clubs, balls, books, games, ceramics, silverware? These are just a few of the many different areas of golf collecting. However, this '3rd Hole' deals with yet another: artwork.

Artwork (prints, drawings, watercolours, oil paintings, photographs, etc) is infinitely collectable, but even within this category further decisions have to be made. Photographs, prints or original works? Antique or modern?

Beware!

And unfortunately there are hazards, so start by purchasing a strong magnifying glass! Modern prints and pictures are often deliberately distressed to make them look old – one reason why

it is better to purchase from reliable sources. Large auction houses, such as Sotheby's, Christies, Phillips and Bonhams, are generally reliable, but if an item is not dated in the catalogue, do always ask.

Some of the more valuable old prints are engravings. These were painstakingly produced by cutting all the markings (lines, dots and so on) that make up the image directly into a metal plate, using a diamond stylus. Most very early engravings were produced on copper, an expensive and very soft material. Only 200 to 250 impressions could be reproduced from a copper plate, and only the first 50 or so were perfect; after that the image became progressively blurred.

When items become valuable there are, and always have been, people who are prepared to cheat and forge. Such underhand practices were used in the case of a fine portrait of Henry

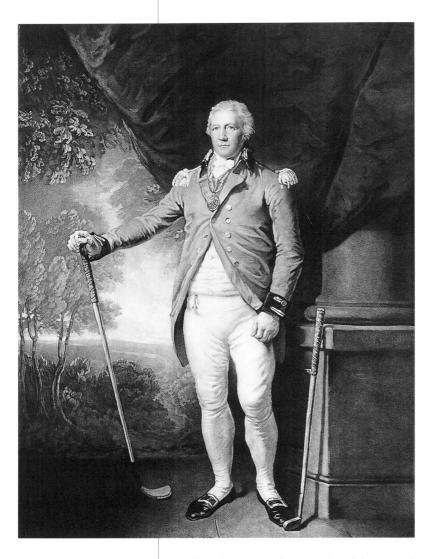

Henry Callender, engraved by William Ward after an oil painting by L.F. Abbott, 1812.

also highlighted various parts of the image in white, including Henry's eyes, giving him a horrible staring look!

However, in our illustration of the Henry Callender engraving there is a different problem. It has been cropped – that is to say, the border has been cut off, together with the impressed mark. This devalues a print by anything up to two-thirds. Each print is made by inking the engraving and pressing good-quality paper hard against the plate to transfer the image onto it. The impressed mark, which goes all round the image, is an indentation made in the paper during this procedure. On a copper engraving the mark is rarely more than ¼ in (6.35 mm) from the image itself, since copper was costly and therefore was used sparingly. In the case of steel engravings, however, it may be 1–1½ in (2.5–3.8 cm) from the image. Steel was much cheaper, and hundreds, if not thousands, of impressions could be made from a steel plate before the image began to blur.

There are literally dozens of ways to produce prints. Besides engraving another major method is etching, whereby the metal plate is covered with a thin layer of a material impervious to acid, usually wax, and the image is drawn into this 'ground' with a sharp instrument. The plate is then placed into acid, which is allowed to bite into the lines and other marks until they are deep enough to hold the required amount of ink. Areas intended to be lighter in tone can then be masked off and the plate again dipped into the acid, this time deepening only those elements of the image that are to be

Callender (an early captain of the Royal Blackheath Golf Club), engraved by William Ward after a painting by L.F. Abbott, dated 16 July 1812. The first half dozen or so prints made from a plate, marked as proof copies, are as sharp and clear as can be (as shown by the illustration). But when this particular plate became worn and the image began to deteriorate, the wretched printers partially re-engraved the plate and reinserted the word 'proof'. They

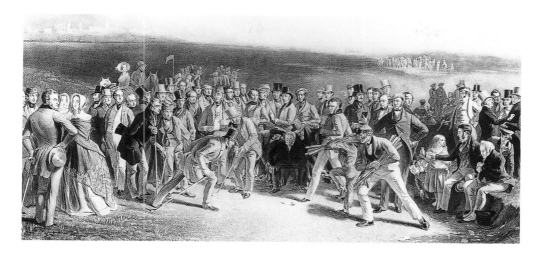

darker. Progressively dipping the plate in this way results in subtle gradations of tone in the final print.

Commercial colour printing started early in the second half of the nineteenth century. Before then, nearly all coloured prints were produced in black and white and subsequently coloured in by hand. This would be carried out at a large table with several colourists sitting round it, each using a different colour paint. The prints were passed round the table from person to person and each in turn would apply his or her particular colour, but not always to the same parts of the picture. Old hand-coloured prints of the same original therefore tend to vary slightly from one another.

If you use a strong magnifying glass to examine closely the illustration on the jacket of this book, you will see that the picture is made up of a series of dots. This reveals that it is a modern photographic (four-colour) reproduction of the original image. Most printing is now carried out in this way. So, if you are offered a supposedly early print but

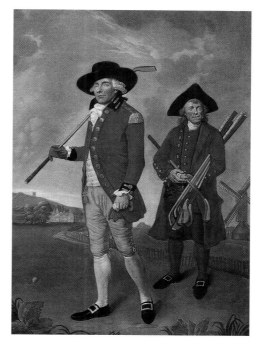

The Blackheath Golfer: William Innes, and his Greenwich Pensioner Caddie, engraved by Valentine Green after an oil painting by L.F. Abbott, 1790.

when you look hard you find the image is composed of dots, you know it is *not* very old! Also, many prints are dipped into strong tea or coffee to make them appear old and stained. Art collecting is a minefield...

Oil paintings and watercolours are a delight to collect, but they have their

George Glennie, unsigned watercolour by Thomas Hodge, titled in his hand, c.1880.

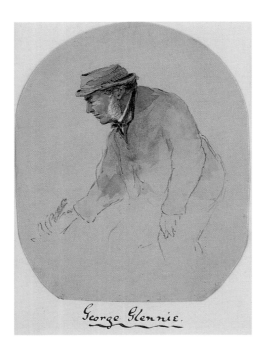

North Berwick Golf Course by Sir John Lavery, c.1925.

problems, too. New oil paintings can be made to look old, either by putting them into old frames or by slightly distressing the canvas. In some instances a golfing connection may have been added to an old oil or watercolour to increase its appeal. In others, oil paint may have been applied over a photograph that has been laid onto a surface such as wood or canvas.

Much of the information given above applies to other areas of art collecting as well as golf. Far be it for us to put the reader off – our intention is purely to advise and forewarn.

There is, of course, no substitute for experience. If art is the direction in which you intend your collecting to

London Scottish Golf Society, playing on Wimbledon Common, watercolour by Charles Pyne, c.1890.

Golf on Reigate Heath, oil painting signed and dated by John Robertson Reid, 1897.

Surviving Open Champions, watercolour *en grisaille* by Michael Brown for the Life Association of Scotland, 1905.

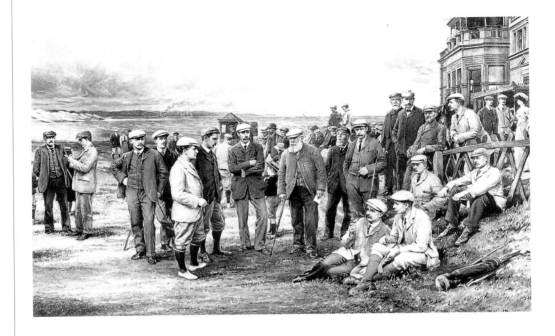

Ladies' Golf Championship, Gullane, watercolour *en grisaille* by Michael Brown for the Life Association of Scotland, 1898. As Michael Brown's grand-daughter sat on his knee, she asked him to draw something. 'He would only draw cows,' she said.

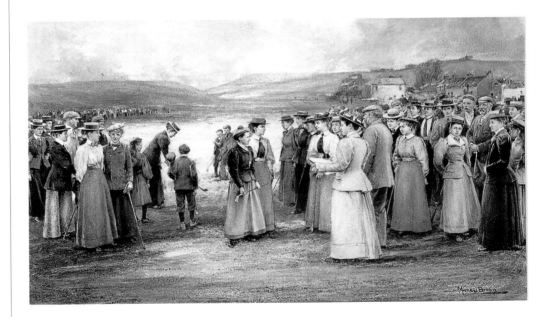

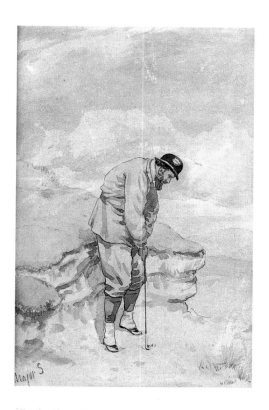

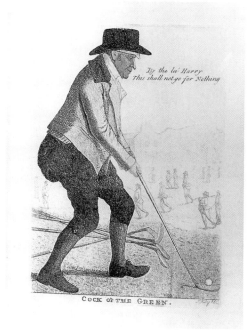

Far left: *The Bunker*, watercolour by Major S. (Francis Powell Hopkins), c.1880.

Left: *Cock of the Green* (Alexander McKellar), engraved by John Kay, dated 1803.

Far left: A lithographic portrait of Old Tom Morris, c.1875.

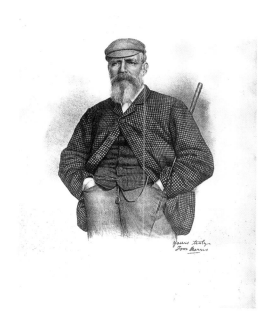

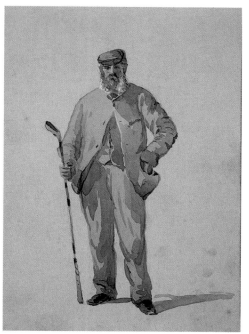

Left: *Old Tom Morris*, watercolour by Thomas Hodge, c.1875.

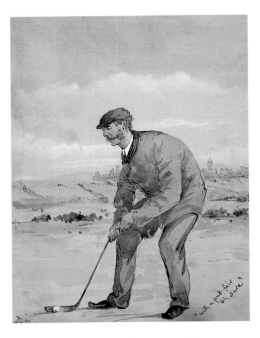

With a Putt Fair and Sure (H.S.C. Everard), watercolour by Thomas Hodge, c.1880.

On Guard, watercolour by Persis Kirmse, c.1930.

go, take every opportunity to visit sale-rooms and exhibitions in order to carry out some research. Read up on the subject in helpful books such as Bamber Gascoigne's *How to Identify Prints: A Complete Guide* (1986). Once you have acquired sufficient knowledge, you will probably derive almost as much enjoyment from unearthing a fake as you will from finding the genuine article.

Auctions

Going to auctions is a very exciting occupation, but, again, be warned – don't get carried away!

First of all, obtain a catalogue and highlight the items of interest to you. Secondly, always go and view. Make up your mind as to the maximum you are prepared to pay for any particular item. Auction houses have buyers' premiums that are added (plus VAT) to your purchases, so you will need to find out what percentage the premium is in order to calculate your maximum bid.

Do not write your bid into your catalogue. It is not unknown for vendors to see figures in buyers' catalogues and bid them up! One perfectly simple way to write your bids secretly is to use a ten-letter codeword in which the letters represent numerals: let's say CARNOUSTIE, where C = 1, A = 2, and so on up to E = 0. Then, for example, £75 could be written as SO – or, if you prefer, ESO (= 075), to make it look like a three-figure sum! To be yet more secretive, you could make use of another letter (or letters) not included in your word to disguise the fact that a zero, or any number, is repeated or

added – e.g. instead of writing 500 as OEE, you could put, say, OEX.

Having memorised your codeword, the next step is to approach the auctioneer to tell him you wish to bid and ask if he needs any details or registration from you. Some auction houses use paddle bidding, whereby you are provided with a numbered paddle to hold up when making a bid. We have all heard horror stories about how one has only to blink to make an unwanted purchase, but such an occurrence is extremely unlikely. Generally you have to wave your arm vigorously simply to attract the auctioneer's attention – *then* you can bid for your item by just nodding, for example. However, accidents can happen…

Many years ago a certain novice golf collector went to his first auction and asked a highly experienced collector friend to give him a helping hand. As it turned out, the new collector was left much to his own devices and did quite well anyway, but his friend inadvertently taught him a salutary lesson nevertheless. On one particular lot the bidding went from £300 to £320 to £350 – then bang went the gavel and the auctioneer called out the experienced collector's name as the successful bidder. 'No, no,' cried the poor man (who had been waving his arms about wildly), 'I was just pointing out to [another friend at the auction] the way to the Gents!'

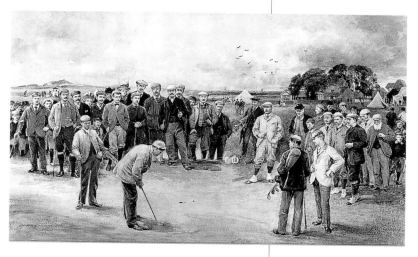

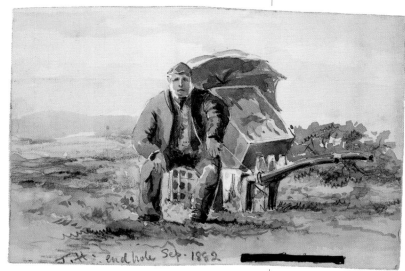

Top: *A Match between J.H. Taylor and Douglas Rolland*, watercolour *en grisaille* by Michael Brown for the Life Association of Scotland, 1894.

Above: *The Ginger Beer Hole*, watercolour by Thomas Hodge, c.1880.

Baltustrol Springfield N. Jersey USA, founded in 1895, watercolour by Bill Waugh.

St Andrews 1900/2000, watercolour by Bill Waugh.

Royal Troon, watercolour by Bill Waugh.

4th HOLE

Woods and other materials
A long hole around the woods

Recollections and thoughts from David Neech

By the time I started collecting old golf clubs, every established collector was already conversant with the history of golf. They knew who was who, who had won what and with whom. They knew all about 'Old' Tom Morris – in fact, I believe they even knew what size shoes he wore and what tobacco he smoked in his pipe. To avoid reinventing the wheel, it was necessary for me, as a new collector, to find a facet of the game that had not yet been thoroughly investigated.

The old club makers

Many years ago, when playing tournament golf, I would travel around the country in my old Ford Thames van, completely equipped with a golf workshop in the back. Along with many of my friends, I was an inveterate golf club 'fiddler', forever changing grips, shafts, swing-weights, lofts, etc.

I was very fortunate. In the early days, when rain, fog or snow precluded practice at Eltham Warren Golf Club in South-East London I would sit in the professional Stan Mason's shop and learn the skills of club making. Stan had been assistant to Harry Brown at Beckenham Golf Club, at a time when Brown had repeatedly won medals for club-making. As first assistant, Stan, of course, did most of the work. In the 1920s Stan often worked on Saturday nights into the early hours of Sunday morning, replacing shafts that had been broken in play on Saturday so that their owners could use the clubs again on Sunday. Anyway, Stan was an

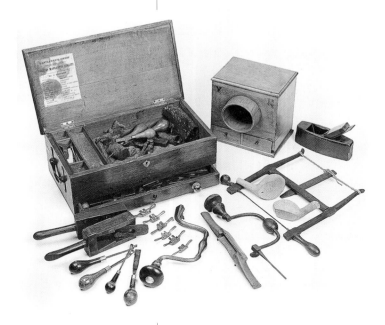

Club-making tools and a ballot box.

White pretended to count all 32 separate edges, before being allowed to use sandpaper on his work. Jack White was sacked in 1926 for 'drinking and womanising' and almost immediately after this event he formed the Jack White Golf Co.

A very interesting chapter in J. Victor East's book *Better Golf in Five Minutes* includes the story of how East copied a driver for Bobby Jones. The shaft was the problem. He tried 5,000 pieces of hickory before he found four that were suitable, and when these were reduced down to two, even one of these reacted differently in varying weather conditions. Finding one in 5,000 – a tough job! Nowadays, True Temper Gold Shafts are all the same.

Club making, I realised, *was* one facet of collecting that had not been thoroughly investigated, principally because few people knew how to detect which wood had been used to make the old wooden clubs. Only the oldest living club makers had any idea what kind of timber a club was made of, and by 1974 people who had made wooden clubs were few and far between.

expert. He was also an expert on horse racing, and it was between races on rainy days that he gave me the benefit of his advice.

I was lucky enough to know many of the old club makers and professionals. One of them was Maurice Bowyer of Castle Golf Equipment Co., London, who joined Jack White, the professional at Sunningdale, at the age of fourteen. He was immediately put to work on shafts and started with a 4 ft x 1½ in x 1½ in (1.2 m x 4 cm x 4 cm) length of hickory, held tightly in the craftsman's vice in the workshop. Maurice would plane the four edges into eight, the eight into sixteen and the sixteen into 32, and then take the shaft to White (who was usually sitting playing chess with one of the club members) for inspection. He would then have to stand there while

Wood for wooden shafts

Nobody I knew had studied timbers as such. When I first started work after leaving school I was employed by a large building and civil engineering company and it was at that time that I became interested in wood. As part of my training I had visited the Timber Research Station just outside High Wycombe in Buckinghamshire, and this seemed the obvious place to start. They were incredibly kind and helpful.

Just turning up on their doorstep one day, without an appointment, I was treated like a long-lost friend. They plied me with books and pamphlets, instructions and advice. I apologised profusely for the trouble I was causing. 'Am I the only "wood nut" you know?' I asked. 'No,' came the reply, 'we have a cosh collector.' (Coshes, or truncheons, are made from a far wider selection of timbers than golf clubs.)

However, this was only the start of my research. It does not matter how many books we read, it's practice that makes perfect – or, if not actually perfect, at least much better. Nothing is better training for assessing wood grains than just looking at timbers. The grain in wooden shafts is much easier to detect than that in club heads, and for this reason we shall start with the shaft.

I guess, and it is only a guess, that when the Pilgrim Fathers left Plymouth in 1620 in search of a new life, taking with them an array of implements – hammers, scythes, axes – probably all the handles and shafts were made of ash wood. Ash is the traditional British wood for making these and other items, such as spokes for cartwheels and the wheels themselves, ladders, and so on. When the Pilgrim Fathers landed in America all these tools were put to work, and soon the handles needed replacing. Local timbers had to be found, and hickory was perfect. Indeed, eventually hickory became an export from America to Britain.

The early professionals did not import hickory but found it at major ports, such as Leith in Scotland, where the timber was used as wedges for cargo. They carried away the huge wedges and sawed them into approximately 4 ft x 1½ in x 1½ in (1.2 m x 4 cm x 4 cm) lengths; ideal for shafts.

Hickory was used for golf shafts in Britain probably as far back as the eighteenth century, when it was found to be vastly superior to ash. It was used a great deal in America and had many applications. In addition to tool handles its main uses were shafts, pit props and scaffolding. Hickory has the exceptional properties of high strength, lightness and the ability to withstand shock, and is quite the best timber for making golf shafts.

Gradually, as golf became more popular, a great shortage of hickory developed and poor-quality wood was used. This was either too whippy or had too much torque (twist). I had one putter whose head could be twisted through 180 degrees: it was made of poor-quality branch wood.

The best hickory came from the United States, particularly the Tennessee hickory belt, Canada, and even Russia. The highest quality hickory was white wood; some red wood was used, but this was of a lesser quality – the very best timber came from the first 12 ft (3.7 m) of the tree, and the very best of this from around the centre of the trunk. Ringed hickory shafts – or tiger shafts, as they were known – were said to be unbreakable. Of course they were breakable! But they were tougher than the rest.

As the acute shortage of hickory became more apparent, other woods were tried, including split cane,

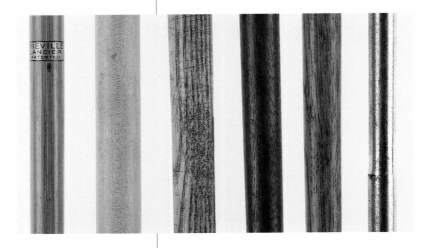

Left to right:
1 One-piece cane
2 Lancewood
3 Ash
4 Greenheart
5 Hickory (note the end grain)
6 A late 1930s steel bubble-type shaft.

End grain.

It is said that hazel was used for the early shafts, but I have never come across it. Of course ash wood had been used, but it was not really of sufficient quality. Some garden putters had 'The Unbreakable' stamped heavily on the head, but many of these had beechwood shafts: one good hit and they snapped. Golf club makers have occasionally told untruths.

Hickory was the best!

It is sometimes very easy to see that a club has been reshafted. The end grains should run up and down the front or the back of the shaft; as can be seen in the illustration, the grain then runs in the direction of flight. If the end grains are placed on the side of the shaft, the shaft splits through to the centre. So even though the shaft is circular, there is a right and a wrong way to put it in the head.

Steel shafts were legalised in Britain on 1 January 1929 and some years earlier in the United States. Steel, of course, revolutionised golf – steel shafts never broke. They were, however, made to look like wood (sometimes very convincingly) by covering the steel in a woodgrain Bakelite sheath. But a magnet quickly identifies the material used!

A point to remember – and this applies to the timber for golf club heads as well – is that nearly all golf timbers start off either white or almost white. It is the way they are stained that makes them different colours. Indeed, dark or black stains have often been used to conceal poor-quality timber. Greenheart is the only real exception as it is already a fairly dark colour in the raw.

Palakona and Spirakona. Hardy Bros of Alnwick in Northumberland made golf shafts, and indeed the clubs themselves, from cane. The shafts were made of twelve pieces of split cane glued together and varnished in exactly the same way as fishing rods. When the varnish became chipped the water entered, melting the glue, and the shaft broke down completely.

Solid cane was rarely used, but some examples have been seen. Danga wood was tried (although there is actually no such timber – it was probably just a trade name). Shafts from the late 1920s are quite often stamped 'danga wood' and these are probably made from either Campestris or Parinari from South America, especially Brazil. Other timbers – greenheart, lancewood or lemonwood, all from Central America – had already been tried and mostly discarded, as they were all really too heavy. They were fine for putter shafts, but too heavy for other clubs. Greenheart had been regularly used for fishing rod tips.

Wood for wooden club heads

It is true to say that the timber for club heads has always been controlled by the ball. It is the ball that has always changed golf, not only from a cost point of view but also in terms of changing the materials from which clubs are made.

Early makers used very specific materials for club heads. The feather ball, similar to our modern wound ball, was hard but had some give in it. Hard timbers were used, thorn being the main type. Hawthorn – or, to give it its correct name, whitethorn – was sometimes planted at 45° into a bank so that it grew outwards and upwards, forming wood ideal for a club head, with the grain running along the head and up the neck for extra strength. These 'thorn cuts' were slow-growing, but since there were so few players, the long wait was not a great problem.

Apple and pear wood were also used. Although of the same family as thorn, these timbers presented a distinct problem in that they often contained invisible flaws. A beautifully crafted head might therefore last only a single hit and then shatter, wasting the craftsman's time and effort. However, if it survived the first round it could go on to last a very long time.

It is not surprising that for the first few hundred years these tough timbers were used. As they are all from the same family, *Rosaceae*, they are very difficult to tell apart. Although most timbers are nearly white, both apple and (more so) pear have a faint but distinct reddish or pinkish tinge. This coloration cannot usually be seen in old,

Thorn

Apple

Beech

Beech

Holly

Evergreen oak

Holly

Holly

used, stained timber, such as that in golf club heads, but all three timbers shown here, whatever their colour, are very hard indeed.

The key to golf club head design is that the wood has to be both resilient and relatively light in weight. The weight of the club head is most important, since the head could be attached to any length of shaft up to about 48 in (122 cm), and it has to be weighted with lead to attain the correct balance.

Impact of the gutta-percha ball

When the gutta-percha ball replaced the feathery, the timber used in club heads changed. The new ball was rock-hard, so softer timbers were used: mostly beech, sometimes holly or even hickory, and on very rare occasions ebony or rosewood, and still only occasionally thorn, apple and pear. Beech was quite soft and damage from the ball caused the faces to crack; they were repaired with thick leather inserts.

Again, club heads had to be light, so the beech was cut from a very specific part of the woodland. If cut from the north-facing edge of the wood, the timber was too slow-growing and too hard and heavy for club heads. If cut from the south-facing part of the woodland the timber was too soft and light. The trees for golf club heads had to be selected with great care. All this was due to the nature of the new kind of ball.

Fixing the club head to the shaft

For about the first 450 years in the game's history, the wooden golf club head was joined to the shaft in the same way, which was totally unlike modern fixing. The shaft was strapped to the back of the head, in a long (about 4 in/10 cm), flat glued join. This join, which was very difficult to make, was called 'scared'; pronounced as if meaning 'frightened', the word is derived from an old carpentry term: 'scarf joint'. This method of fixing was used almost exclusively until 1890, when Bussey of London patented a splice fixing for woods (Pat. No. 16593); in 1891 Anderson & Sons of Edinburgh patented the now universal method of passing the shaft through the head, in other words the 'socket' design.

The socket design became much used from the early part of the twentieth century, when the 'American' rubber-cored ball became widely available. This 'socket' fixing was much easier to make than the traditional 'scare'. And although it was a weaker fixing, because it was fitted to the shaft by wedging and glueing it withstood weather conditions better than the older design and did not come unstuck so easily.

The fact that it was a weaker fixing hardly mattered, as the American rubber-cored ball exerted much less strain on the club head. The socket head fixing was easy to make. The socket was left thick, a hole was drilled and the shaft was glued and wedged in, then the socket was tapered down to meet the shaft – and at this point it is no thicker than a cigarette paper.

Despite this new way of fixing the head to the shaft, some major players continued to use the 'scare'. The great

Harry Vardon never used the socket head. He said that the long scare join gave some 'action' in the neck of the club, which he liked, while Walter Hagen won his fourth and last Open Championship in 1929 with a scared-head driver.

Now let us retrace our steps. When the gutta-percha ball was invented and became commonly used, it was so hard on club heads that the makers decided to use a softer, more resilient timber, namely beech. Beech became almost exclusively the timber used for club heads, which, as we have seen, had to be neither too hard and heavy, nor too soft and light.

The gutta-percha ball was rock-hard and caused damage to the club head, particularly when wet. Clubs were often faced with thick leather inserts, or alternatively, when the beech was damaged, they were repaired with leather patches. This not only protected the wood but also cushioned the shock of the ball. Thick grips also helped in this respect. Patches made of other materials were sometimes used, for example a piece of harder wood on putters, and later vulcanite (hardened rubber). Metal was also used – the 'Mules' patent was for a metal faceplate screwed onto the entire face of the club.

During the 50 years 1848–98 a few clubs were made from different timbers, but not many; this tended to be the case towards the end of the century especially. Willie Park Jr patented the 'Park Compressed' heads in 1894 and these were almost exclusively made of hickory or holly. A few club heads were made of dogwood or horn-

beam and rather fewer from ash, evergreen oak (holm oak), rosewood or even ebony; these woods were used mainly for putters.

The American ball created a revolution in golf. Because the ball was relatively soft, a harder timber was required. For the first time persimmon was used.

Persimmon, the American wood
Persimmon is perhaps the most perfect golf club head material. It came mainly from the central and southern regions of the United States and found its way to Britain in the mid-1890s. In fact, a label on part of the Worcester Golf Club's collection, sold by Sotheby's in their summer sale of 1998, stated: 'Persimmon was first used in 1895 for shoe lasts.' Whether this is correct we have no way of knowing, but 1895 is certainly a realistic guess.

The first golf clubs in persimmon were made a little later, perhaps in 1896/7. By 1905 this hard, resilient American timber had definitely taken over. Even then a few other timbers were still being used occasionally, often in an attempt to save money. Beech, apple, dogwood, holly and hornbeam were all used. The rare one-piece clubs were made from hickory, but all in all persimmon had taken precedence. It was perfect. No inserts in the face were necessary in properly air-seasoned timber.

On the whole, club makers have always tried to save cash by making cheaper goods. Purchasing less expensive, poorly seasoned timber with which to make clubs, they immediately

Right: Persimmon.
Far right: Dogwood.

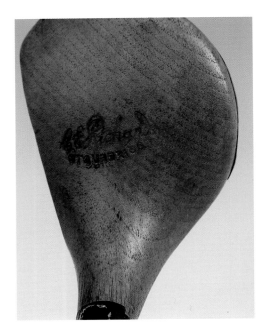 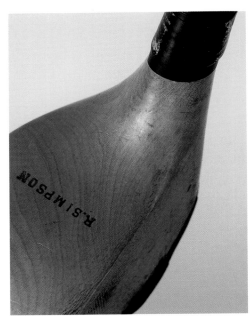

Hornbeam.

found the lasting qualities reduced. They then stained it black to conceal the faults and inserted hard faceplates in vulcanite and other materials to cut down the wear. They also tried accelerating the seasoning and dipping unseasoned timber in oil or hot wax to stop it from expanding and contracting. Robert Forgan & Son of St Andrews developed the 'Forganite' process of dipping the timber in hot wax to seal it. Useless! The wood simply swelled and shrank even more wildly. Eventually they were forced to make club heads with no lead, no horn inserts, nothing – just wood – making it more difficult for the player to see when his club head was swelling or contracting. As aluminium alloys became available that were suitable for the purpose, in the late nineteenth century metal club heads were born (of which more later). Later, however, as glues and other adhesives improved, wood returned to favour; good-quality persimmon was by now too expensive, but laminated maple was developed to fit the bill.

I was very friendly many years ago with Albert Whiting and his son Cyril, who were professional and assistant professional golfers at Royal St George's Golf Club, Sandwich, Kent. Albert is famous in more respects than one. First, he was the model for James

Bond's caddie in Ian Fleming's famous book *Goldfinger*. Secondly, he made golf clubs, as had his father and grandfather before him. Albert's grandfather had been assistant to Peter Paxton, one of the great late makers of long-nosed clubs, in the 1890s.

I sat with Albert and Cyril in the workshop at Royal St George's Golf Club in the summer of 1974, while Albert regaled us with stories of long ago. Albert was 84 years old at that time. He was trying to explain how poor the quality of the modern persimmon was, and in order to demonstrate he picked up a rough block of the wood, claiming that he could blow bubbles from one side to the other through the end-grain. He huffed, he puffed, he went red in the face, then purple. Cyril was holding him up on one side, I on the other. Eventually he succeeded and bubbles appeared on the opposite side of the block. Slumped in his chair, Albert took some time to speak again. He just managed a few final words of wisdom before I left: 'No bloody good, boy!'

I was very fortunate in knowing several of the early professionals who still made clubs. Very soon after that they and their skills became extinct.

Grips and the American grip

Early golf grips are referred to as 'sheepskin'. Actually they are split leather – sometimes called 'shammy'. These grips were wonderful in the dry, not quite so good in the wet. They were used from the year dot up to the early part of the twentieth century. By the late nineteenth and early twentieth centuries other types of grip had come into being; cork, as used in fishing tackle, was one. George Bussey invented the one-piece grip, but more common were the first composite grips, which became widely used. The American leathercloth grip, which was canvas impregnated with rubber, was the forerunner of all the modern rubber grips.

Ramshorn?

All well-made wooden-headed clubs have some sort of protection on the leading edge to prevent damage; even the clubs with brass soleplates should have an insert between the brass and the timber. In the middle of the twentieth century woods had protection that took the form of a complete soleplate without the intervening horn. Latterly, of course, with metal-headed 'woods', this protection has become unnecessary.

In the early days it was essential that all wooden heads had protection. This was usually provided by a horn insert in the leading edge, always referred to as 'ramshorn'. Some were – most were not! Horn is made up largely of the same material as hair (keratin), but by definition it is curved. It can be easily straightened with heat and is also easy to work with, but it always tries to return to its original shape. Therefore the craftsman has to attach it firmly to the club head with pegs.

It is strange how golf sayings seem to have entered general usage with their meanings reversed. Being 'under par' in golfing terms is good, but most non-golfers would take it to mean

poorly or not up to standard. It is the same with the pegs our craftsmen used to attach ramshorn. People use the phrase 'a square peg in a round hole' to refer to a misfit. Not so in golfing terms – a round peg in a round hole would come straight out! Craftsmen always used square pegs in round holes as these remained fixed.

The term 'ramshorn' is itself something of a misnomer. The only solid part of the actual ramshorn is the tip. Up to the nineteenth century the only sheep in Scotland with a big enough horn to make golf parts was the black-faced sheep, which had black tips to its horns. Even then – and with difficulty, owing to the curl of the horn – a craftsman could take only one piece large enough for long-nosed woods. This had to be boiled in order to straighten it, but the horn forever tried to return to its original shape. Therefore it had to be pegged solidly into its wooden nest (with square pegs, of course).

As 'ramshorn' was so difficult to use, clearly the experienced makers looked for easier alternatives. Cattle horns were flatter, and bigger areas of them could be made use of; the large horns of Highland cattle in particular would make many flat pieces. Cattle horn is usually mostly white, but vulcanite, which was black, was also used. (Vulcanite – hardened rubber – was invented in the middle of the nineteenth century. At the beginning of the twentieth century manufacturers found a way to produce red vulcanite as well.) There is a simple test to tell vulcanite from ramshorn: if you take a scraping with a sharp knife (Stanley or similar), a vulcanite scraping is black and 'ramshorn' is colourless.

Twine

Twine was always used on wooden clubs, either to conceal the join between the head and shaft, or to strengthen it in the case of the 'scared' join. The twine used was flax derived from the linseed plant. The only easily attainable flax whipping now is Stewarts No. 2 pitch thread.

The old golf professionals often unravelled fishing line and then covered it with hot pitch to protect it.

Soleplates

The final part of the making of wooden-headed clubs is the soleplate, originally always made of brass. Nearly all brass castings, soleplates, brass putters and any other brass parts were made by P.G. Allday of Northwood Street, Birmingham. J.B. Halley of London advertised themselves as brass casters, but on speaking with them many years ago I learned that even they purchased all their brass castings from Alldays. In the late 1970s I spoke with Alldays, who confirmed that they had given up specialising in golf parts about ten years earlier.

The penultimate shot to this long hole concerns the fixing of the brass soleplate to the wooden club head. Most soleplates used to be fixed with ordinary brass screws. However, in the early 1900s Robert Simpson, of the famous Carnoustie family, developed the use of 'Simplex' screws – not unlike our modern Phillips screw but with a square hole in the head. A number of

makers followed Simpson's example, but most stuck to using ordinary standard screws.

This long hole now comes to a low-lying sticky finish…

Glues

My word! The wonderful smells that emanate from an old professional's shop. The evocative scent of newly cut timber and wood shavings, and the overpowering aroma of the bubbling witch's cauldron that is the hallmark of a club maker's workshop!

The bubbling cauldron was, of course, glue being heated – glue made from a source nearly as old as time: keratin. This is a homogeneous mixture of sheep and cattle horn and hooves, which used to be crushed and combined together to form the base of all animal-type glues. This fixative was quite good, until it got damp and became unstuck.

Nowadays, as one old club maker remarked, 'We have "poxy" resin.' He meant, of course, epoxy resin, which actually is quite splendid.

Steel shafts glued into wooden heads are quite difficult to remove, and soleplates whose screws have been glued are also a problem. Heat may be the answer; applying a red-hot soldering iron to the offending screwheads can melt the resin just enough to get one turn of the screwdriver. Then the problem is solved.

Drilling screws out is a tough job, as the screw is so much harder than the timber surrounding it. It's equivalent to holing a slippery three-foot left-to-right putt to avoid four-putting.

Early golf clubs
A difficult hole

Unfortunately there are no surviving implements from the very first days of golf. The earliest clubs we can see are those depicted in old paintings. Perhaps the oldest clubs still in existence are a group belonging to the Royal Troon Golf Club, which were originally found walled up in a house in Hull together with a newspaper dated 1741. The clubs are much older than the newspaper!

The oldest club that has been handled by Sotheby's is an iron from about 1680. This came from a shed in Edinburgh, where it had been well cared for by the owner, who had kept it wrapped up in a cloth soaked with linseed oil for 40 years. The club was sold by Sotheby's in 1992 for over £92,000 (about $150,000) and is currently on display in the museum at Valderrama Golf Club in Spain.

Iron clubs were bad news for feather balls and players carried only two or three of them. The first, a rut iron (equivalent to our wedge) was for very bad lies. Carts would criss-cross the links, and a rut or track iron fitted neatly into these grooves – no free drops in those days. Feather balls were in general much larger than our modern 1.68-inch ball, and these large balls only just fitted the face of a rut iron. The unmentionable – shanking – was a regular occurrence. The second club carried was a 'general' iron, roughly akin to a long-shafted, deep-faced no. 6 iron. Last was the 'cleek' or driving iron, equivalent to our no. 1 or no. 2 iron.

All these clubs were hand-made by blacksmiths (later known as 'cleek makers'), by beating iron around the sharp end of the anvil. Because there were so few irons made in the early days, they are generally more valuable than old woods.

In those days blacksmiths did not

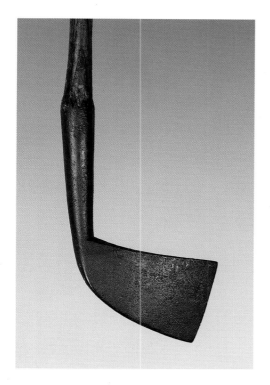

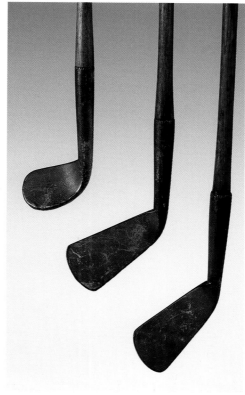

Far left: Iron club head from the late 17th century.

Left: (*Left to right*) Rut iron and two general irons.

stamp their wares, although later they were to learn the usefulness of advertising. Those made by F. & A. Carrick and Jn Gray were the only named irons in the mid-nineteenth century.

Of course, there were more wooden clubs in the player's 'collection' – a set held under the arm by the caddie (no golf bags as yet). The driver or play club, sometimes as long as 46 in (117 cm) or so, was the first, followed by the grassed driver, a club similar to the driver but with a little loft.

The next clubs were a series of spoons, mainly with the same loft but with shafts of differing length: the long spoon, up to 46 inches in shaft length; the medium, 3 or 4 in (7.5 or 10 cm) shorter; and the short spoon, 3 or

Far left: Complete 17th-century club, including 'listing' grip.

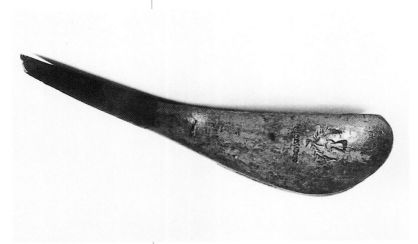

Above: James McEwan long spoon head, c.1785, bearing his 'Thistle' mark.

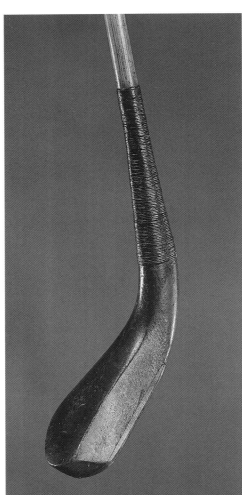

Right: Early unnamed spoon, c.1800.

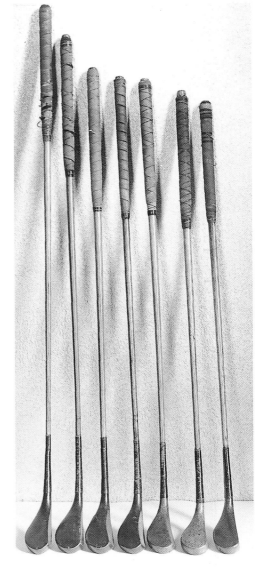

Above: Complete set of seven clubs by Hugh Philp, c.1830.

Left to right: Driver or play club; long spoon; mid spoon; short spoon; baffing spoon; driving putter; putter.

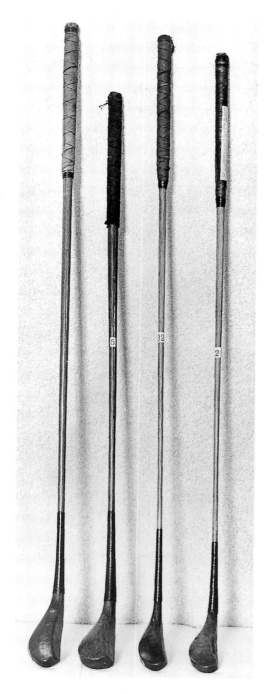

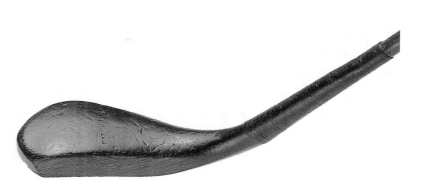

4 inches shorter still. Then, for a change in loft from the baffing spoon, the same sort of length of shaft as the short spoon but with more loft; and the wooden putter was a must. The rarest of all wooden clubs is the wooden niblick, a short-headed wood with a stout shaft, some loft and often a brass soleplate designed for bad lies. This club is frequently mistaken for a transitional wood because of the shortness of head. However, the head needed to be short to fit the 'cuppy' lies.

Unfortunately we have no room to list all the early wooden club makers, but some did stamp their beautifully crafted wares. Cossar, McEwan, Jackson, Philp, Forgan and Robertson are the better-known names. A rare find is a John Patrick (father of Alex), who stamped his elegant clubs simply 'Patrick'.

Another club maker whose son eventually joined him in the business was J.C. Smith of Monifieth, Scotland (the company then becoming J.C.

Far left: (*left to right*) Long and short spoon by Simon Cossar, c.1800.

George Glennie's long spoon by Hugh Philp, c.1845.

Allan Robertson's play club by McEwan, c.1840.

Above: John Patrick driver, c.1845.

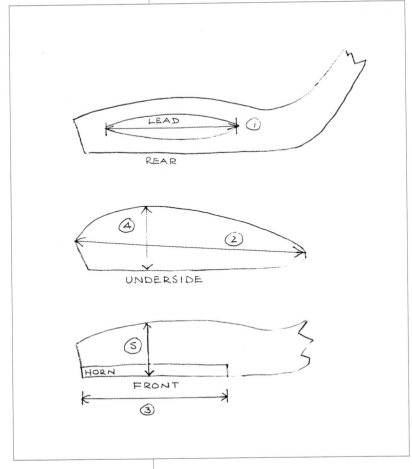

Smith & Son). A superb early putter by this maker has been seen, with a horn to the leading edge so long that it had to be made in two pieces, with four dowels to hold it in position.

If you want to collect long-nosed woods, always try to buy clubs in good condition. Examine the clubs for 'filler' and/or extensive woodworm. Remember, the beetle has already flown by the time there is a hole, but the powder in the holes contains the eggs of future woodworm. Woodworm-killer and wood preservative are readily available at DIY stores. Woodworm beetles literally rain down all over roofs at certain times of the year, so it is not just golf clubs that may have a problem. Look out for fresh dust, as this indicates a new infestation.

A system has been worked out by which collectors can determine whether or not a club is long-nosed (see diagram). All the measurements are gauged in millimetres and in each case

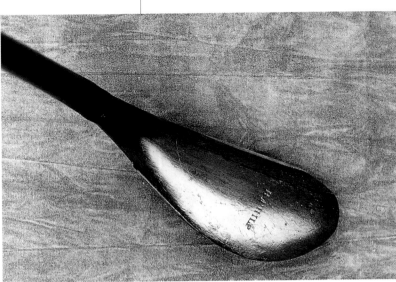

Above left: Method for working out a long-nosed wood:

1	=	100
2	=	121
3	=	92
		313
4	=	50
5	=	24
	Less	74
TOTAL:		239

Left: Hugh Philp long spoon.

the longest possible measurement should be taken. Deduct the total of the figures for measurements 4 and 5 from the total of those for 1, 2 and 3. If (as in our example) the result is in excess of 195, then the club *is* long-nosed.

Using this formula, an expert can even tell a collector over the telephone whether or not a particular club is long-nosed – as long as he is given accurate measurements. But if the club is persimmon, beware: this means it will be quite modern. I was once tricked into driving over 400 miles to see a '1920s' Forgan putter, only to find it had a persimmon head! When buying old clubs, do take care. Old irons can be copied using a process that retains all the marks and dents, making some imitations look quite authentic, so it is sensible to purchase only from reliable sources.

Rules of Golf, 1754.

6th HOLE

The solid ball
1846 to 1898 – look at the size of those bunkers!

In 1846 the game of golf underwent its first major change with the arrival of the gutta-percha ball, which was followed closely by the gutty ball. Both balls completely rejuvenated the game.

The gutta ball

The earliest samples of gutta-percha arrived in Britain from the Far East in about 1843. In its natural state gutta-percha is a hard and resilient substance; it is derived from the sap of the *Palaquium* genus of tree, which is indigenous to South-East Asia. The *Palaquium* tree is a very slow grower and one tree yields only two-and-a-half pounds of gutta-percha! No one is certain who first thought of using this material to make a golf ball. The two most likely candidates are Robert Paterson, when he was a young Scottish theology

student, or another Scotsman, William Smith, who was a clockmaker by trade.

Smith claimed to have formed gutta balls out of wooden moulds in 1846 or 1847. However, there is no evidence to support this, and Paterson, to whom the invention of the gutta-percha ball has been attributed, did at least make gutta balls with his name on them. Robert A. Paterson was a divinity student in 1845. Intrigued by the gutta-percha shavings protecting the contents of a crate his father had received from the Far East, Paterson speculated about possible uses for the material. (Until then the main use the Paterson family had made of gutta was to re-sole their shoes.) The story goes that young Robert, a keen golfer himself, thought the material could perhaps be used to make a new type of golf ball. He placed

the gutta-percha in very hot water to make it pliable and thus formed the first ever gutta ball.

Paterson's success, by all accounts, was instant. The balls flew in the air and travelled a pleasing distance. However, because of impurities in the gutta and the unsophisticated production techniques he used, all the balls subsequently broke up. No one knows just how much time or effort, if any, he put into the idea during his remaining year of study, but it soon became apparent that young Robert's vocational calling was stronger than his desire for wealth. Upon graduating he handed over his invention to his half-brother John and emigrated from Scotland to America.

John Paterson then tried to improve on the technique for dispelling the small air pockets in the gutta ball that were creating internal cracks and making it fragile, but this remained an ongoing problem. Air trapped in the gutta caused an uneven distribution of weight that affected the balance and flying potential of the ball. John was more commercially-minded than his half-brother and he sold the smooth gutta balls as 'Paterson's Composite Patented' and later as 'Paterson's New Composite'. In *The Scotsman* of 25 June 1901 a correspondent wrote of John Paterson: 'He was a man of very considerable ingenuity, and very "handy" in many ways. I recollect of him making a mould for gutta-percha balls, and of seeing himself and his sons moulding the balls.'

A quantity of the Paterson balls were exhibited in London in 1846. A former St Andrews captain, Admiral

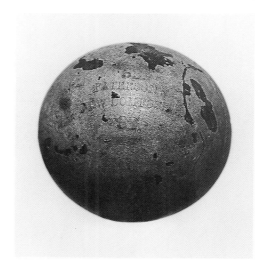

This is one of only a handful of surviving Paterson's New Composite gutta balls.

W.H. Maitland Dougall, used them at Blackheath and was so impressed with them that he had some sent up to Scotland. In April 1848 H. Thomas Peter won a medal event at Innerleven playing with a Paterson's Composite. Forty-two years later he was to recount his first encounter with the new balls in his memoirs, *Golfing Reminiscences by an Old Hand*:

I believe I may with justice claim the credit of having first brought them to the notice of the golfing world, and this at the Spring

Although it is not named, this could be a Paterson ball. It dates from the 1840s and its incised lines were made to imitate the seams of a feathery ball. This very rare ball was sold for £6,000 at Phillips in Chester in 1994.

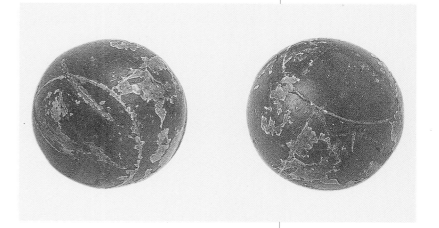

Meeting of the Innerleven Club in 1848. The previous month, I chanced to see in the window of a shop down a stair in St David Street, Edinburgh, a placard bearing the words: 'New golf balls for sale.' I found them different from anything I had seen before; and was told by the shopman they were 'guttie-perkies'. 'Guttie-Perkie! What's that?' I asked, for I had never heard of it. 'It's a kin'o'gum like indiarubber.' 'What kind of balls does it make?' 'I ken naething aboot that – best try yin yoursel!' I bought one for a shilling. It was not painted, but covered with a sort of 'size', which, after some practice with my brother James, who was a good golfer, I saw reason to scrape off. I then determined to try it upon the Innerleven Links, against Mr David Wallace, a golfer with whom I had often played, and who always beat me. I noticed that after I had 'teed', he looked at my ball with great curiosity; so I told him its history and the result of my experiments; and away we went. The upshot of our day's play was, that I beat him by thirteen holes – a thrashing.

Most golf historians are agreed that the homogeneous golf ball, as invented by the Rev. Dr Robert Paterson and later developed by his half-brother John, changed the game from being an exclusive sport of the privileged and rich to one that could be afforded by the many.

The gutty ball
In 1877 William Currie, the proprietor of the Caledonian Rubber Works Company in Edinburgh, launched the pale yellow-coloured Eclipse ball, which was made from India rubber mixed with ground cork and leather. The cork made this composite ball much more resilient, and because it was more pliable than the gutta it was initially called the 'putty ball'. In due course the 'putty' became known as the 'gutty'. The following alliterative tongue-twister about Peter Paxton, the professional at Eastbourne Golf Club, was published in 1898:

> If Peter Paxton picked and packed a
> peck of painted putties,
> Where's the peck of painted putties
> Peter Paxton picked and packed?

Golfers who played with the Eclipse complained that it was too soft in comparison with the gutta ball. One player summed this up by observing: 'It goes off the club with the silence of a thief in the night.' Because it was so soft and resilient, players could not get the ball airborne quickly. A further disadvantage was that because the Eclipse was more elastic than the gutta, players found it hard to control in and around the green. However, on the plus side, unlike the gutta the Eclipse did not crack or split open in cold and frosty conditions.

In 1878 the India Rubber Gutta Percha and Telegraph Works Co., later to be known as the Silvertown Co. (after the Silvertown district of East London in which it was based, which in turn had derived its name from the company's former title of S.W. Silver & Co.), launched its own composition golf ball called the Silvertown No 4. Compared to the Eclipse this felt much harder, and it was popular with weaker drivers as it rose quickly and had a

longer flight. The club makers and repairers liked the Silvertown ball too, since, like the Eclipse gutty, it had a tendency to damage wooden clubs!

The following comment on the resiliency of the new St Andrews gutty appeared in *Golf* on 14 December 1894:

The curious circumstance is that when dropped on a stone slab it rebounds about two thirds the height of a black or red gutta; but off a hard wooden floor it exceeds the other balls by about as great a height. In being driven by the wooden club it does not emit the sharp click usually heard from the ordinary hard moulded gutta ball; it resembles more the sound of the Eclipse...

In 1895 there were more than 40 golf ball manufacturers in Britain (and thus the world), but by the end of the nineteenth century raw gutta-percha had become scarce and costly. For example, in 1890 high-quality gutta-percha cost between 2s 3d and 2s 6d per pound weight; by 1897 the price had doubled.

Makers of the gutta and gutty balls
Established feather golf ball makers

Allan Robertson, Tom Morris, John C. Gourlay, David Gressick and Willie Dunn (see Appendix 2) all switched to making gutta-percha balls. Their established reputations as feather ball makers proved useful in swaying their regular customers away from the old ball to the new.

Not in every case was the change-over immediate, however, as evidenced by the following extract from *Golf*, 5 October 1894:

There was a prejudice against the guttas when they first came in, and especially upon the part of the makers of feather balls. Allan Robertson was particularly sore at the innovation, and his prejudice led to a rupture in the business relations of Tom [Morris] and himself, though it never interfered with their friendship.

When Allan Robertson – who was not only a ball maker but the greatest player of his era – first saw the gutta

On the left are three hand-hammered gutta balls in 'fair' condition; they are not particularly attractive in this play-worn state. The gutty balls on the right were originally known as 'putty' balls.

The solid ball

ball in 1848, he at once took objection to its use. He realised that this new ball could lose him 25 or 30 shillings a week in lost revenue from feather ball sales. His agitation was so great that after buying up every available ball in St Andrews, he set fire to them. The smell can only be imagined! For further comment on his antipathy to the new ball, we turn again to H. Thomas Peter's *Reminiscences*:

I showed the new ball to Allan Robertson and Tom Morris. It was the first time either had seen a 'gutta'. I told them of its greater superiority to 'feathers', and that the days of the latter were numbered; but Allan would not believe it. At my request, he tried the new ball, but, instead of hitting it fairly, struck it hard on the top in a way to make it duck. 'Bah!' he said, 'that thing'll never flee!' I, however, struck it fairly, and to Allan's disgust, away it flew beautifully!

However, by 1852 Robertson had relented, realising that he alone could not stop progress – and he needed the revenue. He made his own branded gutta ball, still distinctively marked in capital letters with his Christian name. It was not until the 1860s that Tom Morris, after being sacked by Robertson, learned the art of hand-hammering the gutta ball from Robert Forgan's younger brother, Andrew.

Many feather golf ball makers regarded the new ball as simply an adjunct to their existing business, and few, if any, forecast the demise of the feathery. They soon realised their mistake when they discovered how easy the new ball was to make. The whole process was much quicker and there were good profits to be made. In 1858 Allan Robertson, using one of his own gutta balls, went round St Andrews in 79! That record stood for eleven years and further sealed the fate of the feathery.

Club professionals and ball makers

Making up the second group of gutta and gutty golf ball makers are those with workshops in and around the links. By the mid-nineteenth century ball and club makers, together with caddies, constituted a distinct category of player in their own right. Many of them – such as Tom Morris and the Dunns went on to achieve great success in the game, and since they played in head-to-head matches for profit, these golfers can be considered as the original professionals.

Although such men obtained regular work from the gentry, who enjoyed partnering them in money matches, most could not have afforded to play if they did not make golfing implements themselves. Caddies either obtained their clubs as 'seconds' from the players they carried for or found them discarded or lost on the links, and some players supplemented their golfing income by working as greenkeepers.

Club professionals and ball makers regarded the gutta-percha ball as being a good business opportunity that involved very little outlay. All they needed was the raw gutta, basic apparatus for the hot and cold water applications, later on moulds, and the painting and drying equipment. However, there were few club professionals who really exploited the opportunity.

One exception was Peter Paxton, who in 1892 installed hydraulic machinery to make gutty balls. Within twelve months his shop had turned out a thousand dozen of both black and red gutties. His booming manufacturing enterprise was operated from the workshop at the rear of the shop.

Large commercial outfits specialising in rubber products

By the 1870s there was a third category of ball makers. These were the commercial gutta-percha and India rubber companies that owed their existence to Britain's Industrial Revolution. British factories now had a skilled workforce, together with modern steam-driven plant and machinery that was capable of mass production. This was a time when Britain monopolised ball manufacture to such an extent that the golf ball was known as the 'British ball'.

Before the advent of the gutta-percha ball, many of these companies produced rainwear and other rubberised products. Anderson, Anderson & Anderson Ltd, for example, advertised 'Every Description of India rubber and Gutta-percha Goods for the Mechanical, Engineering, Surgical, Mining, Sanitary and Domestic...', their products ranging from fire-hose fittings to firemen's mackintoshes and oilskins. The St Mungo Manufacturing Company, which described itself as a 'Gutta-Percha and Golf Ball manufacturer' at the end of the nineteenth century, made a variety of rubber items including pencil erasers. Until the beginning of the twentieth century, when the Haskell rubber-cored ball – which was known as the 'American ball' – came onto the market, all these British companies enjoyed healthy sales both at home and in the export market.

This flourishing trade received mention in an item published in the January 1899 issue of *Golf Illustrated*, which referred to the firm of J. & D. Clark thus: 'By-the-by, they have just received an order for 5000 dozen "Musselburgh" balls ... Sixty thousand golf balls at one order gives the impression that there is going to be a good golfing season in '99.' In February of that year Clark's sold three tons weight of their Musselburgh gutty ball, and they still had ten tons' worth of work in progress! It was also in 1899 that the American firm of A.G. Spalding & Bros. introduced the Vardon Flyer ball – 'manufactured in England from Special Gutta'. In 1900 (as yet unaware of the new rubber-cored ball being hatched by Haskell in the United States) Spalding had Harry Vardon promote the ball whilst on tour in America. He won the US Open that year!

The Vardon Flyer, Vardon's own ball, and the Silvertown O.K. gutty, c.1901.

This substantial Brodie Breeze ball press with original golf ball mould was made and used in 1900; it was sold at Sotheby's in July 1991 for £1,750. The cast-iron golf ball moulds on either side of the press would have made mesh-patterned gutties.

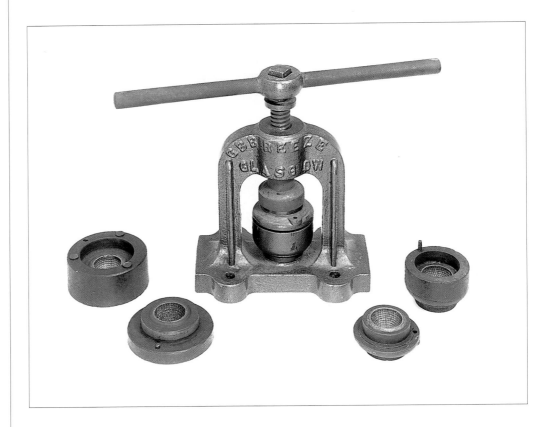

Club professionals and players who remade damaged balls

Towards the end of the nineteenth century many of the large companies were remaking old or damaged golf balls. These were sold as 're-mades' and came in two sizes: Regular and Under Size.

Identifying a niche in the market, professionals took to advertising nationally for damaged golf balls that could be refurbished. For example, W. Tucker, who in 1894 was the professional at the Redhill Golf Club, issued an advertisement with the wording: 'Where can I send my Old Balls to be Re-made?' Re-mades were sold at about half the price of a new ball: Tucker offered 'Old Balls re-made equal to New for 3s. per dozen'. A quantity of damaged balls would be boiled up and, once soft, squeezed individually in a bench press or vice. After a minute each remoulded ball was cooled off in cold water. Following a period of drying out the balls were repainted and offered for sale to club members. The re-made was usually a good ball and Tom Morris even preferred to use them in his big matches.

A caddie's story

'In the days when gutty balls were hand-hammered and remade, those St Andrews caddies who were capitalists would be the owner of a mould, or in the case of an exceptionally prosperous caddie, he might proudly acknowledge two. In those days Robert Forgan allowed them the use of the

fire in his shop, and there, in their spare time, they remade their patrons' balls. One old caddie had two moulds – one size 27½ and one 27, the latter of course being the smaller. Unfortunately, one day he drank too much whisky and got the two moulds mixed up. He put the top of one onto the bottom of the other. The result was that when the ball came to be used, a certain noble lord for whom he was carrying, noticing the difference said, 'How is it that one side of this ball is marked 27½ and the other 27?' Not to be found wanting, the caddie made this ingenious reply: – 'When you are playing with the wind, my Lord, tee the 27½ side to the front, and the 27 side when playing into the wind.'

Golf Illustrated, 3 January 1913

How gutta and gutty balls were made

From the very start gutta balls were superior to feather balls in terms of their ease of production and simplicity of content. There were no unhealthy birds' feathers, no twine or leather, just raw gutta-percha. It was the first one-piece, all-solid golf ball. The gutta was procured in long rods measuring between one and two inches (2.5–5 cm)

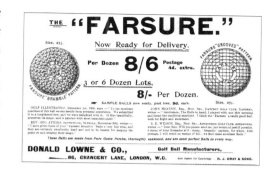

By 1898 the bramble pattern had become the most popular cover pattern.

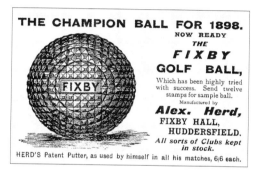

The Champion Ball for 1898 – meanwhile Coburn Haskell was inventing the rubber-cored ball.

A Bryce & Robertson St Mungo golf ball, c.1898.

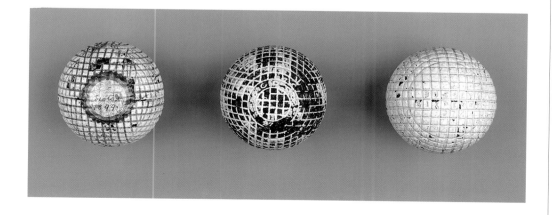

Left: A machine-marked Scoto gutty; *centre*: Scoto gutty made from a mould; *right*: Bussey Sixpenny gutty.

in diameter. One of the most active companies in the market was the Hyde Imperial Rubber Company, of Woodley in Cheshire, which supplied large quantities of gutta-percha rod to British makers of golf balls.

The ball maker used his preset gauge, which measured in fractions of an inch, to determine the amount of gutta-percha needed to make the right size of golf ball. The homogeneous gutta was softened in a pot of very hot water until it was sufficiently pliable to be shaped. Before the advent of moulds the gutta-percha used to be rounded in the hand. The ball was then dropped into a pot of cold water and hardened. However, it had to be continuously moved around within the pot and kept submerged, since any part of the ball that came above the water tended to swell out of shape.

By the late 1850s the ball makers had devised metal moulds in which to form and shape the hot gutta-percha. These hemispherical moulds were brought together and then compressed either by hand or using the vice attached to the ball makers' bench. This technique obviated the need to roll the gutta in the hand. If it was a composition ball, the addition of cork, iron filings or whatever was usually made before the ball was rolled or moulded into shape. In 1897 C.J. Grist obtained a patent (No. 26801) for a process '...whereby hemp or other fibre immersed in linseed oil which has been partially oxidized and dried by heating to 400 degrees F' was 'ground between crushing rolls twice'. A mixture of sulphur and gutta-percha was then added, and: 'The mass is finally moulded to form the balls, painted, and allowed to

Smooth gutta mould sold at a Phillips auction in 1994 for £3,700; *right*: Ross's Home Press, used by golfers at home to make good their damaged gutta balls.

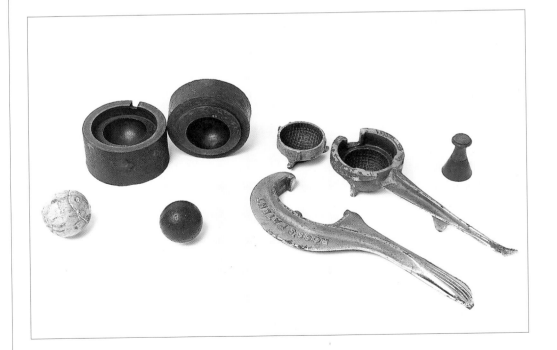

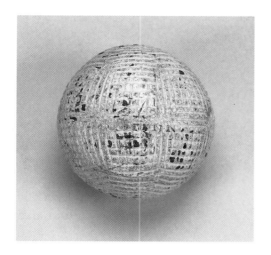

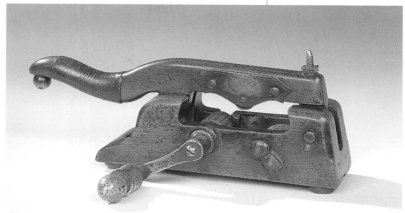

dry.' In 1902 J.P. Cochrane was granted Patent No. 1809: 'A piece of gutta-percha rod is softened in hot water, and then formed by hand into a ball. The ball is sprinkled all over with sulphur, and is rolled on a hot plate, so as to impregnate the outer part with sulphur, this producing a hard surface. The ball is finished in a mould in the usual way.'

The main criticism levelled at the smooth gutta was that during its flight it had a tendency to duck and dart. But players were quick to notice that once the smooth ball had picked up a few nicks or cuts in the course of play, its aerodynamic qualities improved greatly. Better results could be obtained from balls that had been played with or those that had become a little scuffed or cut. It did not take the ball makers long to make such cuts an integral part of the ball. Willie Dunn Sr is credited with designing the hand-hammered pattern using the claw end of a hammer to groove the parallel lines that ran longitudinally. This regular pattern soon became the standard (although

Robert Forgan developed his own hand-hammered criss-cross pattern, which was basically a grooved diamond-mesh design).

An oak cup positioned in a hole in the workbench kept the ball in place as it was slowly turned with one hand while being hammered (between 240 and 280 blows) with an ordinary chisel-headed hammer held in the other hand. The hammer first cut longitudinal grooves into the ball. When this was finished, the ball was turned through right angles and the process repeated. The whole operation took less than three minutes to complete. The regular mesh pattern became the most popular and was copied by other ball makers. The smooth gutta, whether rolled by hand or formed in a mould, is the rarest type of golf ball because it was made only between 1848 and the early 1850s. Very few smooth gutta balls have as yet come onto the collectors' market.

By the late 1870s it was possible to pattern the ball with hand-held mechanical cutting machines resembling a

Above left: This gutta ball was made by Willie Dunn Sr and nicked in the Forgan style; in 1997 it was sold by Phillips in New York for $10,050.

Above: Willie Dunn Sr's gutty ball line-cutter, c.1860, made of beech and capable of being mounted onto his workbench; it was sold by Phillips, New York in 1997 for just under $73,000.

The solid ball

Right: An Auchterlonie moulded-mesh gutty.

Far right: The Eclipse ball went off the club 'with the silence of a thief in the night'

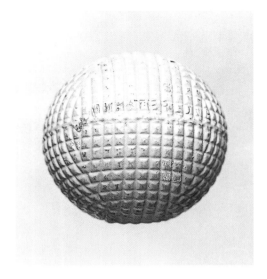
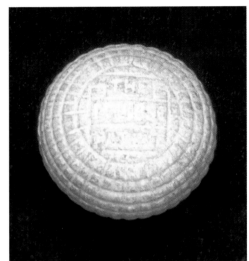

carpenter's plane. These produced lines that were parallel, straight and fine, resulting in an aesthetically good-looking ball. However, this wasn't the end of hand-hammered balls since there was still a healthy demand for them from players of the 'old school'.

Engineering firms such as John Grieg & Sons supplied club professionals with all types of machinery: 'To Golf Ball makers – plain and engraved moulds, screw presses, and cutting machines, new and improved marking machine marks 36 dozen balls per hour.' In 1894 the ball and club maker Ben Sayers recommended a golf ball marking machine made by W. Hurst & Co., of Rochdale, Lancashire. In an advertisement Sayers commented: 'It is the cleverest and cleanest Machine in the Market. It knocks all others out of time.' For those small concerns that faced opposition from the larger commercial golf ball outfits, whose balls were patterned whilst in the mould, this cutter was of great benefit. It

enabled them to produce at a quicker rate and made their product look much more professional.

During the 1880s brass golf ball moulds rose in popularity among the larger commercial firms, who were interested in mass-producing golf balls. These moulds were made in British foundries such as that of J. White & Co. Ltd of Edinburgh. As the gutta cooled in them, the hemispherical moulds were brought together under great pressure, either by hydraulic equipment or using a large screw mechanism. When the pressure was released from the moulds this produced a perfectly round gutta ball. The moulds were made in different sizes and initially their inner surfaces were smooth, but later the inside was patterned with a fine mesh, followed by the bramble design in the 1890s. The Silvertown Co. pioneered the original moulded mesh pattern and the Caledonian Rubber Works Co. used canvas liners on the insides of the moulds to repro-

duce their own mesh pattern on their Eclipse gutty.

Sometimes it is hard to tell whether the mesh pattern has been made by hand, by a machine or in a mould. For example, Goudie & Co. of Edinburgh made a moulded ball in 1893 that at first glance looked like a hand-hammered ball. It is hard to differentiate between the patterns made by a mechanical cutter and a mould. However, the lines produced by a cutter were generally finer and narrower than those cast from a mould. After a ball had been removed from the mould, there was usually a thin ridge of surplus gutta where the two halves had been joined together. This was known as a fin and the ball maker would trim it off with a sharp knife before the next stage; this surplus gutta was then recy-

cled to be used for the next batch of balls. In 1898 Bryce & Robertson of Glasgow invented and patented 'New Golf Ball Fin Cutters; cuts 6 Balls in the time the knife cuts one. 4/6d each'. This cutter consisted of a small brass cylinder fitted with a double-edged knife; the cylinder was held in the palm of the hand and the ball turned against the knife.

The next stage in the making process was very important: a period of drying out or maturing called 'seasoning'. When newly made, gutta-percha balls were relatively soft, but gradually, over a period of months, they hardened. In W. Millar's advertisements for the Mirco ball this period was described as six months' imprisonment. Seasoning took place over a minimum of three to six months and often up to twelve

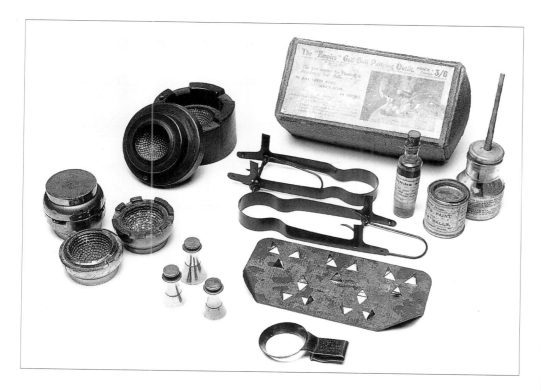

An iron bramble-patterned mould, and below it a brass gutty ball bramble mould. The boxed Empire golf ball painting outfit was made around 1900 and included varnish, paints, cleaning fluid, two golf ball grippers and a ball-drying rack.

months. The Brackett ball made by Frank Johnson in the late 1890s was advertised as having been seasoned for two whole years! Golf ball manufacturers such as the Craigpark firm showed the period of seasoning on the box lid and made it a selling point.

One of the disadvantages of the gutta-percha ball was the poor adhesion of paint. The best type of paint to use was enamel, but even this had a tendency to crack and peel. Silvertown's Eureka ball was painted with a new adhesive paint that was 'bluish-grey in tint' and was one of many balls to be advertised as having been painted with chip-free enamel. In the formative years of the gutta-percha ball most were sold unpainted, but these naturally brown balls were difficult to distinguish on the course. When players asked for white or red balls for use in wintry conditions, lead paint was applied to the ball and it was then rolled in the palms of the hands. Usually the gutta ball was given four thin coats of paint, but if its surface was marked with a pattern (i.e. had 'cover' markings) only the second coat was rubbed in. Invariably the paint soaked into the fine lines, as found on early balls, and they took on the appearance of being smooth. The solution was a spiked frame that held the balls while the paint was applied with a brush.

Once painted, the balls were again put on racking and stored away to dry before being boxed up ready for sale. By 1897 British ball makers were using 500 tons of raw gutta-percha annually. It was reported at the time that 'there is an outlay approximately of £500,000 a year in the manufacture and sale of Golf Balls. A fact like this tells not only a vivid story of the growth and popularity of the game, but of the commercial importance of the Golf Ball trade.' In 1901 it was estimated that there were over twenty million gutty balls in use in Britain alone, not counting the number being used in North America and the British Empire.

Curious...

Mr. J.E. Ranscome writes: 'When playing at Brockenhurst on the 10th inst., a singular thing happened, which I have not seen recorded before, and it may perhaps interest you. I was driving a brassey shot to the third hole, over some trees and low bushes, at a distance of, say forty yards, when my ball struck a thorn bush at about eight feet from the ground. On going up to the place, instead of finding my ball (a red gutty) on the ground below, I found it impaled on a thorn, unsupported by anything else, and so firmly that it had to be knocked off...'

Golf, 19 October 1894

Price, size and weight

Priced at 1s 3d, which was at least half the price of a feathery, these cheaper balls led to increased participation in the game by the not-so-well-off, many of whom were tradesmen. Golf courses in North Britain in particular began to suffer from congestion. *Golf*, 25 February 1898: 'Another old Edinburgh club has had to look out for "fresh fields and pastures new" owing to the overcrowded state of Musselburgh. As the name bears, the Bruntsfield Links Club originally met on the Bruntsfield Links,

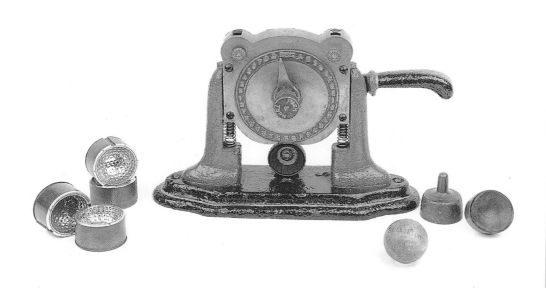

A patent ball-marker in brass on iron legs. The side lever and letter-and-numeral dial provided the appropriate letter and/or number stamp for the owner's ball. On the right is a pair of ball maker's hardwood cups that would have been used to hold a feather ball in place, together with a lightweight wooden ball.

Edinburgh, and though the old minutes have been lost, it is believed that this club was formed in 1760.'

Even though by the mid-1890s the game's popularity was beginning to explode in Britain, golf had still not taken off in America:

Many American daily papers display an amount of ignorance about Golf which is simply alarming. Of course they cannot be expected to really understand a game which is quite new to the country, but they make their want of knowledge worse by making a show of knowledge, and giving a lot of misleading information in so doing. One of the most glaring mistakes they have made is to describe the game as an imitation of Shinney, otherwise known as Hockey.

Golf, 28 September 1894

Gutty balls were generally large, at least as large as the modern ball (1.68 in). Early hand-hammered balls were still marked in ink to show their pennyweight, which ranged between 26 and 29 dwt. A 26-pennyweight ball was very light (1.43 oz), whilst a 29-dwt ball was very heavy (1.59 oz). The most popular ball weighed 27 dwt (1.48 oz) and was just heavy enough to run well on the putting surface; lighter balls tended to be deflected off course. A good characteristic of the gutty ball was that it could usually be hit firmly into the back of the hole.

Golf ball moulds took away much of the guesswork as to how much material was needed to make a ball. After a while (no one is sure exactly when), the numbers on the ball ceased to indicate the ball's weight and related instead to its size. The smallest mould made a 26 ball. In 1898 the Forth Rubber Co. made a 26 ball called the Bullet, which it was claimed would

'outdistance others not only with but against the wind'. Other companies added 'metal filings or any other pulverised materials' to the gutta-percha, ensuring that the size remained the same but its weight increased.

Damaged balls were made good by remoulding, but one consequence of heating and re-pressing the gutta was that the ball was reduced in size. Many players enjoyed using a remould because the material seemed to be denser and more resilient. However, if the ball was remoulded a second time it shrank still further and was then sold as a 'Boy's' ball, to be used for practice or by juvenile golfers. The price of these very small remade balls in the 1880s was 8d.

Packaging and presentation

Early gutta-percha balls were presented just as featheries had been. There was no need to wrap them; ball makers tended to sell on the look of the ball, so why hide them in tissue paper? Later, commercial manufacturers, who all tended to use one of the main ball patterns, needed to make their products stand out from those of their rivals and so packed their balls in cardboard boxes with a paper label describing the contents. Towards the end of the nineteenth century these boxes, which were designed to hold either a dozen or half a dozen balls, became more colourful and ornate.

A funny story

In *Golf Illustrated* for 11 May 1906, Ben Sayers wrote of his ball-making experiences whilst at Leith in the 1880s:

I was a ball maker at that time – a ball maker only – as I did not go in for club making

Two red boxes containing J.B. Halley's Ocobo gutta-percha balls; each ball was individually wrapped. The upper box has faded to a pink colour and lacks one ball, but this item still fetched £3,200 at a Sotheby's auction in July 1993. The other box of twelve balls realised £5,400.

Top row: The Silvertown Co. made the Exhibition gutty and the Silvertown gutty in the late 1890s.

Bottom row: The Cestrian gutty was made in 1898 by The Telegraph Manufacturing Co.; the Star Challenger made in 1907 is the rubber-cored version, and the Eclipse gutty was made by Wood-Milne.

until I went to North Berwick. My wife worked at it then, along with me; and I can assure you I did a big trade in this line even at that period. I well remember a very funny thing that happened sometime during that part of my life. A certain golfer happened to send a ball of my make, bearing my name upon it, through the window of a house near the links. A policeman came to me about it, wishing to charge me with the breakage, because my name was on the ball. I had to appear at the police court with other samples of my golf balls, before I could satisfy them that I had no hand in it. This shows how little even a policeman knew about golf at that time!

The effect of the gutty on the golf swing

When playing with the gutty, the golfer had to get the ball well up into the air. Consequently his stance became more open to square. The left arm was bent to 45 degrees on the take-away, and at the top of the swing the right elbow faced upwards to the sky. A strong wrist action was the best technique to get the gutty airborne.

Golf Illustrated, 18 February 1927: 'Playing with the hard, resisting ball called for what may be termed a flowing rhythm from the feet. In other words, we did not hit at the ball and brace the left leg hard and taut – as Abe Mitchell is apt to do, and as young players like Frank Ball, and J.J. Taylor of Potters Bar, undoubtedly do.'

The effect of the gutty on the rules

Although the ball was easily dented and hacked, or even knocked out of shape, it was, generally speaking, a robust ball. Its biggest weakness was trapped air within the gutta-percha; this made the ball less homogeneous and as such 'solid' balls had a tendency to break up during play. The rules of golf were amended so that when a gutty ball split into pieces during a game, a replacement ball could be placed by the largest broken piece without penalty.

Comparison of the gutty with the feathery

Although the new ball was popular owing to its low cost, robustness and

The three unused bramble-patterned gutty balls marked with their original owner's name, 'W. Davidson', were sold by Sotheby's in July 1996 for £800. The 'Edinburgh' was made by North British for the first time in 1894, the ball in the middle has no name, and the gutty on the right is stamped 'Le Tour Patent'.

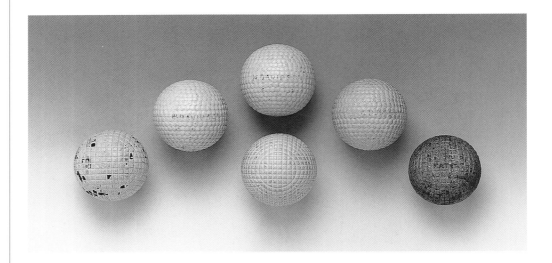

controllability on the greens, it did not have the same length as the old ball. Historically it is true that the 18th at St Andrews has been driven more often with a feathery than a gutty. An example of the feathery's raw power was seen in 1836, when Samuel Messieux drove one 361 yd (330 m) from beside the Hole o'Cross green into Hell's Bunker at St Andrews. The average distance of the feather ball was 200 to 220 yd (183–201 m), whereas the average drive with the gutty was only 170 to 200 yd (155– 183 m). A ball that had lasted several rounds of play lost between five and ten per cent of its original elasticity; this meant less 'bounding' power.

The calibre of play and scoring improved dramatically when golfers got used to the gutty. In 1869 Young Tom Morris scored a 77 at St Andrews. In 1870 he won his third consecutive Open at Prestwick, scoring 149 over 36 holes.

In 1902 many leading golfers wanted the new American ball banned and the gutty retained as the standard ball for the game. They feared that otherwise existing golf courses would have to be radically redesigned and the holes lengthened considerably. In *Golf Illustrated* of 25 July 1902 the comment was made: 'One never realised what a stubborn inert thing a gutty is until the Haskell came on the scene.'

7th HOLE

The rules of golf and the stymie
A tricky hole

The original thirteen rules of golf were drawn up in 1744 by the Company of Gentlemen Golfers (later the Honourable Company of Edinburgh Golfers). These were copied and modified by other golfing societies and clubs, including the St Andrews Society of Golfers, formed in 1754.

Of the original thirteen written rules, Rule 6 was to become the most contentious. It stated: 'If your Balls be found anywhere touching one another, you are to lift the first Ball, till you play the last.' Thus, if two balls were touching, the ball nearest to the hole was to be lifted out of the way to allow the other player an unobstructed putt at the hole. Immediately there were disputes over what was and what wasn't a touching ball.

In 1775 the reference to 'balls ... touching' in Rule 6 was interpreted by the Honourable Company of Edinburgh Golfers to mean that the balls lay within 6 in (15.24 cm) of each other, so that whenever two balls lay this close, the obstructing ball was to be lifted out of the way. For example, if the balls were four inches apart, then Rule 6 applied and the player was entitled to ask his 'adversary' to lift his ball to give him a clear run at the hole. If, on the other hand, the balls were eight inches apart, they were deemed not to be 'touching'; if the ball nearest to the hole was obstructing the line of the other ball, then a stymie had been laid and the ball could not be lifted.

'Stymie' (occasionally spelt 'stimy', 'stimie' or 'steimy') is an old Scottish

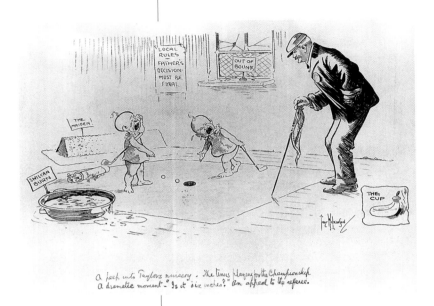

A peek into Taylors nursery . The twins playing for the Championship a dramatic moment — "Is it six inches?" An appeal to the referee.

Pen and crayon sketch:
A Peek into Taylor's Nursery.

word meaning a purblind, or extremely short-sighted, person – and one can certainly imagine a golfer squinting hard to see if there's a way out of the stymie! However, in view of the fact that golf is related to early ball-and-stick games played in the Netherlands, in a golfing context the word 'stymie' could perhaps be connected with the Dutch phrase *stuit mij* (the verb *stuiten* can mean to stop or check, *mij* is 'me').

Rule 12 stated: 'He whose Ball lyes farthest from the Hole is obliged to play first' – i.e. the player furthest from the flag played first. And so a stymie was 'laid' when the ball closest to the hole lay in the direct path or line to the hole, blocking out the ball that was farther away. Something similar to a stymie features in another ball game, snooker. When the opportunity (or need) arises, a player tries to 'snooker' his opponent by ensuring that it is impossible to hit the white cue ball directly at the next ball to be played. However, a signifi-

cant difference between the stymie and the snooker is that the latter is an integral part of the game, whereas the stymie was not to be played on purpose. The stymied player, being furthest away from the hole, had to play first, and if it was match-play and his ball hit the other ball on the putting surface, the hole was forfeited. The stymie was also relevant in medal or stroke play when there was an actual opponent; the penalty for failing to get out of the stymie was two penalty strokes.

There were two types of stymie: the 'dead stymie' had the path to the hole completely blocked, whereas the 'half stymie' afforded the player some chance of getting out of it.

The golfer who was stymied could not ask his opponent to remove and mark his ball, but he did have some options. He could play a stroke past the other ball, or he could play his ball around the other ball, or he could use a lofted club to play over the blocking ball. Sometimes a player would hit his own ball hard into his opponent's; this could clear the stymie and at the same time put the opponent's ball further away from the hole, but sometimes this backfired because the opponent's ball could be propelled into the hole. Also, at any time a ball could go into the hole after ricocheting off the other ball! However, these tactics transgressed one of golf's fundamentals, which was not to interfere with your opponent's ball.

Rule 7 stated: 'At holeing, you are to play your Ball honestly for the Hole, and not to play upon your Adversary's

ball, not lying in your way to the Hole', which meant that a player was not to hit the other player's ball on the way to the hole.

This caused a stand-off within the game, and for many it justified getting rid of the unwelcome stymie.

The stymie had a differing effect on golfers. Some literally saw red – it was just so unfair. Others felt that the stymie should be regarded as being like the rub of the green, just as the pointed American football or the British rugby ball ensured an unpredictable bounce. Those against the stymie argued that it was an unfair aspect of the game because, unlike heavy rough or green side bunkers 'laid' by the golf course, the stymie was laid by an opponent. Also, the stymie could happen quite suddenly, particularly if both balls were lying close to the hole. Advocates of the stymie liked its unpredictability, and regarded it as being no more than a slice of bad luck. Undoubtedly a certain amount of skill was needed to play the stymie and to get out of one.

Many argued that the stymie was just part and parcel of the game, but because of its controversial nature the R.& A. banned it in 1833. However, it was back in the game within a year! Before the advent of six-inch-wide scorecards, golfers who played the game strictly to the letter of the law

McFoozler (whose eye-sight varies after lunch): 'Hang it! 'nother beastly stymie!'.

made a six-inch rule on their putter shaft, either by cutting out two notches in the wood or by marking it with ink. If there was a dispute as to whether the balls were touching, the club was laid down and used to measure the distance.

The stymie was never popular with American golfers, who tended to favour medal competitions. They did not like having to add penalty shots to their overall score just because of an old-fashioned rule popularised years ago in Britain, for a format of the game that was seldom played in America. In 1938 the United States Golf Association (USGA) relaxed the rule, and after a series of meetings the golf governing bodies in Britain and America both agreed to abolish the stymie with effect from 1 January 1952.

8th HOLE

Later golf clubs and players
An easier hole

Of course, all games have had their heroes. Golf is no different. The most famous golfing figure from the early days is certainly 'Old' Tom Morris, who was born in St Andrews in 1821. He became apprenticed to Allan Robertson, but after falling out with him – over playing with a gutta-percha ball – started making clubs on his own account in the late 1840s.

In 1851 Old Tom was invited to become Keeper of the Green at Prestwick. He won his first three Championship Belts (the belt was the forerunner to the silver claret jug that has been the British Open's prize since 1872) while employed by this famous club. By the time he won his fourth and last belt in 1867 he had returned to work at St Andrews, and became professional to the Royal and Ancient Golf Club.

Inextricably linked with Old Tom is his son, 'Young Tom' Morris, who died in 1875 while in his mid-20s– it is said

of a broken heart after the death of his wife and baby. The entries in Old Tom's scrapbook, now in the possession of a golf collector, cease on the day that Young Tom's wife died in childbirth.

Young Tom won the Championship Belt on three successive occasions (1868–70 inclusive), thus earning the right to keep the belt as his personal property. The event was not staged again until two years later, 'when a fresh trophy was substituted, to be held by the leading club in the district from which the winner hails'. The winner of the first Open Championship Cup, in 1872, was yet again Tom Morris Jr.

Old Tom continued to make beautiful golf clubs for many years. Indeed, his golf club business was still operational when he died, in 1908, after a fall down the cellar stairs at the New Club St Andrews.

Long-nosed clubs continued to be made by other fine makers, such as

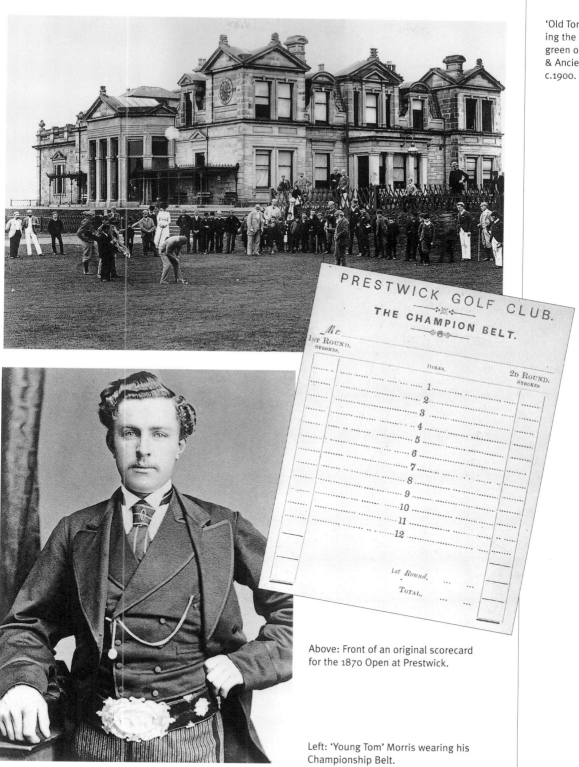

'Old Tom' Morris attending the flag on the 18th green outside the Royal & Ancient clubhouse, c.1900.

Above: Front of an original scorecard for the 1870 Open at Prestwick.

Left: 'Young Tom' Morris wearing his Championship Belt.

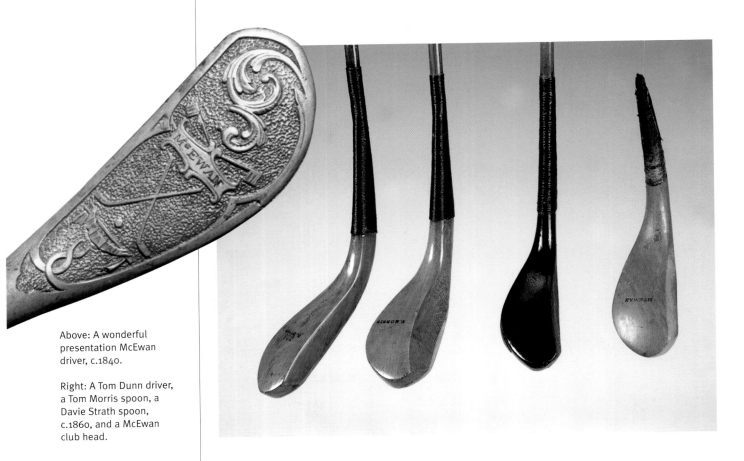

Above: A wonderful presentation McEwan driver, c.1840.

Right: A Tom Dunn driver, a Tom Morris spoon, a Davie Strath spoon, c.1860, and a McEwan club head.

Wille Park Sr, James Anderson (both several-times winners of the Open Championship in the nineteenth century), Tom Hood, James Beveridge, Peter Paxton, the Dunns, the Straths, and of course Forgan and McEwan, who were still manufacturing.

A significant change in club manufacture occurred around 1885 when long-headed clubs began to become obsolete with the invention of the short-headed club, the bulger – some say by Willie Park Jr, some say by the amateur Henry Lamb. Whoever it was, golf was changed. A huge number of iron clubs were now made by an ever-growing volume of cleek makers. Aluminium clubs were also becoming popular.

All woods were now short-headed, and one can easily see, by looking at the 'scare', which of the clubs were designed for the gutty ball and which for the new rubber-core. The neck of the club for the rubber-cored ball is much more delicate than for the gutty. The new rubber-cored ball bounded on and had to be controlled. The cleek makers stamped all sorts of designs onto their iron club faces in order to try to stop the ball.

Once again, it had been the golf ball that changed golf irrevocably.

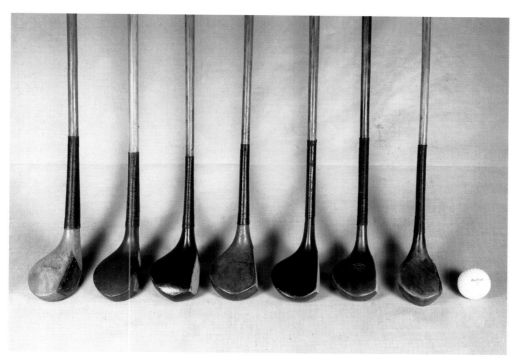

A group of scared head woods from the late 19th–early 20th century.

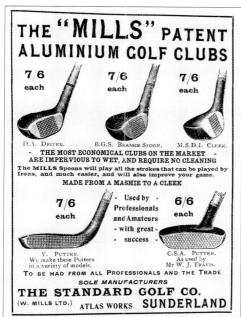

A Mills advertisement, 1905.

A group of iron clubs showing face markings.

Harry Vardon and the English grip
A hole with no boundaries

We have absolutely no idea why the double-handed golf grip – that is to say, a palm grip, with both thumbs outside the shaft – is called a baseball grip. True, the baseball bat is also gripped in such a fashion, but golf must be some few hundred years older than baseball, and the golf club was gripped in this way from the start.

Ergo, the baseball grip should really be called the *golf grip*.

This age-old grip was changed late in the nineteenth century when the Vardon grip became popular. Harry Vardon, who won the Open Championship six times, starting in 1896, revolutionised golf with his grip. The Vardon grip entailed placing the left thumb on top of the shaft, and covering it with the right hand rather than wrapping both hands round the shaft. It is well recorded that when Vardon was asked how he invented the grip, he replied: 'When we were kids in Jersey we used to cut blackthorn sticks out of the hedgerow, and by placing my thumb down the shaft I avoided the prickles.' Harry Vardon was not the first person to use this grip, but he was the most famous. Nearly everybody copied him.

So what started by accident led to the famous man winning one American and six Open Championships (British) – more than anyone else in history. Variations of the Vardon grip are taught today by all modern teaching professionals: the overlapping grip (Faldo), the reverse overlapping (for putting), the interlocking (Nicklaus) and the two-handed (Dai Rees). In fact, all the modern grips have the thumb down the shaft.

Harry Vardon.

10th HOLE

The American ball
1898 to 1920 – back into the wind

The advent of the Haskell ball

In 1898 the game of golf underwent its second major change with the introduction of the rubber-cored golf ball – an American invention. This new ball, devised by Coburn Haskell, had a compact rubber core of wound, vulcanised tensioned-rubber thread. Soon a winding machine had been designed to enable the manufacturers to mass-produce the ball. The Haskell ball, which was the first of many new types, made the game even more popular. It drove the solid ball, until 1900 made in millions, out of the field and led to hundreds of courses being altered or newly built, on both sides of the Atlantic.

Although Haskell didn't know it, hand-wound rubber-cored balls had been made in Scotland as early as 1871. In 1906 Captain Duncan Stewart, then aged 71, gave evidence in the patent infringement case of Haskell Golf Ball Co. versus Hutchison, Main & Co. (described in greater detail below) when it was heard on appeal. Stewart explained that he had already made golf balls with a rubber thread wound under tension and then covered with gutta-percha, which he used to sell for a shilling each. The Stewart ball had not enjoyed popularity, mainly because, like the Eclipse composition ball, it did not make an audible 'click'; it was also a little too lively on the putting surface. Stewart had not considered his ball a commercial success, therefore few were produced. The Court of Appeal held *inter alia* that Stewart's rubber balls were substantially the same as the Haskell ones, although not so well made!

At the same trial another rubber-cored ball was discussed. The Court of

The Haskell Golf Ball Co. soon realised that their ball performed better with a bramble cover pattern.

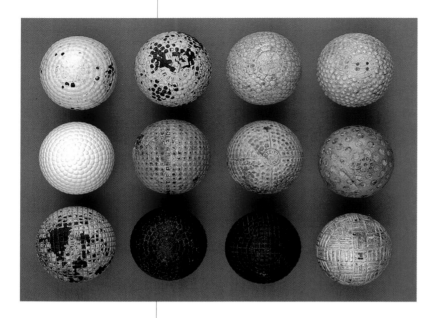

A selection of golf balls, mostly rubber cored showing various cover patterns and designs.

that Captain Stewart or George Fernie missed the chance of a lifetime. Here was the tide in the golfing affairs of these men which, had it been taken at the flood, would have led on to fortune. But it would be unfair to judge them harshly. When Stewart and Fernie were experimenting with rubber balls the golf flood was yet far from the high water mark. Stewart's ball had no click, and according to the sentiment of the day golf without a click was, as one of the judges put it, not golf.

The Haskell ball is significant because, although it was not the first ever rubber-cored golf ball, it was the first such ball to be mass-produced. The following extract, originally published in the *London Globe*, was reproduced in a 1907 advertisement for the new Gravitator golf ball:

Those who remember the advent of the Haskell ball do not need to be reminded of the quite fierce discussions which its coming provoked. It divided players into two camps; it disturbed the serenity of a game whose chief attribute perhaps is its demand on steady nerves and even temper; it made the quietest and most secluded of links ring with the noise of controversy... As befits the follower of a game as ancient as it is royal, the golfer is eminently conservative; he is not easily induced to try the new or make experiments with the unfamiliar. Protesting at one time that he would never succumb to the Haskell and its many imitators, he has lived to swear by the rubber-cored.

Origin of the Haskell ball

Various stories have circulated explaining how the Haskell ball came to be

Appeal was told that in 1893 George Fernie had made such a ball by cutting triangular-shaped strips out of rubber football bladders, each strip measuring three-eighths of an inch at the base. These had been stretched over small cores of cork and kept under tension by sewing them in place with Irish linen thread. The spheres of stretched rubber had then been built up to the size of a golf ball and covered with a shell of gutta-percha. At the trial, George Fernie's nephew, Willie, testified that at least two dozen balls were made in 1893 and sold to players as 'remades' at 8d each. It became apparent from his testimony that the reason for the Fernie ball's lack of success was that it tended to split open. In 1906 the newspaper *The Scotsman* was quoted in *Golf Illustrated* as follows:

Having regard to the enormous amount of money spent on rubber-cored balls during the last four years, it would almost seem

invented. A particularly credible one was published in *The American Golfer* in December 1926:

No other step in the development of golf running back over a period of some five hundred years has had so far-reaching an effect as the introduction of the rubber-cored ball...

On a hot summer's afternoon back in 1898, Mr. Coburn Haskell, a retired business man, strolled into the office of a friend, Mr. Bertram G. Work, at that time superintendent for the B.F. Goodrich Tire and Rubber Company, and in due course began to unburden his mind of the woes incidental to a fit of shanking his mashie shots, which was gripping him at the time.

'Well, if you ask me,' answered Mr. Work, as his visitor reached a temporary pause in his sad recital, 'I think it all probably serves you right, wasting so much time on the silly business of knocking a little ball around the fields. Why don't you turn your hand to something worth while; get out and make two blades of grass grow, where formerly but one grew, for instance?'

'Not interested in grass, except that which grows on fairways and putting greens, and there are lots better greenkeepers than I am. Anyhow, there's more to golf than you may think. It's a great game.'

'All right then, go ahead and do something to make it an even better game. Invent a new ball or design a new stick or something of the kind.'

Now here was an idea. For a minute or so Haskell sat silent, and then:

'If a good rubber ball could be developed – a solid one – why I believe it would mean a big improvement in the game.'

'Solid rubber won't do,' interrupted his companion, 'too soft; it would take too much compression in the hitting.'

'Then how about compressing the rubber in the manufacture?'

'No, that won't do either.'

Again Haskell paused in silence for a minute or more, then, 'Well, what of this idea – suppose you cut the rubber in strips and stretched these and wound them into a ball; you could get the ball as hard or soft as you can choose, couldn't you?'

'Now, you have said something,' answered Mr. Work. He sent out and had a supply of rubber yarn brought in and invited Mr. Haskell to go to work on the first rubber golf ball ever attempted.

'It was an amusing sight,' explains Mr. Work now as he recalls those experiences.

'The day was hot and before Haskell really got started on his task he was perspiring from every pore. You who have never tried the experiment can't fully appreciate the difficulty of trying to wind this ball of rubber yarn, keeping the strand pretty well stretched while it is being wound. I don't know how many times it happened that Haskell got the thing going and brought it up to about the size of a marble only to have it slip from his grasp and quite unroll itself on the floor.

'Finally in the dusk that evening, with a beam of triumph, he presented to me a ball about the size of a walnut, fairly round and with strands quite tense. It felt firm and solid, but of course the need for a covering of some kind was obvious. Otherwise the first slight cut would start the thing ravelling and in less time than it takes to tell it, there would be no ball left.'

The core was covered with gutta-percha and marked with a mesh-and-dot

pattern in a mould. The finished article was then painted and soon afterwards Haskell took the ball to his club's professional, Joe Mitchell, and asked him to hit it down the first. Mitchell did so, unaware that this was a new type of ball. Reportedly his drive went further than any previous shot at this hole and flew a bunker that until then had penalised poor second shots!

The Haskell patents

An application to patent the Haskell ball was filed in the United States on 9 August 1898 and one week later a similar application was made in Britain (later to be granted as Patent No. 17554). The American patent for the Haskell ball (No. 622,834) was issued on 11 April 1899, with the rights set to expire in 1915. The letters patent stated that the 'Balls for golf or other games' would be formed of two parts: an inner elastic part and an outer inelastic part. The inner part comprised rubber thread, which was wound into a spherical form under high tension. A small central hard core could be used upon which to wind the thread. The outer part was a moulded gutta-percha shell, but any known substitute could be used in place of the gutta-percha.

The original Haskell ball measured a large 1¾ in (4.45 cm) in diameter but weighed a light 1.48–1.5 oz (42–42.5 gm). And it could float! The core of wound rubber thread occupied half its diameter and the rest was a thick gutta-percha cover with a mesh-type pattern. A.E. Penfold, the founder of Golf Ball Developments Ltd and maker of the Penfold ball, discussed the second type of Haskell ball in the 17 October 1924 edition of *Golf Illustrated*:

The Haskell ball, as first I saw it, consisted of a solid ebonite ball [India rubber vulcanised until practically brittle] on which was wound I.R. [India rubber] thread, commonly termed 'elastic,' to form the rubber core, which was a little over 1 inch diameter. The 'core' was coated with a comparatively thick covering of gutta-percha, the surface of the coated ball bearing rounded projections giving what was known as the Bramble marking.

Much of the ultimate success of Haskell's ball has to be attributed to a Goodrich engineer called John R. Gammeter, who was asked by Haskell to invent a machine for winding the balls of rubber thread. This Gammeter did, and requests to patent his tape and

This machine measured about 3 ft (9.15 m) high and wide and comprised some 50 or so working parts. The ball was held on an axis by two winders and turned by four cylinders, and the two continuous rubber threads were applied under great tension to the ball.

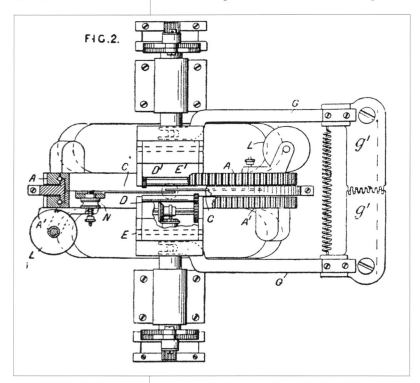

thread winding machine were submitted at the end of 1899. Patents for the device were duly granted in Britain on 5 March and in the United States on 10 April 1900. It is likely that, if Gammeter had failed to invent this machine, the whole project would have been shelved, since it would not have been commercially viable.

Fame and fortune

The first title to go to a golfer playing with a Haskell ball was taken by W. J. Travis, who won the USGA Amateur Championship in 1901. In the British Amateur Championship the following year both the winner, C. Hutchings, and the runner-up, S.H. Fry, played using Haskell balls.

In the 18 February 1927 issue of *Golf Illustrated* Harold H. Hilton, winner of two Opens as well as one US and four British Amateur Championships, wrote:

Mr. Charles Hutchings won that championship, and it was without doubt the use of the Haskell which made his success possible. For some time previous to the event he had been in the throes of distress in regard to his game, and had practically given up hope. But a few shots with what in those days was termed the 'Bounding Billy' sufficed to make him regain all his old confidence.

A few weeks later Alex ('Sandy') Herd used his one-and-only Haskell for four rounds to win the 1902 British Open by a single shot from Vardon and Braid. Looking back on the event, Bernard Darwin wrote in *The American Golfer* of November 1933: 'The Amateur

Championship had shown what Mr. Haskell's ball could do, but the professionals obstinately refused to believe in it. Herd arrived at Hoylake determined, with the rest of them, to cling to the gutty.' When Herd had finished, his ball was in tatters!

In 1902 Laurie Auchterlonie played with a Haskell rubber-cored ball to win the US Open and in 1903 Harry Vardon won the Open at Prestwick, again using this type of ball. In 1904 W.J. Travis came to Britain, where he won the Amateur with a Haskell ball; Ted Brackwell, playing with a gutty, was runner-up. In 1906 James Robb won the Amateur Championship at Hoylake playing with a Scottish-made rubber-cored ball – the Springvale Kite – even though the Haskell company had filed a lawsuit (detailed below) against the manufacturers of it and this was still on appeal!

Haskell Golf Ball Co. versus Hutchison, Main & Co.

On 1 July 1904 the Haskell Golf Ball Company, weary of having their letters patent for improvements in golf balls infringed in Britain, decided to make an example of a British company. They initiated legal proceedings against Hutchison, Main & Co., a Scottish firm making rubber-cored balls under the trade name Springvale. After a trial that lasted ten days, Mr Justice Buckeley in the High Court found that the British company had not infringed any patent rights in view of the fact that Stewart and Fernie had been 'prior users' of rubber-wound balls years before the Haskell ball.

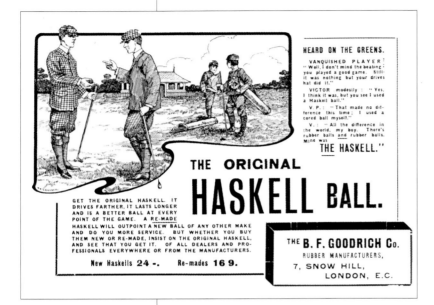

GET THE ORIGINAL HASKELL. IT DRIVES FARTHER, IT LASTS LONGER AND IS A BETTER BALL AT EVERY POINT OF THE GAME. A RE-MADE HASKELL WILL OUTPOINT A NEW BALL OF ANY OTHER MAKE AND DO YOU MORE SERVICE. BUT WHETHER YOU BUY THEM NEW OR RE-MADE, INSIST ON THE ORIGINAL HASKELL, AND SEE THAT YOU GET IT. OF ALL DEALERS AND PROFESSIONALS EVERYWHERE OR FROM THE MANUFACTURERS.

New Haskells 24 -. Re-mades 16 9.

HEARD ON THE GREENS.

THE ORIGINAL HASKELL BALL.

THE B. F. GOODRICH Co.
RUBBER MANUFACTURERS,
7, SNOW HILL,
LONDON, E.C.

In 1904 Goodrich were telling golfers that a remade Haskell would outperform a new ball made by any of their rivals.

The case then went to appeal and two years later, after eight days of argument, a further judgement was given (in February 1906), again in favour of the 'home side'. Their lordships held that the balls made and publicly used by Stewart and Fernie embraced all the essentials of the Haskell ball and that in the state of public knowledge at the time there was no subject-matter for the Haskell patent, and no room for intervention. The appeal was dismissed, with costs awarded against the Haskell Golf Ball Company. Once again they appealed.

In November 1907 Lord Halisbury declared in the House of Lords that the alleged invention was a golf ball comprising two parts, a cover and an interior, but that the idea of the cover was old and so too was that of the interior. He concluded that the combination of the two had been anticipated. Lord Maonaghten agreed, holding that

there was no novelty in the invention. Lord Atkinson, in his written judgement, pointed out that balls called toy balls, composed of rubber thread wound by hand under tension round a kernel of cotton waste or rubber waste, had been made, sold and used for over twenty years before 1898, in hundreds of grosses. He admitted that the Haskell ball was probably made from better quality rubber thread and that these longer threads were wound under greater tension, but stated that this alteration or improvement did not involve ingenuity or invention. He argued that handballs and baseballs were also given the characteristics of elasticity and resiliency by using a core composed of rubber thread wound around a kernel of cork. Further, the suitability of gutta-percha not only for making golf balls but also for covering them had been common knowledge prior to 1898. As to the supposedly unique characteristics of the Haskell ball, Lord Atkinson went on to state that although it was true that the cover of the ball did prevent excessive springiness on the green in putting, it was not true that the cover so muffled the ball that it became relatively inelastic on the green, while conceding that it did retain its great resiliency when struck with force from the tee. As before, it was judged that in the state of public knowledge at the time there was no subject-matter for the Haskell patent and no room for invention. The appeal was dismissed with costs.

Golf Illustrated for 9 March 1906 forecast that the legal costs of the House of Lords hearing would amount to at

least £20,000 and calculated that: '... estimating counsel's fee at the lowest possible figure, and taking the average of the time they spent in speaking in Court and the rate at which they spoke, they earned a Kite each for themselves for about every dozen to twenty words they uttered.'

Further ball developments

Within a couple of years of the introduction of the Haskell ball (or hollow-core ball, as it was sometimes called) other inventors patented their own types of rubber golf ball – among them E. Kempshall, H.M. Singer and C.T. Kingzett. Whereas the Haskell ball had a core made entirely from wound rubber thread, the next development was to have a centre around which the rubber thread was wound. Gradually the core became larger and the cover thinner.

E. Kempshall was an American who had originally been a car tyre maker and had made a fortune selling his own brand of celluloid shirt collar. His Patent No. 20295, dated 10 October 1901, was the most significant. The Kempshall ball was made with a core of elastic material such as gutta-percha; this was made slightly too big so that it was in compression in the finished ball. The shell was made of celluloid. One year later Kempshall made a dramatic improvement by replacing the elastic solid core with a liquid core. The Kempshall Flyer made its first appearance in the summer of 1902, and although it was more expensive than the Haskell it was an immediate success. Kempshall was paid a royalty on

every liquid-cored golf ball made between 1902 and 1919, and the principle of this ball remains the basis of the modern three-piece golf ball.

C.T. Kingzett was the chairman of a British disinfectant company, Sanitas, formed in the late 1870s. He became interested in inventing new ways to make golf balls and formed his own Improved Golf Ball Company in 1906. An example of Kingzett's ingenuity is his Patent No. 3482, dated 18 February 1901, in which the ball was made with an outer shell of gutta-percha at least $\frac{3}{16}$ in (0.48 mm) thick. The central core was made of wood, cork, leather or like material and was coated with pitch or gutta-percha. The ball was sufficiently light to float. A subsequent patent had alternating layers of gutta-percha and India rubber enveloping a rubber core, all of which was encased in a shell of gutta-percha or equivalent material.

In 1905 Frank H. Mingay, another prolific British golf ball inventor, stated that 'any convenient uncompressible liquid such as water, treacle, glycerine or the like' would, if encapsulated at the centre of the golf ball, receive and then translate into motion the energy of a blow on the ball's surface. Three years later Mingay obtained a patent for putting liquid into a 'suitable receptacle or shell made of elastic material, preferably vulcanized India rubber or the like, and also preferably of spherical shape, and with or without an orifice ... the liquid is forced or inserted in the receptable by means of the sharp nozzle of the filling instrument or by means of a needle or piercer ... when the rubber bag is expanded by the

15,856. Singer, H. M., Auchterlonie, D., and Auchterlonie, W. July 16.

Balls for golf &c. are formed with a hollow interior in which a small metal or other ball is free to move. In the arrangement shown in the Figure, a metal sphere *a*, consisting of two parts screwed or otherwise secured together, is embedded in gutta-percha or similar material *c*. The sphere contains a metal, bone, or other ball *b*. The Provisional Specification states also that two or more balls may be placed in the sphere, and that the sphere may be divided into separate compartments, one for each ball, and that solid balls may also be embedded in the gutta-percha.

15,800. Kempshall, E. May 22, [*date applied for under Patents Act, A.D. 1901*]. *Void.* [*Published under Patents Act, A.D. 1901.*]

Balls for golf &c. are constructed so that they float in water. A small sphere 1, of celluloid or other hard-springy material with or without enclosing-segments 2 of soft rubber, is wound with successive layers of thin sheet caoutchouc in tension, so as to form a thick coating 4. The core thus formed is enclosed in segments 5 of gutta-percha &c. welded on the ball, under heat and pressure.

FIG.1.

152. Justice, P. M., [*Davis, C.*]. Jan. 2.

FIG.2. FIG.4.

Balls.—Golf and other balls are made with a hollow core A¹, Fig. 2, of celluloid, steel, &c., and an outer covering B¹ of gutta-percha. The outer layer may be closely adherent to the core, or may be formed with ribs *b* so as to form air spaces *b⁰*. In modifications, layers C, Fig. 4, of rubber under tension are interposed between the core A² and the outer layer B². The outer layer may be closely adherent to the layers C, or may be formed with air spaces *b²*. The inner core and the air spaces may be filled with compressed air or gas.

H.M. Singer was another prolific inventor during the early 1900s, a time of great innovation and progress.

liquid it, of course by its contractile action, presses on the fluid and thereby insures a solid although mobile core.' Mingay sold the rights to his patent to A.G. Spalding & Bros., who waited until 1916 to launch their first liquid centre ball, the Spalding Witch.

The various makers of the American ball
Large commercial outfits, most already expert in rubber products

Initially there were only three companies licensed to make golf balls under the Haskell patent, and all three were American. These were B.F. Goodrich Co., A.G. Spalding & Bros. and the Worthington Ball Co. No one else could make the Haskell ball legally. By 1903 the Spalding company had begun advertising in British golf magazines: 'We can now supply Haskell balls in any quantities...' A notable omission from the list is Goodyear, who were not offered the rights and had to develop their own ball.

When Haskell balls first made an appearance in Britain, British golf ball manufacturers quickly realised that this innovation possessed sufficient advantages to put an end to their gutta ball industry, which was essentially British. At this time a large proportion of the refined gutta-percha used for ball-making in the United States was prepared in Britain and then exported, but this trade now seemed doomed. However, in 1901 a British company, the St Mungo Manufacturing Co., was awarded a licence to make Kempshall golf balls, and in 1904 the same company became licensed to make balls

under the Haskell patent. Many other British companies that had formerly made the gutty ball also turned their expertise to making American-type balls when they heard that these had been used to win the 1902 Amateur and Open Championships.

The pace was set by the Scottish firm Hutchison, Main & Co., who released their Springvale Rampant ball in 1903 and quickly followed it up with further Springvale models: the Eagle, the Kite and the Hawk. One direct consequence of the Haskell v. Hutchison legal proceedings over alleged patent infringement was that British manufacturers were able to make rubber-cored golf balls and sell them within Britain and the Empire. However, B.F. Goodrich tried to prevent these British-made balls from being marketed in America.

There was also a new category of rubber producers emerging – the wire and cable companies, such as Craigpark and British Insulated & Helsby Cables Ltd, both of which made protective coverings for electrical cabling. These companies discovered that golf ball manufacture was a lucrative subsidiary business. In addition, other tyre manufacturers seized the opportunity. In 1902 B.F. Goodrich were joined by their biggest competitor, Goodyear Tire & Rubber, who launched the Pneumatic rubber golf ball. Both these companies sold their golf balls across the United States in their gas-station forecourt stores. The counterparts in Britain of the two American giants were Dunlop, Avon India Rubber Co. and Wood-Milne (whose marketing slogan in 1914 was 'Fit Wood-Milne Tyres to your car for comfort, strength and speed'). Other, less well-known tyre producers that became ball makers were W.T. Henleys Tyre & Rubber Co. Ltd (also known as Scottish India Rubber Co.) and the Beldam Tyre (1920) Co. Ltd. Ball-making was also undertaken in Britain by the French tyre manufacturers Michelin.

Some companies only made rubber golf balls, an example being J.P. Cochrane of Edinburgh, who came to prominence in 1904 with the Challenger ball. In 1912 Cochrane exported over one ton of their Challenger golf balls to an unspecified British colony. Another British firm, Martins of Birmingham, had patented their invention in 1903 (Patent No. 12059) and launched the Martin Flyers; one year later they released their High Tensioned Rubber Core golf ball.

Golf equipment companies and 'Golf Club Specialists and Ball Makers'

This category consists of companies that had previously made only golf clubs, but found it made commercial sense to add golf ball manufacture to their business activities. F.H. Ayres Ltd, founded in the early nineteenth century, was well known for its clubs and in 1909 introduced the Vaile golf ball. Operating on a much smaller scale were the club makers and golf club professionals, who purchased rubber cores from the manufacturers and then added the windings and covers. One example is W.H. Ball of Bangor Golf Club in North Wales, who made golf balls between 1909 and 1919.

The American ball

J.P. Cochrane & Co. advertised themselves as being the the oldest golf ball-making firm in Scotland.

The World's Best Golf Ball

XL CHALLENGER

Tested and Proved to Go Further Than Any Other Golf Ball Ever Produced

Invented and manufactured by J. P. Cochrane & Co. of Edinburgh and Carnoustie, Scotland, and London, England—the oldest and most experienced house in Scotland, in golf ball construction. The cover being treated by a special process is practically indestructible, and it is therefore an economical ball to use.

Below you will find a few of many unsolicited testimonials:

One of the best known professionals, who has played in mostly all the British and French, and in the American Championship says:— "I can say with confidence that the X L Challenger is the best ball that has ever been produced for the game. It outdistances all others from the tee, and in the States, where there are so many mighty swipers, it should be in great demand. Most balls lose their life in play, but this really improves in use, being more lively in the second and following rounds than in the first. You should sell tons of them."

A Plus 4 Man says:—"I have played 16 rounds with the X L Challenger, and after getting it repainted, it looks as good as new. I have never played with a ball like it."

A Scratch Player writes:— The X L Challenger is the finest ball I have ever struck. It gets further, and it lasts longer than any other. One peculiar merit about this ball, compared with any other make, is that it really improves in play."

A Ball that inspires confidence. Its wonderful response to powerful hitting and delicate placing makes your best game better still.

Price $1.00 Each Per Dozen $12.00

To be had from all leading Golf Professionals and Sporting Goods Stores.

J. P. Cochrane & Co.,
95 Chambers Street,
New York City.

Local Representative
JOHN G. HUNTER
Phone Worth 4168

EDINBURGH, CARNOUSTIE & LONDON

Wholesalers and retailers, many with their own brand

These included the wholesalers and large retailers who had golf balls made for them for sale under their own brand name. Holmac, Inc. were the official agents in the United States for Beldam golf balls. Sears, Roebuck and Co. sold an own-brand golf ball in their American stores, while in Britain the Army & Navy stores chain, Benetfink & Co. (who marketed themselves as 'The Great City Depot for all Golf Requisites'), J.B. Halley & Co., Mitchell & Co. in Manchester and A.W. Gamages all did the same.

Tom Morris was involved in developing the Morris rubber-cored ball in 1906, which was made by the Morris Golf Ball Co. and sold in London exclusively by Benetfink & Co. In January 1907 Tom Morris played with a rubber-cored ball for the first time; it wasn't his own brand of ball, but a Springvale Kite. So Old Tom, who on this occasion played two holes, was associated with all three types of ball from the 1860s through to his death in 1908.

Re-covering by commercial firms and club professionals

This category of makers of the American ball included companies like the Centre Press Ltd, the Maxim Golf Ball Co. and Fisher & Viper Recovering Co., who recycled old golf balls by re-covering the cores of salvaged balls. One company that enjoyed a roaring trade in branded remoulds was the Improved Golf Balls Co. In their - advertising they even specified which original core was in the remoulded ball.

For example, the RCH was a remoulded Haskell and the RCW a remoulded Spalding Wizard. St Mungo was just one of the many larger concerns that made remoulds as well as new balls, coding them so that golfers would not be duped. For example, the Colonel Remade was a Colonel ball re-covered for the first time, whereas a Colonel Special Remade was on its third life as a golf ball. Smaller businesses such as D. Anderson & Sons in St Andrews, who had been 'Professional Golf Club and Ball Makers' since 1894, actively advertised their re-covered golf balls in 1904.

Golf Illustrated, 4 February 1910: 'Do you recover golf balls?' asked the beginner rushing into the professional's shop. 'Yes, Sir,' replied the assistant. 'Well, just run over to the ninth hole,' said the agitated novice, 'and recover those half dozen new balls which I bought from you this morning!'

The rubber-cored ball compared with the gutty

In an Oxford and Cambridge Golfing Society meeting held in Scotland in April 1910, gutty balls were pitted against rubber-cored balls. A report was published in *Golf Illustrated* for 6 May of that year: 'A deficient of sixty yards in the drive, estimated by one player, will not be compensated for by superior steadiness on the putting green.'

Four years later leading British players – including Taylor, Vardon, Braid and Duncan – some of whom were still unconvinced that the gutty had had its day, played in a series of

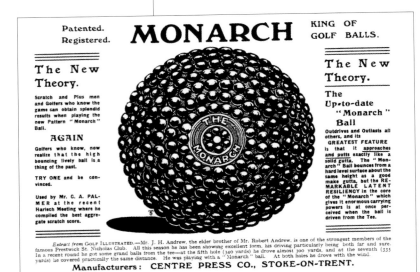

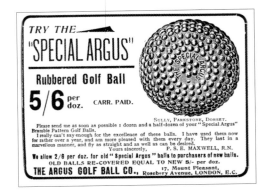

Left: The Monarch bramble ball.

Above: The Special Argus bramble, c.1906.

matches at Sandy Lodge and St Andrews, in which both types of golf ball were used. A comparison between the gutty ball and the rubber-cored was made in the September issue of *Golf Illustrated*:

A great deal is being made of a competition at St Andrews, played with the old gutty balls, where none of the scratch players returned a score under 90. It is said that this shows that the rubber-cored balls are at least ten to twelve strokes superior to the gutty balls. The critics who draw this conclusion are talking through their hats. If the scratch players had played a few rounds with the gutty balls before starting on the competition there would have been a good many in the eighties, in spite of the lengthened holes and the new bunkers. The rubber cores admittedly drive further than the gutties, but a good many of the strokes lost in driving would have been retrieved in the approaching and putting. The best score with a gutty was an 86.

An initial assessment by James Braid of the new rubber-cored balls had been published in the 23 May 1902 edition of *Golf Illustrated*:

I found very little difference in the length of a drive between them and gutta-balls; perhaps they run further, but they certainly don't carry as far. They are also difficult to stop when approaching and on the putting green are very liable to jump out of the hole.

And in *Golf Illustrated* for 16 January 1920, Sandy Herd looked back to 1902:

The Haskell was not introduced until the spring of the next year … I was not playing well enough to have won with the guttie … but you know, there was not a great deal of difference at that time between the guttie ball and the Haskell. A good shot with the guttie gave just as satisfactory results as a good shot with a Haskell, but if you did not make the shot quite well the effect was less serious with the American ball than the guttie.

In *Golf Illustrated* for 28 October 1927 Harold H. Hilton wrote:

One fact was impressed upon my mind, and that was if the player of the rubber core struck a slightly foul blow, the distance lost was not so great, while if the player performing with the solid ball did so he inevitably lost considerable distance. The solid ball calls for truer hitting than does the rubber core...'

Price, size and weight

Sandy Herd was the only British player to obtain Haskell balls in the period immediately following his win in the 1902 Open Championship. He was sent supplies of the ball at intervals, and other professional golfers came to him to buy any he had to spare; by all accounts as much as ten shillings would be offered for one. Even so, many of the club professionals were against the Haskell because they were unable to get hold of stocks to sell to their members; meanwhile the demand for gutties was rapidly waning. If the professionals did get a supply of Haskells, they asked up to one pound each for them!

In 1904, before the price began to fall, it was argued that the rubber-cored ball could once more make golf the élite game it had been in the days of the feathery, since it was only well-off golfers who could afford to use a new ball when the one they were playing with began to lose its elasticity. Some golfers believed that the average rubber-cored ball, after two or three rounds, flew just as well as the old gutty.

By 1905 the price was two shillings. It fell to 1s 3d in 1906 but again stood at two shillings in 1907. *Golf Illustrated*, 22 February 1907:

The contemplation of a shortage in the supply of gutta-percha, with which the rubber-cored ball is at present covered, is not calculated to exercise a very tranquillising influence on the minds of golfers, most of whom consider they have already a real grievance in having to pay 2s. for what formerly cost 1s., and then afforded better value.

The price was still two shillings in 1909 but rose to 2s 6d in 1910. The manufacturers justified the 25 per cent increase by pointing to the rise in the price of crude rubber from 11s 6d to 15 shillings per pound.

Alex ('Sandy') Herd, Harry Vardon, J.H. Taylor and James Braid in 1905.

When he won the Amateur Championship in 1911, Harold Hilton used gutta-percha balls at the short holes at Prestwick, which had undergone a very dry summer.

ball. However, when production began in Britain some British ball makers continued to state the weight of the ball using the traditional troy measurement system.

There was still no legal requirement to indicate size or weight. It was not until September 1919 that the Royal & Ancient Golf Club of St Andrews (the R&A) felt it necessary to pass a resolution regarding weight and size: 'In order to preserve the balance between the power and the length of holes and in order to retain the special features of the game, the power of the ball should be limited.' From then on, many rubber-cored golf balls were stamped with their weight in avoirdupois ounces and their size in inches.

The majority of golfers had been content with the large Haskell-type ball until 1908, when Dunlop introduced a small heavy ball that gave golfers excellent results, especially into the wind.

How rubber-cored balls were made

Compared with the gutty ball, which improved with 'seasoning', the early rubber-cored balls had to be used up quickly. The following article appeared in *Golf Illustrated* for 28 December 1906:

The early rubber-cored balls made in the United States were seldom marked with their weight or size. Initially, between 1899 and 1901, the market was monopolised by the American B.F. Goodrich Company, and because they did not mark their balls with this information, neither did their competitors. The pennyweight system was not used in the United States, and all American golfers were told was the brand name and manufacturer of the

The science of making the rubber-cored ball is only in its infancy. I was shown over a factory the other day, and found men working half-time. I wondered that the firm did not make use of the slack winter time to make a store for the summer, and questioned the courteous manager: 'We had a lesson last year, sir. We worked full time, and by spring had a stock of some 5,000 dozen [60,000]. Out of that we lost 3,000

and a lot of custom. It does not do to keep these balls. They must be played with fresh before the interior loses its elasticity.

The biggest problem with the rubber-cored ball was that its gutta-percha cover became cut too easily. Also, the cover tended to vary in its thickness and the core or centre of these early balls was seldom truly round. These factors, added to a lack of symmetry, caused many balls to bounce badly, to show poor aerodynamic characteristics and to run untrue on the greens.

The following 'advertorial' copy explaining how Dunlop made the 'V' ball was published in *Golf Illustrated* on 28 February 1913:

Golfers are always curious as to the details of ball manufacture, and the following description of the new and improved methods employed in moulding the famous Dunlop 'V' Balls will be of great interest. The presence of air has always been a source of trouble in moulded balls, and in the old gutties seriously affected their balance and flying powers. The trouble

Champions in long-distance driving! (1910).

YOU KNOW THIS BUNKER AT SANDWICH

continues to a lesser but still considerable extent in the rubber-cored balls, and hitherto no efficient means of getting rid of air has been devised. By ordinary methods of manufacture a certain amount of air is imprisoned in the mould when closed down under pressure for the purpose of moulding on the shell. The presence of this air in the ball causes uneven distribution of weight and a lack of homogeneity generally.

By means of the Dunlop vacuum process, the balls when ready for moulding are placed in the moulds; the moulds in turn are put in the press, the press is made air tight and all the air is extracted, making a vacuum, and the balls are then moulded with a total absence of air. The Dunlop Co. find that by their vacuum process the shell penetrates with an even distribution of its material, a very considerable distance into the interior economy of the ball, rendering the whole mass inseparable and of an even consistency all round and through. In other words, the extraction of the air from the core permits the flow-down of the gutty to take place perfectly evenly. With a ball from which the air has not been extracted one is

liable to get large air bubbles and, consequently, loose shells. If the trouble does not go so far as this, there will yet be a difference in the degree of adhesion between the shell and the core in different parts of the ball. Although in the 'V' Balls the gutty does not penetrate much further than under other processes, it goes down very evenly. This evenness of shell and union makes the ball very durable, as if the shell cannot become loose and the ball cannot crack. Anyone who has studied Professor Tait's theory on flight will appreciate the value of this improved balance and homogeneity in the ball. Professor Tait mentioned that it is the lack of homogeneity and perfect sphericity in a golf ball that creates the erratic spins noticeable in the flight of a smooth ball, and it is this that necessitates the brambling or dimpling of the shell in order that specific backspin may be imparted to control and overpower all other spins. It is therefore perfectly clear, if Professor Tait's theory is correct, that the more homogeneous a ball is the straighter and farther it will fly. It is doubtless the perfect homogeneity attained by this vacuum process that is the secret of the wonderful steadiness and fine flight of the 'V' Balls.

Packaging and presentation

The idea of wrapping golf balls individually gathered pace in the early 1910s. Tissue paper was replaced by heavy waxed paper, wrapped loosely around each ball, and a paper label described the contents. The Dunlop Company packaged their 'V' ball in a hessian sack. Although a cardboard box, holding either six or twelve balls, was the norm,

A box of Haskells.

manufacturers such as Dunlop and St Mungo also presented their wrapped balls in tin boxes.

Further improvements made to the ball

The Haskell ball, with its mesh-and-dot pattern, could at first glance be mistaken for a gutty. It is said that James Foulis, the professional at Chicago Golf Club, thinking that he was remoulding a gutty, in fact remoulded a Haskell in an Agrippa bramble-patterned mould. The story goes on that upon playing with this bramble he was favourably impressed by its distance and control. What kind of ball had he been playing with? Back at his workbench he studied the Haskell by cutting it open and to his astonishment discovered its rubber thread entrails. Realising that the control in flight came from the bramble pattern, he reported his findings to the Goodrich Company – where the moulds were soon changed to this pattern!

In 1902 the Pneumatic golf ball was released by Goodyear using T. Saunders' 1901 Patent No. 8069 for a ball with a 'compressed air core'. They had realised that air was not only easily compressible but also very elastic. Goodyear dispensed with gutta-percha in its golf ball construction and the cover was made instead from a thin layer of 'purest para rubber' (India rubber). This held in place the rubber windings, secured originally by stable Sea Island cotton thread (later described as silk tape), which in turn covered the 'heart of the ball – Com-

pressed Air'. Goodyear and their British agents, Giepel and Lange, stated that this made the cut ball resistant because India rubber was tougher than gutta. Arthur Smith, who played the Pneumatic to victory in the 1906 Western Championship in America, claimed in a Goodyear advertisement: 'I can drive the Pneumatic farther, loft it better, and putt it surer than I can any other ball.' A strong enough casing to hold the air could not be found and the ball failed because it lost its compression too easily and too often. There was a glut of stories of how balls either died on the green or exploded in the air. *Golf Illustrated* for 14 January 1907:

Mr Ernest Lehmann puts forward an ingenious idea for an ideal golf ball which shall not suffer from any of the disadvantages of the soft-core ball, especially the tendency to crack or get out of shape. His idea is to substitute for the single-rubber-core, liquid core, gelatine core, or whatever it may be, a set of small rubber-cores set over each other somewhat in the manner of the ball bearings of a bicycle. He suggests five cores, one in the centre and four at even distances from it, all five being securely fastened to each other, and the outer ones to the outer casing, the whole of them being firmly wound around by rubber filaments till they form a homogeneous filling for the ball, the thin, highly rubberised outer shell being firmly and adhesively fixed to the inner part.

In 1907 the first rubber-cored ball to be made without a cover or centre was introduced. The first solid rubber ball, it was made by the Coverless Golf Ball

Rubber-cored balls came in a variety of cover patterns ranging from the ever-popular bramble to the newer dimple design. The Pneumatic ball's centre was made of compressed air and was only available between 1902 and 1907.

Co. and known as the Final. At much the same time the Gravitator Golf Ball Co. released their Gravitator ball, based on Wilfrid M. Short's patent. This ball had a bramble-patterned gutta-percha cover and a celluloid core in which were four loose steel balls. The core was surrounded by rubber thread wound under tension. The company's advertisements stated: 'The Gravitator is not heavier than the majority of the existing rubber-cored balls.'

Mixed reactions to the Haskell ball

The Haskell ball was hard to control in and around the green, and because it tended to bound along the fairways even when badly hit, it picked up the nickname 'Bounding Billy'. The implication was that anyone who played with the Haskell was taking an unfair advantage and could be seen as a bounder or cad!

The discrimination against those who played the Haskell ball was sometimes quite blatant. Golfing correspondents in America were outraged when Miss Genevieve Hecker, who had used a Haskell in a long-distance driving competition, was instructed by the organisers to rehit, but this time with a gutty ball. It is not reported how she fared in the event, but an American reporter was quoted as saying: 'There is nothing in the Rules that defines the nature or size of the ball; a player has the right to use any ball that suits him, be it made of gutta-percha or of chewing gum and sawdust, and three cornered at that.'

However, there was stiff opposition to the Haskell ball from many of the 'old school' in Britain. *Golf Illustrated* for 25 October 1901 quoted an article that had appeared that month in the *Manchester Guardian*: 'It should be slaughtered at the ports. The discovery of a ball that flies considerably further would be a menace in the game of golf. It would immediately make all our holes the wrong length…'

The opposite view was presented by the same journal in 1902 when it quoted the following from the *Dundee Advertiser*: 'The rubber-cored balls have demonstrated their value … irons have been improved again and again and no one has offered the slightest protest … as soon as a clever American puts a ball manufactured on a new principle on the market, a shout is raised that the game is being ruined.'

The effect of the Haskell ball on golf course design

As the popularity of golf increased, more and more courses were designed and constructed. In some instances they were built on inappropriate sites, as suitable land soon became difficult to acquire. The rubber-cored ball was often made the excuse for any decline in a player's skills, but golf course architects were also blamed. Even before the advent of the new ball it was generally felt that holes and courses should make an equal demand on the three main aspects of the game: driving the ball, approach shots to the green and the art of putting. Golf hole design had gradually shifted priority to the driving shot. Holes were lengthened and old par fours became par fives. This in turn minimised the value of the approach

shot with iron clubs, because most players could not reach the green without taking a wooden club. There had been a tendency to remove green side hazards or place them at a greater distance from the hole.

The golfing correspondent Horace Castle wrote in 1907:

The great disadvantage of the Haskell, however, is the absolute ruin of the length of present courses; all the good length holes laid out for the gutty are spoiled by the Haskell. The good two shots which used to mean a well hit drive, and a good cleek or long iron, are now in the reach of a man who half hits his drive, and the whole beauty of the lengthy hole is spoiled. This is a serious matter, and will have to be rectified in some way. Either the courses will have to be lengthened or the ball will be barred.

Architects were advised to design the golf hole by starting with the green and walking back to where the tee would be. Then the landing area for the driving ball could be determined, indicating the likely length of the hole.

The effect of the Haskell ball on the golf swing

Playing techniques had evolved too. The gutty had been hit for carry; the rubber-cored ball could be hit for roll! Consequently the draw or hook shot became more and more popular. But although the flight of the ball was much lower than it had been in the 1890s and the carry considerably less, the draw imparted less backspin and the rubber-core 'bounded' along probably twice as far as the gutty had run. Golfers

achieved greater overall distances with the American ball. On average the ball could be driven between 200 and 240 yd (approx. 180–220 m). Arnaud Massy, the 1907 Open champion, stated in a St Mungo advertisement that he drove the Colonel ball 260 yards (238 m).

Players also noticed that it was more difficult to keep the rubber-cored

The Sporting Goods Sales Company were the American distributors for Martins of Birmingham in 1913.

ball on the green. The opinion was that the greens were too small for the more elastic rubber-cored ball, and the remedy that was adopted was to enlarge the size of the putting greens and reduce the severity of the green side bunkers. Again, some saw these solutions as further reductions in the skill factor. Players had had to adopt new putting techniques for the rubber-cored ball – it needed a lighter and more delicate touch, and then there was the terror of holing out. With the old gutty ball, players could usually play firmly for the back of the hole, but the rubber-core had a tendency to hit the back of the hole and leap out. A popular move mooted in 1907 was to increase the size of the hole from 4¼ in (10.8 cm) to 5 in (12.7 cm), or even slightly more.

Horace Castle again: 'If a putt is hit properly, does it matter what ball is used? One often hears the exclamation of an exasperated golfer as his putt lips the hole, "If that had only been a gutty, it would have been in," or some such nonsense. In my opinion, if cleanly and correctly struck, the Haskell is quite as good as the gutty on the green.'

G.G. Smith, another concerned correspondent, wrote in *Golf Illustrated* for 22 March 1907:

It is possible to think, and we are glad to observe that the idea seems at last to be beginning to strike several competent critics, that the impoverishment of the game, and the strange deficiency in rising talent, both in the amateur and the professional ranks, are due not to the rubber-cored ball, but to the decrease in the variety of skilful shots which has resulted from the new theories of course construction.

Golf club patents
A twisting hole

To the modern golfer, perhaps the most interesting clubs are the patent ones. Almost every 'modern' idea has an older counterpart – a phenomenon we cover in the 14th Hole. Only the materials have changed!

However, in this 11th Hole we look at a few of the strange ideas that failed to work or that were not allowed, as well as some that did work and were allowed.

Vulcanite club heads

The first golf club patent was granted in 1876: 'Pat. No. 1683 – Johnston T. Club heads in Vulcanite or Ebonite moulded to shape.' Very few of these have been seen, and even then mostly putters. A very valuable short spoon of this type was offered to a Swedish collector whose business was in woodworking machinery. He was heard to say: 'I don't buy rubber clubs!'

Vulcanite, which is mentioned several times in this book, has many uses. 'Pat. No. 12019 C.J. Jacobs. Another moulded club head made of Vulcanite and other materials' was produced commercially in 1894 and sold by the Army & Navy Stores in Victoria Street, London. It was made in a very peculiar way, in that it had a scared head containing a vertical groove that fitted into the shaft with a matching tongue. The carpentry term is 'rabbeted'. This is a very rare club and extremely difficult to make. The inventor, Charles John J. Jacobs, was both professional and manager at the Royal Isle of Wight

Sir William Mills, founder of Standard Golf Co. of Sunderland and inventor of the Mills Bomb.

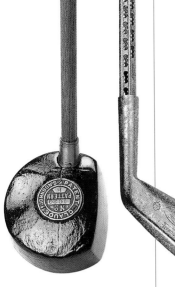

Above left: Claude Johnson Patent.

Above right: Patent steel shaft by A.G. Spalding.

Left to right: Browns 'Rake' iron; Urquhart Adjustable; illegal 'Nicola' putter with three striking faces

Golf Club. A man of many parts, he was also a talented artist (see Appendix 1).

Sir William Mills

Sir William Mills formed the Standard Golf Company of Sunderland in the mid-1890s. He started by copying his long-nosed wooden putter in aluminium alloy, because he was certain that it changed characteristics when wet.

Mills went on to produce hollow-headed metal woods and solid-headed aluminium 'irons' (see illustration in the 14th Hole). This company was the first to 'mark' the faces of its products and the first to number its set of irons. The set included 1, 1½, 2, 2½ and 3, and a 3½ has also been seen. The final clubs in the set were an NK (Niblick) and an illegal double-sided Duplex club. The Standard Golf Co. also made a huge range of mallet-type putters, some of which are very rare, while others are quite common.

Steel shafts

The first steel shafts were forged in 1893 by Thomas Horsburgh, a founder member of the Baberton Golf Club, Edinburgh, at his Johnsburn smithy in nearby Balerno. The shafts were made in solid one-piece iron with a reverse screw thread fixing into the head. Some time later Slazenger patented the reverse screw fixing, but with a hickory shaft.

The Horsburgh clubs were designated illegal. However, in 1918 A.G. Spalding of Rockord, Illinois invented a different steel shaft. The USGA sanctioned the use of steel shafts in America in 1924, but the Royal & Ancient Golf Club of St Andrews refused to allow steel until 1 January 1929. We all know what has happened since.

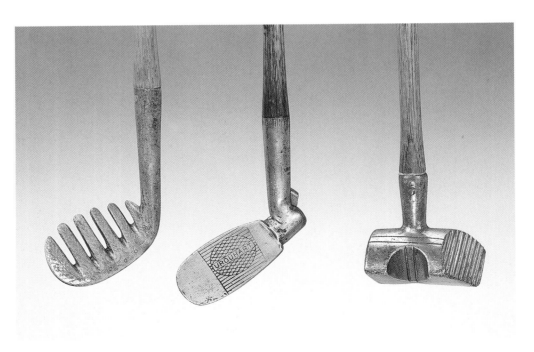

Other patents

One of the most interesting – and most inappropriately named – patents is that for Brown's Water Irons: 'Pat. No. 20343.1903 Brown JR Perforation of iron clubs.' These clubs had perforations or slots described in the Patent as 'Open slots resembling a comb or a rake'. They were nothing to do with water and were simply intended for use as ordinary clubs, although they did have an interesting and attractive design. All the teeth and perforations are surrounded with decorative engravings. The clubs were manufactured by W. Winton of Montrose, Scotland. There have been modern attempts at copying these old clubs by cutting slots into ordinary lofted clubs. However, on careful inspection one can usually see that either the maker's logo has been pierced or there are no engravings around the teeth.

Another interesting club is the Claude Johnson Patent, c.1905. This is a socket-headed wood, slightly centre-shafted, very similar to the modern Cleveland VAS wood. Johnson Patents are rare and difficult to find.

There are thousands of different variations in golf club development. Different grip shafts, strange ways of joining the head to the shaft – all sorts of delights. It is impossible, however, to write about patents without covering adjustables.

Adjustable clubs

The best and most famous adjustable is the Urquhart, for which there are at least five patents, beginning in 1892. This club could be adjusted to many lofts, both left- and right-handed, by depressing the button on the rear of the hosel and pulling out and twisting the head.

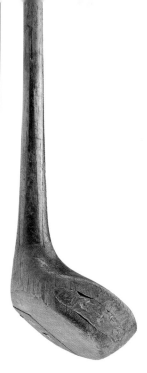

Fulford & Wallis four-spliced driver.

A collection of adjustables.

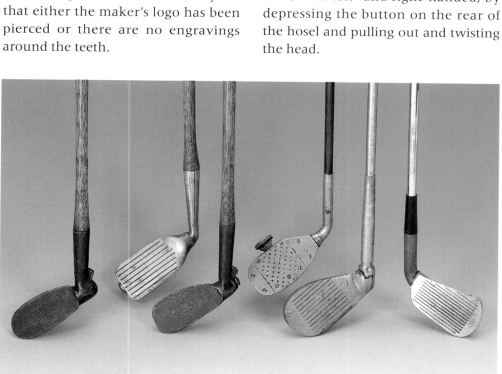

Left to right:
Sir W.H. Dalrymple hammer cross-headed driver and brassie, c.1892; unusual hoe-shaped iron; Anderson of Edinburgh patent centre-shafted iron, c.1895.

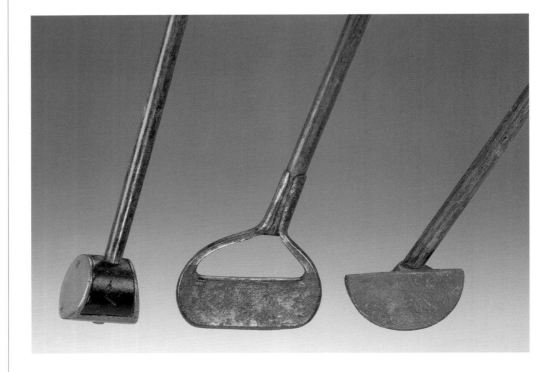

Urquharts are beautifully made, but not of great use on the golf course. In any case, the club manufacturers did not approve and they were banned from competition. There have been many different designs of this kind, but none proved really effective in use.

Different methods of joining the shaft to a wooden club head

1. The scare.
2. The through socket, patented by Anderson of Edinburgh in 1891.
3. The semi-socket, used to avoid infringing the Anderson patent – this was to drill part of the way into the head and wedge and glue the shaft into position.

There are of course several, often complex, 'spliced' fixings:

1. The Bussey of London Patent of 1890, whereby the shaft is fitted into a tapered slot as in a cricket bat splice.

2. The A.H. Scott of Elie, Scotland, with a rectangular taped splice that can be seen both at the front and back of the head.

3. By far the most difficult joint to make is the Fulford & Wallis of Bradford & Brough, Yorkshire Patent, spliced or with four-way spliced join (as illustrated on the previous page).

Patents are fun, so do look out for clubs with patent numbers. You then have to work out what is different, which is often hidden inside the head where it cannot be seen. From there on it's guesswork!

12th HOLE

Display points
A hole with a view

In the 1930s, '40s and '50s British ball manufacturers supplied loyal club professionals who sold their product with countertop advertising figurines. These were provided free for display on the shop counter, with the aim of encouraging sales.

The Golf Ball Development Company featured in its advertisements a cheeky-looking but smartly attired golfer wearing plus-fours and a large baggy hat. His cheeks were puffed and he smoked either a small black pipe or a fake cigarette. The figure was presented on a wooden plinth that carried one of two slogans -- either 'He Played a Penfold' or 'He Played a Bromford' – advertising the company's two best-selling golf balls. It was known accordingly as either the Penfold Man or the Bromford Man. The figures, made from papier mâché that had been moulded and then painted, were produced between 1930 and 1939 and for a few

years after the war by Harris & Sheldon Company, located close to Golf Ball Development in Birmingham. Several moulds must have been used over the years because minor variations occur. The height of the figure varies between 20.08 and 20.87 inches (51–53 cm) and there are different styles of plinth. Figures that were made in the 1930s have a gap between the legs from the shoes up to the plus-fours, and the face and shoes are sharper and more detailed than in later figures. There are two plinth types. Early types measure $2\,7/8$ in (7.3 cm) high and are shaped with rounded sides. The underneath of the base is hollow and the words 'He played a' are slightly raised. Later types are smaller, measuring $2\,1/2$ in (6.35 cm) in height, and have a solid base. The plinth's sides are well angled and the slogan is not painted in relief.

The pipe was easily lost or broken and this has to be a consideration when

The Penfold Man in tip-top condition had risen in value to £500 at the end of 1999, but the Scottie dog was even more valuable.

figures the 1½ inch-long pipe has a chrome-threaded screw at the end, which fits loosely into the hole within the figure's mouth, such that the pipe hangs from it at an angle.

In 1981 Maureen Faulkner of Penfold Faulkner Sports, the then owners of the brand, placed a notice in various golf magazines in an attempt to locate and catalogue every figure made. Only 40 figures were traced! In 1988 resin copies made by Puckmill Studios of Bath in Gloucestershire were advertised for sale, priced at £95. These were much heavier and slightly taller than the original figures, measuring just over 21 in (54–55 cm) high.

The Dunlop Rubber Company also developed a composition character in the 1930s, which was called the Dunlop Caddie. Just as with the Penfold Man, the Dunlop Caddie was displayed by the shop professional to encourage his playing members to play with Dunlop golf balls. There are two types of Dunlop Caddie, each with a head resembling a round dimpled golf ball. Both figures wear a cap and a scarf and rolled-up trousers, and both carry a bag with two irons and four wooden clubs. The more common figure measures 15–16 in (38–40.5 cm) in height. This measurement includes its green canted rectangular wooden base, on which is inscribed: We Play Dunlop. The rarer type is considerably smaller at 12½ in (31.75 cm) high and bears the slogan: We Play Dunlop '65'. The Dunlop 65 golf ball took its name from Henry Cotton's famous 65 at Royal St George's in the second round of the 1934 Open. As well as being shorter,

valuing a Penfold or Bromford Man. All sorts of pipes have been used as replacements, the majority of which do not look like the genuine article. In the case of older figures the black pipe measures 2⅞ in (7.3 cm); its metal stem measures 1½ in (3.8 cm) and its bowl 1⅜ in (3.5 cm). The inside of the bowl contains simulated burning tobacco. This type of pipe fits tightly into the hole in the figure's mouth and protrudes horizontally. With newer

this display figure has 'Dunlop 65' on the rear of the head. As was the case with the Penfold Man, resin replicas of the larger Dunlop Caddie came onto the market in 1988. These are very good copies and, although heavier, can easily be confused with originals.

The North British Rubber Company commissioned the Sylvac Company in the 1940s and '50s to create black pottery replicas of their logo, a Scottie dog holding in its mouth one of their round dimple balls. Sylvac already made both black and white Scotties for a whisky company and the mould was altered so that the dog held a golf ball in its mouth. The ceramic dog so made measures 11 in (28 cm) high; some were presented on 2¾ in (7 cm)-high blue plinths with the slogan: 'North British: The Choice of Champions'. The colour of the tartan dog collar varies and some balls feature the words 'North British' with the number eight. Reproductions have at times been passed off as real. Genuine Scotties have '1209 Rd No. 778504 Made in England' on the base. The North British Scottie is of great interest to collectors and at the beginning of 1999 its value had risen to around £800.

The Silvertown Company also gave advertising figures to golf professionals in Britain who stocked their Silver King golf balls. There are two Silver King figures, both made from a pressed card material. The earlier type was issued some time during the 1920s and is sometimes called the 'Silver Queen'. It is the rarest of all the figures and there is no record of it ever being sold at

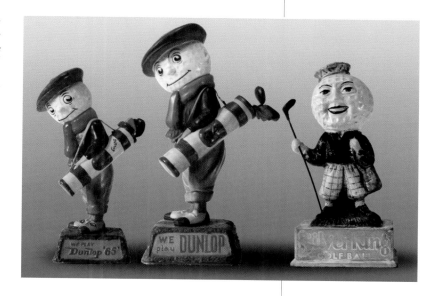

auction. Dressed in a pink and black outfit with a harlequin-style pattern, and wearing a golden crown on a head that resembles a golf ball, this figure displayed a slogan on the plinth advertising 'Silver King Golf Balls'.

During the early 1930s it was replaced by a smaller Silver King figure measuring just over 14 in (36 cm), which was produced for the Silvertown Company by Universal Seamless Containers Ltd. It, too, has a mesh-patterned golf ball as the head and is dressed in plus-fours. This figure also wears a crown, holds a metal bulger-style club in the right hand, and is presented on a rectangular hollow wooden plinth inscribed with the words 'Silver King Golf Balls' and marked 'Patent No. 208063' on the base. This type of Silver King figure is the second rarest and usually reaches a four-figure sum at auction.

The small Dunlop Caddie is rarer and more valuable than the larger and older version, while the Silver King figure is also hard to find and seldom comes to auction.

13th HOLE

Golfing memorabilia
A decorative hole

Opposite: A montage of various collectables.

Two fine 1890s silver and enamel matchboxes and a pair of early 20th-century Irish gold and enamel medals.

We shall now explore some further fascinating facets of collecting – and encounter some more hazards.

Silverware

First, buy an English silver hallmark book. It will be quite inexpensive and can be obtained from most bookshops. A book of this kind tells you when and where silver items were hallmarked, but not necessarily where they were made (although generally the silver-smith would send his wares to the near-est assay office to be hallmarked). The hallmark guarantees the quality of the silver. Scrapings are taken at the assay office and, if the silver is sub-standard, the silversmith's offering is beaten into a mangled lump with a hammer and returned whence it came. English hall-marked silver is 92.5 per cent pure.

The letters E.P.N.S. denote electro-plated nickel silver. It is important to look carefully at the base of any pro-spective purchase; at first glance, 'E.P.' or 'E.P.N.S.' may appear to be a silver hallmark – it is not.

In general, silver golfing items are collectable only if they can be seen to relate to golf at ten paces. If you have to read the inscription in order to find that an item is golf-related, unless it comes from a very famous golf club the value is much reduced. Be aware that inscriptions or engravings can be added to old silver trophies at a later date.

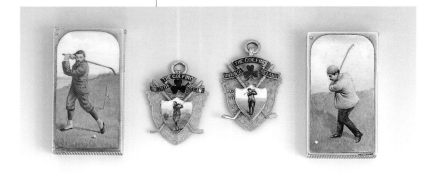

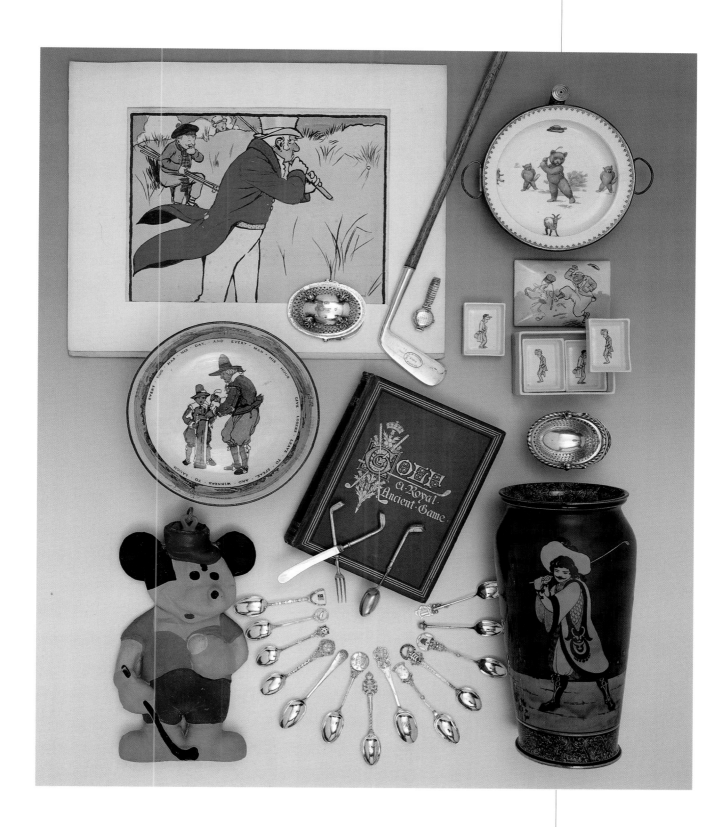

A wonderful silver buckle, hallmarked London 1898.

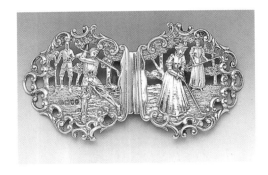

A collection of silver trophies and other golf-related items.

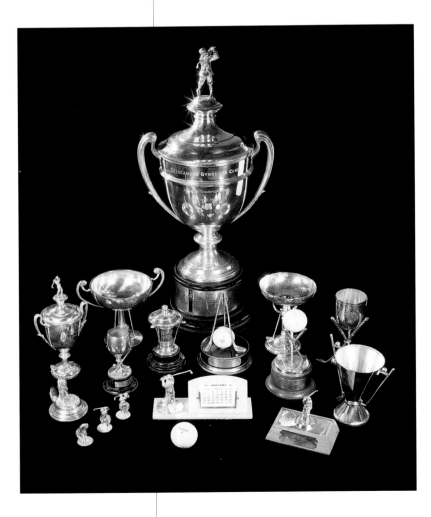

American silver is usually stamped with the word 'Sterling'.

Silver and other precious metals are traditionally weighed in troy ounces (approximately ten per cent heavier than our normal avoirdupois ounces). So if you weigh your silver trophy at home on the kitchen scales and then take it to the jeweller to sell, don't think you are being cheated because the two weights are different.

Since Mr Bunker Hunt attempted to corner the silver market years ago, the price of scrap silver has been fairly depressed and has stayed around or just below £3 (US$5) per troy ounce. Casting silver as used by manufacturing silversmiths has for a long time cost around £10 (US$16) per ounce. These facts only go to show how inexpensive the raw material is and how comparatively expensive it is to purchase in the shops. For golfing items the prices are usually much higher again. However, collecting these items is fun – but always remember to take your magnifying glass and hallmark book.

Books

There are thousands of golf books from which to choose. The major book-collectors generally try to acquire non-instructional books. However, it is important to collect books that interest you. Always try to purchase books in good condition, with dustwrappers if possible. If the book is old and valuable, make certain all the pages are still there. Often some of the picture plates will have been removed to sell individually as prints. Make sure, too, that the blank pages at the front and back are intact; these are referred to in the trade as the 'endpapers'. If any part of the book is missing it is very much devalued. Purchase a bibliography, such as *Murdoch's*

A selection of golf books old and new.

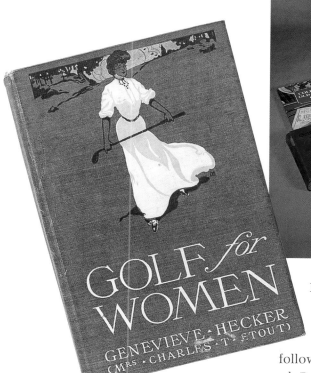

Library of Golf, 1968 (although this is out of print and therefore very expensive) or Donovan & Murdoch's *The Game of Golf and the Printed Word* (available from golf booksellers).

Ceramics

Many companies throughout the world have produced golfing ceramics, but the most prolific of them all is probably Royal Doulton of England, granted the Royal seal in 1902. This company has made golfing ceramics over a very long period. Perhaps their earliest and most valuable product was the Doulton Burslem range, produced in fine bone china, hand-painted in blue and white, in the late nineteenth century. This was followed swiftly by Doulton Lambeth and Doulton Kingsware. Less well known is Doulton Queensware, which was produced for only a very short time and is valuable. The most extensive range of Doulton ceramics is their 'Series Ware'.

Other factories that produced golfing ceramics include Copeland (later Copeland Spode), Carltonware, and of course the American firm that made the fine 'Lenox' pottery in Lawrenceville, New Jersey in the last part of the nineteenth century and the early twentieth century.

Be very careful to check any prospective purchase for repairs that may have been carried out on it, bearing in

A group of fine ceramics: (*front*) a Doulton Lambeth mug and a Copeland mug; (*rear*) a Copeland-Spode mug, a W. Wood & Co. biscuit barrel, c.1895, and a continental porcelain figure.

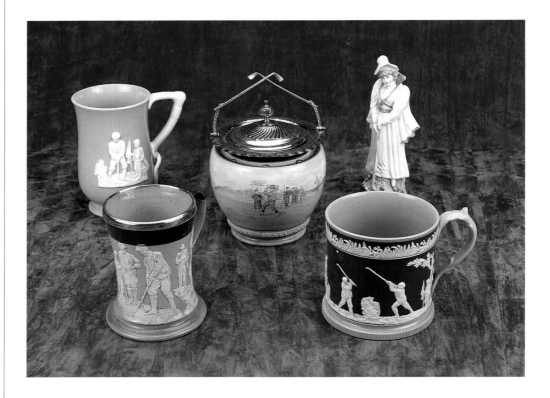

Right: A set of fine Doulton Kingsware with a golfing motif.

Opposite: 'Lenox' ware from the United States.

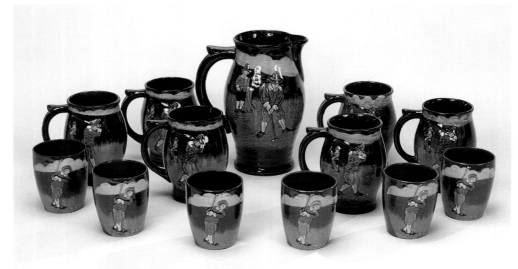

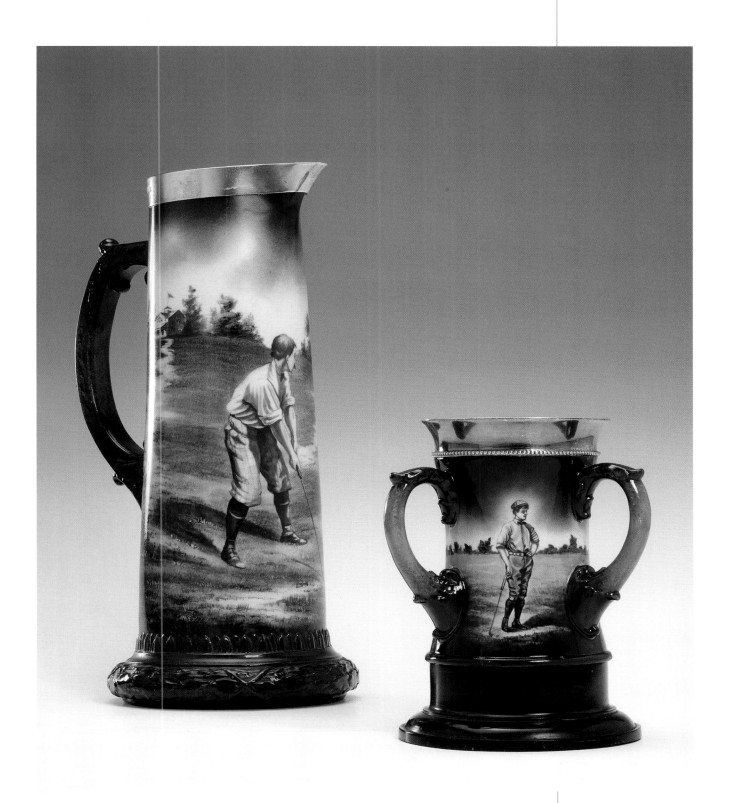

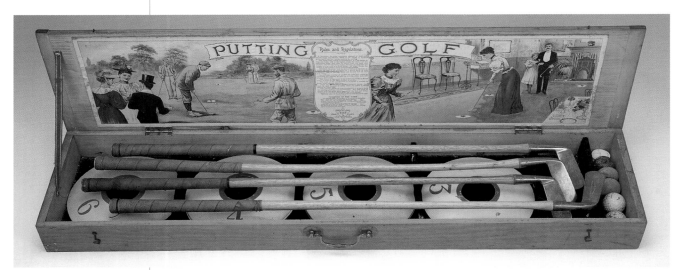

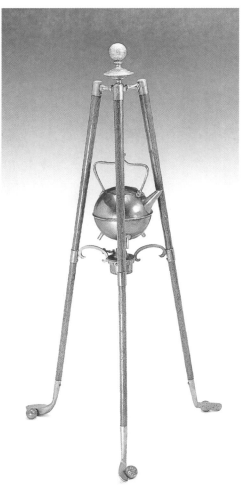

Above: Clock golf putting set.

Right: A golfer's water heater – for tea at the 19th.

Below: A collection of tees, etc.

mind that rims, handles, spouts and bases are particularly susceptible to damage. If the item is 'crackled' (i.e. has a crazed surface as an element of the design), repairs cannot match this effect, so always look to see if an area that should be crackled is not. Also, beware: new pottery can be artificially crazed to make it appear old.

Odds and ends

As well as the larger items pictured here there are a multitude of smaller golfing knick-knacks that are fun to collect – for example, buttons, badges, medals and spoons (see illustration at the beginning of this 13th Hole). The main thing to remember is always to collect what you enjoy and find interesting.

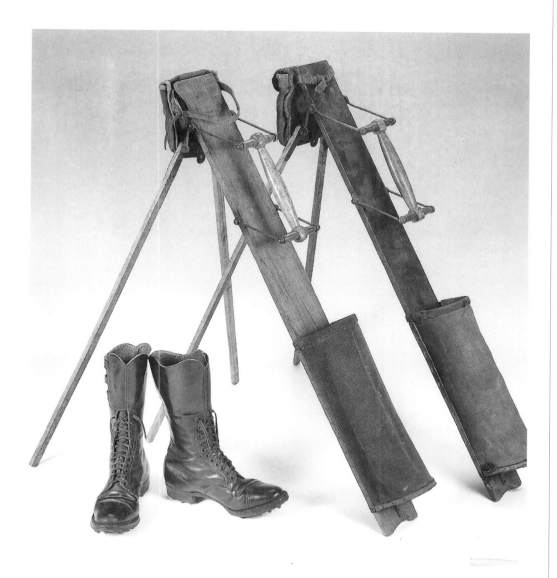

A pair of George Bussey of London automaton golf club carriers and an early pair of golfer's boots.

Golf in backspin
The deceptive hole – golf ball theory and club design
Further thoughts from David Neech

The ball that stopped and the ball that did not

Apart from its lasting and re-pressing qualities (i.e., being solid, it could be pressed back into shape by heating and remoulding), the only asset the gutty had was stopping. It didn't go very well, but it stopped wonderfully.

I remember years ago, at the European Open Championship at Sunningdale, watching a Ryder Cup player practising from a bunker. He was brilliant: every ball within a yard or so of the hole. I threw him a handful of gutties and the effect was extraordinary. To begin with, he could not bring himself to hit them hard enough to get them out, but after a while he got used to the extra power needed to remove the balls from the bunker, and then he

splashed them out even closer than his modern golf balls.

I have often played with a gutty and found there is a difference from the modern ball of about two to three club lengths, and play around the green is much easier because the ball falls so dead each time. The rubber-cored ball patented by Coburn Haskell in 1899 was much like the wound ball of today, which has a length of rubber winding roughly equivalent to Greg Norman's average drive: about 275 yards. Two or three club lengths further and – wow! – the ball bounded on and on. No easy stopping round the green now!

What was uppermost in the manufacturers' minds, therefore, was how to give the ball more control. Haskell's idea, although it had been used before,

was to make the surface of the ball grip the ground better by covering it with bumps rather than indentations (the 'bramble' pattern).

Another transformation brought about by the Haskell ball was in the design of golf clubs. Until 1900 all golf clubs, both irons and woods, had been made smooth-faced (without grooves). I've found it fascinating, when looking at old iron clubs, to see how many of them started life as smooth-faced, until their owners, on changing over to rubber-cored balls, marked the faces themselves in very amateurish ways.

Now, in an attempt to control the ball, the manufacturers began marking the faces of clubs in order to produce more backspin. The new ball flattened itself against the club face, gripped and flew away with the greater backspin. The old gutty had backspin too, but merely bounced off the club face rather than gripping onto it.

It has been proved that the markings on the club face make only about a five per cent difference. However, they certainly *do* make a difference. The modern professional – as indeed was the case with the old professional when hitting the ball with a driver – produces about 3,000 revolutions per minute of backspin, and much more with lofted clubs.

Makers began producing clubs with more and more loft in order to give the ball greater height and backspin to stop the ball. Eventually the Mammoth Niblick came along, with a face the size of a saucer and incredible loft – perhaps a no. 15 or no. 16 iron with a loft of maybe 65° or 70°. There is a wonderful story from Walton Heath Golf Club in Surrey concerning their very difficult 2nd hole on the Old Course. At the bottom of the hill, in front of the raised green, is an area of thick heather. One member always hit his second or third

Below: A letter from Harry Vardon to G. W. Beldam.

Below Left: Harry Vardon's clubs in 1903, with dimensions.

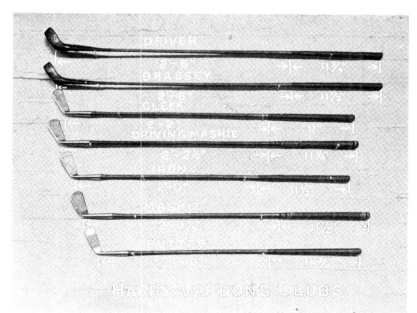

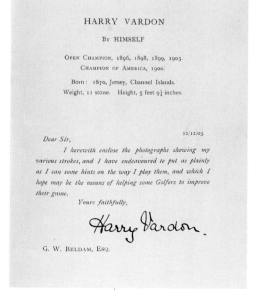

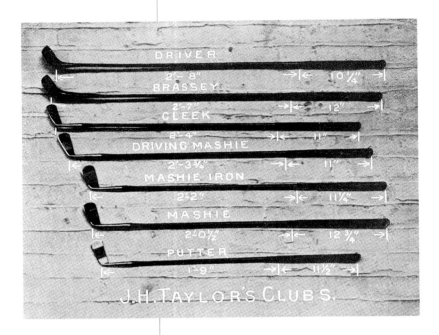

J.H. Taylor's clubs in 1903, with dimensions.

A letter from J.H. Taylor to George Beldam dated 10 December 1903.

shot into this awful hazard, but one day he appeared at the club saying that the 2nd hole would not defeat him that day. Arriving at his usual unplayable spot in the heather at the 2nd, he took from his bag a thin-bladed, very lofted Niblick, which he had honed to razor sharpness. One hit and he sliced through the offending flora, only to wonder where the ball had gone. It was, of course, impaled on the leading edge of his newly sharpened golf club, somewhere around his right ear.

The dimple ball was patented on 15 September 1905, but it gave the golfer even more uncontrollable distance than the bramble-patterned ball and did not find favour until much later.

Using one of the new rubber-cored balls, in 1902 Alex ('Sandy') Herd, who was then the professional at Huddersfield Golf Club, Yorkshire, won the Open Championship at Hoylake (Royal Liverpool) with a score of 307, equal-

ling Vardon's lowest score to date. Herd was the first person to win the Open with a rubber-cored ball, having borrowed one from a local amateur, and it is said that he played all 72 holes with it – the last few with the ball very badly damaged.

George Beldam's book *Great Golfers and Their Methods at a Glance* (1904) is a very interesting read. The first three chapters start off with letters from Vardon, Taylor and Braid, together with either a photograph or a description of their clubs. The clubs these players used show more than anything the essential difference of the gutty from the rubber-cored ball. All three of these great golfers were obviously still using the gutty ball, as quite clearly none of them had a club more lofted than a modern no. 6 or no. 7 iron. Gutties stopped!

The Triumvirate, as they're known, won sixteen Open Championships in

the years between 1894 and 1914, and it is likely that some of these Championships were won with the gutty ball. As late as 1914, as already related, these great British players took part in a series of matches at Sandy Lodge and St Andrews to prove which was the better ball. With hindsight we all know now!

But then the Great War intervened. Golf slowed down and after the war most golfers were familiar with the extra length and bounce of the rubber-core and the makers started to look for a ball that went further.

The design of the cover was shown to add length – first, back to the square-mesh design of the late 1890s, then back to dimples. Since the British dimple patent of 1905 came into its own, golf has never looked back.

Practical club design

We have seen how golf balls started out with a filling (feathers), became solid, went back to a filling (wound rubber), and today – a Mr James R. Bartsch of the USA having patented the solid ball in 1966 – are becoming solid again. This delights the manufacturers, as the solid ball is so much cheaper to make than the wound ball, and they can charge more for it.

Golf clubs have a similar history. Mr Carruthers visited Sotheby's office one day with the original patent of the Carruthers short hosel through socket iron, otherwise known as the drilled hosel cleek (1890). (His forebear Thomas Carruthers of Edinburgh was a very interesting man, according to

his great-grandson. He had been a professional runner – a most unusual occupation in the late nineteenth century.) The Carruthers through socket design has been copied many times. Spalding were using the short hosel through socket design in 1905, and so are Callaways today. (In fact, in the early 1980s Callaways purchased two or three Carruthers irons from the present writer.)

In 1894 three separate makers patented metal-headed woods. The early club makers had nothing but aluminium alloy to use – stainless steel and titanium had not been developed at that time. Nowadays we are used to metal-headed woods, but it is only the materials that have moved forward.

The Standard Golf Company of Sunderland, the biggest manufacturer of aluminium-headed clubs, made aluminium 'wood' heads filled with

James Braid.

Left: Letter from James Braid to George Deldam.

Right: Dimensions of James Braid's clubs.

JAMES BRAID

By HIMSELF

OPEN CHAMPION, 1901.

Born : Earlsferry, Fife, February, 1870.
Weight, 12 stone 6 lbs. Height, 6 feet 1½ i

DEAR SIR,
Herewith I enclose Photographs, also the different strokes. I hope what I have sufficient to help some Golfers on their way.

Yours fait

W. BELDAM, ESQ.

DIMENSIONS OF JAMES BRAID'S CLUBS.

Name of Club.	Length of Grip.	Length from bottom of Grip to Heel of Club.
Driver	12″	2′ 6″
Brassey	11″	2′ 6⅛″
Baffy	11″	2′ 5″
Cleek	11″	2′ 4¾″
Driving Mashie	11¼″	2′ 2″
Mashie Iron	11″	2′ 3¼″
Mashie	10½″	2′ 2½″
Putter	13½″	1′ 9″

The dimensions are taken as shown in the photographs of Vardon's and Taylor's clubs.

Left to right: A Ping TISI Driver c.1999; a driver c.1930; a Braddel (Belfast) aluminium alloy spoon c.1898; a Mills alloy 'iron' c.1905; a Spalding Executive 'iron' c.1980; a lead-filled aluminium alloy-headed putter c.1925.

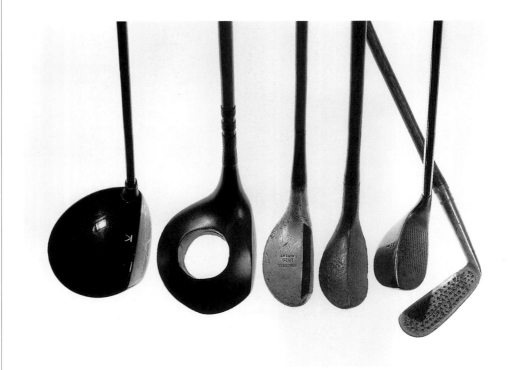

An A.G. Spalding advertisement c.1905.

A. G. SPALDING & BROS.
53-4-5 Fetter Lane, LONDON, E.C.
ATHLETIC GOODS MANUFACTURERS

SPRING-FACED 10/-
CLEEKS each
and
IRONS

FREE
Write for
our
beautifully
Illustrated
Art Catalogue,
No. 63, sent free
upon request

DRIVERS
and
BRASSIES

6/6 each

HIGHLY FINISHED AND BEAUTIFULLY BALANCED
LADIES' CLUBS OF ALL DESCRIPTIONS A SPECIALITY
WIZARD GOLF BALLS, 24/- Per Dozen

timber (beech) inserts to stop them sounding like empty dustbins. This company, founded by Sir William Mills, went on to produce the Mills Bomb as well as golfing equipment.

Braddell of Belfast manufactured aluminium woods with leather faces and Brougham of London filled their aluminium club heads with gutta-percha.

Metal-headed clubs as such are by no means new; it's just the materials that are. And – incidentally – titanium is a poor golf club material, because it is brittle!

The *Golfers Handbook* of 1905 carries a beautiful advertisement for Standard Golf Co. 'Mills' clubs and Spalding 'Spring-faced' cleeks. We thought that total peripheral weighting (which helps in a small way to enlarge the 'sweet

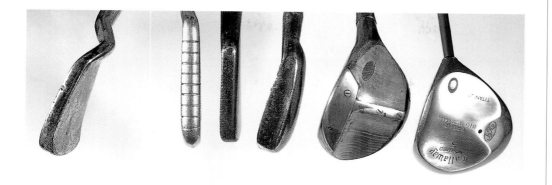

Left to right: A heel and
toe weighted anti shank
F.G. Smith iron c.1905;
a 1930s putter with
rounded sole; a
Carruthers short hosel
through socket iron
c.1900; a Spalding
spring-faced cleek; pre-
cursor of the Callaway
Warbird sole in persim-
mon c.1930; a Callaway
Warbird sole club c.1998.

spot' on the club face by surrounding it with weight) was new. Not so! The heads on Spalding's spring-faced clubs were made in two parts: the back and the neck in one piece, leaving a hollow, and the faceplate riveted onto the head with six rivets, forming a complete cavity that produced total peripheral weighting. Of course, unlike the modern Taylor Made ICW hollow irons, the heads could not be made in a single piece, but the principle is the same.

Now we come to the present day and the Callaway Warbird sole. Perhaps this had never been thought of before? Of course it had. Our photograph shows a persimmon-headed wood alongside a Warbird sole, circa 1930! The Great Big Bertha had predecessors, too, and so did the Taylor Made bubble shaft (ill. page 36). There is nothing really new in golf except the materials and manufacturing processes. Even the Cleveland VAS irons invented by my friend Roger Cleveland were developed from a much earlier design, the Anderson cross-head iron from the late nineteenth century.

Nick Faldo has left Mizuno and joined the Adams 'Tight Lie' Company.

They have come up with a new club – a lovely shape, too shallow for use with other than tight lies. An excellent new idea? Not at all. Alex Patrick of Leven produced 'Adams'-principle woods in the early 1920s. And they were, in my opinion, a little better then, as they were deeper in the face and it was not so easy to go underneath the ball in the rough and 'sky' it. Alex Patrick's 'Adams' woods were called 'Perfector' woods, and of course they were made in persimmon rather than metal. Yet again, only the material has changed.

Some time ago sets of anti-shank irons were made: one set was manufactured by Ben Sayers in North Berwick, the other was American and had Miller Barber's name appended to it. These anti-shank clubs were not new either. They were exact copies of the F.G. Smith model of around 1905. Of course, the modern clubs are in stainless steel with steel shafts, but the principle is just the same as in those early days.

These anti-shank clubs are very interesting. I'm sure the reader will never have shanked, but I have. When this happens the ball flies off at an angle

of 45° and even with shouts of 'Fore!' sometimes hits somebody. With the F.G. Smith model there was no shank. However, that doesn't stop the player from hitting the ball where the shank was! In this case, a fine glancing blow and the ball whistles backwards and hits the player's shin or ankle – very painful indeed. Therefore anti-shank clubs can be much more painful than iron clubs with shanks!

Soft-faced putters are not new. Until about 1890 nearly all putters were soft-faced: they were wooden. I have seen clubs by William Park Jr from the 1880s with vulcanite inserts. However, a lot of aluminium putters were made, and aluminium is soft. Some of them have lead inserts in the face, and not many materials are softer than lead.

Clearly manufacturers have to sell golf clubs – it's their job. But sometimes outrageous claims are made for their products that are really indefensible. The great Henry Longhurst wrote an article in the mid-1960s in which he compared manufacturers' literature covering the period from 1900 to the time of the article. He pointed out: 'If all the manufacturers' literature was true we would be hitting the ball something over a mile and a half.'

There have always been very long hitters and it is only relatively recently that we have discovered why. Most golf teaching up to the middle of the twentieth century concentrated on strong hand and arm action. Golf instructors are now teaching the use of the big muscles in the legs and lower abdomen, which the very long hitters have always unknowingly used anyway.

At the beginning of the twentieth century F.G. Tait hit a drive that measured 341 yd 9 in (312 m), and before 1905 Edward Blackwell is said to have driven a total of 387 yd (nearly 354 m) from the 18th tee at St Andrews, his ball hitting the steps of the Royal & Ancient clubhouse and rebounding. By 1922 the longest recorded and fully authenticated drive was that made in August 1913 by E.C. Bliss, who drove 445 yd (407 m) at Herne Bay. The drive was measured and levels taken by Mr L.H. Lloyd, a government surveyor. There was a 57-ft fall from tee to green. In the late 1920s Abe Mitchell, when playing the 600-yd 18th at Verulam Golf Club, St Albans, hit a drive and 4-iron – hickory-shafted – 40 yd through the green into a hedge guarding the clubhouse. The 18th at Verulam is flat.

In 1961 I played in the British Amateur Championship at Turnberry. I was fortunate to play in the practice rounds with Richard Davies from Pasadena in the United States, who a year later became Amateur Champion. The longest hitter of this period was the huge George Bayer of the United States. I had played with nearly all the big hitters in the UK – Peter Alliss, Dave Thomas, Harry Weetman and the like – and never felt out of place. However, playing with Richard Davies was something quite different. With a well controlled, apparently gentle, swing, he was always 60 or 70 yards ahead and on one occasion nearly 100 yards – and that with a 4 wood. Not wanting to appear too impressed, I recall remarking casually: 'You seem to give it quite a good hit.' He replied: 'I

play a lot with George Bayer and I can knock it past him!'

Generally speaking, the golf ball travelled at its furthest in the late 1920s. The reason was simple: there was very little control over the size and weight of the golf ball. Manufacturers made smaller, heavier balls!

I recently had a discussion with Dr Roy Jones, Head of Manufacturing Engineering at Loughborough University, who is widely recognised as a world authority on golf clubs and balls. He started by saying: 'The manufacturers hate me because I tell the truth.' Taking him up on this, I asked to what extent he thought equipment had improved golf in the last thirty years. Very unscientifically, I thought, he held out his thumb and forefinger to indicate about an inch. When I asked how much effect he felt the human had had on golf over the same period, he opened his arms to about two-and-a-half feet!

Golf clubs have become a fashion that sometimes has little to do with their performance. Acquiring one that is the biggest, the longest, the latest or the most expensive may help you 'keep up with the Joneses', but sometimes the playing advantage gained can be measured only in inches, if that. Expensive new equipment often has not much more than a placebo effect, which wears off long before the clubs wear out. Even though the cost to the manufacturer of turning an item into the latest and supposedly best may be relatively small, a large sum of money is almost always charged for the new design. And indeed, even 'illegal' copies can cost almost as much as the so-called genuine article. Who, really, is copying whom?

I have lots of sets of irons. My favourite was given to me by the late Maurice Bowyer, formerly the owner of the Castle Golf Equipment Co. in south-east London. The set he gave me were his 'Silver Leaf' blade irons, c.1976, which had the only iron heads ever made by Rolls-Royce, and first-class shafts and grips. The price of these was a fraction of that of clubs made by more famous makers, because Maurice did not spend money on publicity. It is the high cost of advertising that makes golf equipment so expensive. This is mainly what you and I are paying for – much more than the cost of actually making the implements.

Maurice told me, as I sat in his office for hour after hour, that in 1918/19 Jack White was still producing about two dozen gutties a year, while Maurice himself was engaged in golf shaft

A modern professional thinking of his next, invention.

making. As many old professionals will tell you, Maurice Bowyer was perhaps the last genuine inventor and innovator in golf, and even up to their respective deaths a few years ago he and Sir Henry Cotton were working together on new designs.

Golfers are charged huge amounts, in some cases hundreds of pounds, for goods that probably cost less than twelve pounds to make. Added to that, many items are now made to look nice but are no longer functional. Woolly club covers are useless in the wet, and we get our hands and gloves soaked taking them off. Not everyone can afford caddies to perform the task. Modern grips are much too short on the pitching clubs, and sometimes we have to grip steel or graphite. There should be longer grips on the shorter irons, but unfortunately the makers can produce them more cheaply if they are all the same length.

Lastly, but certainly not least, I know the reader will never have stubbed the ground behind the ball when putting, but I certainly have! The pretty milled-faced putters with razor-sharp leading edges and no loft are designed for completely smooth billiard-table greens, and players who *never* stub the ground behind the ball. The razor-sharp leading edge stops the club and makes a bad shot even worse. Makers should make putters with a little more loft, for our average greens and winter greens. And every putter ever made should have a rounded leading edge. This would make the putter slide rather than stop when hitting the turf.

Ideas like these can clearly be seen to help golfers. But none of them are new! And as further 'innovations' come along, I suppose we shall just have to go on paying more and more, especially for advertising.

15th HOLE

Cover patterns
The windy hole

In *The Book of the Ball* A.E. Crawley wrote: 'The markings on a ball, bramble, or dimple or line or whatnot, give it a texture and consequently a power of grip, both on the ground and in the air.'

The pattern on a golf ball's cover, as well as its construction, determines the aerodynamic characteristics of the ball. During flight, the ball encounters both lift and drag forces; these dictate the shape of its trajectory. Lift is the force that causes the ball to rise, and drag is the air's resistance to the ball's movement through it. The cover patterns were, and are still, designed to optimise the positive effects of the lift forces and to minimise the effects of drag forces. As a golf ball moves through the air, the pattern of ridges between the indentations, circles or dimples create a thin blanket of turbulence around it. Consequently the airflow is allowed to follow closely the surface of the ball, thus reducing the size of the wake and the drag. This turbulence blanket and the ball's spin combine to stabilise the airflow, enabling the ball to enjoy good lift.

Hand-hammered patterns
As stated earlier, in the late 1840s it was realised that gutty golf balls which had been nicked and marked during play displayed better aerodynamic properties than smooth balls. Consequently, one of the last procedures the ball maker carried out was to hand-hammer a random pattern onto the ball. Allan Robertson's earliest pattern resembled crazy paving. At this time there was no optimum pattern, however; it fell to the imagination of the ball maker. Sometimes it is

This pristine red gutta-percha ball shows the Forgan style – it was sold by Sotheby's in July 1998 for £7,475.

119

hard to distinguish early balls marked intentionally by the ball maker from smooth balls marked by clubs during play.

The first regular patterns

The earliest regular pattern on a golf ball was probably one that comprised longitudinal nicks running from each pole in near-continuous lines. This was designed and made popular by Willie Dunn Sr in the 1850s. Soon ball makers realised that they had to master this hand-hammering skill, as balls with 'clean nicking' became a good selling point and immediately distinguished one ball maker from another.

In the 1860s Robert Forgan devised a criss-cross pattern. This comprised groups of parallel ridges that circled the ball at right angles to each other; they formed a series of mesh groupings around the central part of the ball. Each group contained some 25 or so squares, lined up five across and five down. The area near the poles was detailed with small linear cuts and nicks. This pattern was copied by most of the gutta-percha ball makers and became known as the 'Forgan' pattern. Alexander Patrick and John C. Gourlay were exponents of this pattern.

Of the other hand-hammered patterns possibly the prettiest was Tom Morris's fine-mesh pattern, which covered the entire ball.

During the 1870s hand-held cutting machines replaced the hammer to reproduce the criss-crossed mesh lines. Compared with hand-hammered lines, the ones made by these machines were straighter, and the hand-held machine generally produced finer and narrower lines than those in a moulded pattern.

Balls made from patterned moulds often have poorly joined halves, such that the lines of the pattern fail to marry up. In the 1880s, machine lathes cut the lines into the ball, these machines replacing the hand-held ones.

In the early 1890s moulds were etched in reverse to make the ball's cover pattern. In 1893 the Silvertown Company successfully pioneered a moulded-mesh pattern that had evolved from the Forgan mesh pattern. Their moulded-mesh design comprised six large circles that covered the entire

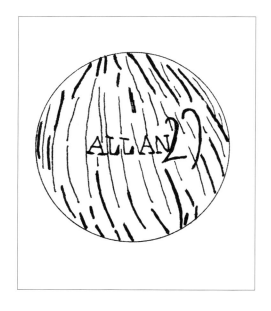

surface of the ball, and within these circles longitudinal and lateral lines criss-crossed each other, making hundreds of raised squares. This pattern became known as the Silvertown marking and by the mid-1890s had become one of the three universally accepted patterns. The first type of Haskell ball had a fine-mesh Silvertown-type pattern, but each raised square contained an indented dot.

The Ocobo pattern

In 1894 J.B. Halley launched the Ocobo gutty ball. It featured a new pattern of longitudinal deep grooves that criss-crossed at right angles with a series of sharp lateral grooves. A circular collar at each pole featured the ball's name and weight. The name Ocobo was sometimes pronounced with the vowels short, and sometimes with the second one long. It was supposedly an occult reference to Colonel Bogey! Many makers used the Ocobo pattern, an example being William Millar, who made the Mirco Special in 1901.

The bramble pattern

In 1894 Robert Forgan introduced a new ball called the Agrippa, which had a revolutionary cover resembling a blackberry. Forgan called it the bramble pattern, and this became the most popular golf ball pattern of the early 1900s, superseding the moulded-mesh patterns. Until then all the patterns had been linear, whereas the bramble consisted of rounded pimples covering the entire ball. Golfers now wanted more control, not necessarily more length, and it was soon apparent that these

pimples gave the ball better grip on the green and made it pull up much more quickly. The bramble ball did not travel as far through the air because the pimples interfered with the airflow and, although it may have gripped the club face better, it certainly gripped the ground well when it landed spinning. The big disadvantage was that the pimples tended to wear down or break off. Once the brambles were reduced to below what was known by the ball manufacturers as the 'critical height', the ball tended to lose its good flight characteristics. Consequently, some ball makers made the brambles slightly proud of the optimum, with the result that for a round or two a new bramble ball lacked distance.

The second type of Haskell ball was made with a bramble pattern. The Spalding and St Mungo companies called their bramble pattern 'Pebble' and the Worthington Company developed the pattern further so that the pimples resembled large flat discs, this pattern being called the 'Flat Bramble'.

The six-pole bramble was developed from the original bramble pattern.

121

The depth of the bramble's pimples are clearly illustrated in this Wood-Milne advertisement.

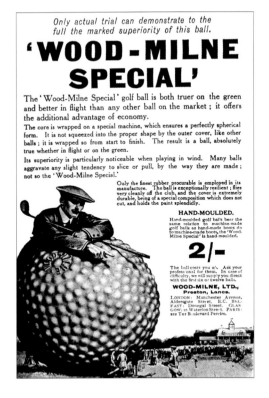

An attractive variation of the bramble design was the 'Six Pole Bramble', which was defined in a legal case as being 'six similar, distinctive and equidistant marks formed by the omission of parts of the bramble pattern, and arranged concentrically on the surface of the ball'.

Hutchison, Main & Co. first used the Six Pole Bramble in 1904 on their Springvale Kite ball. The bramble was the universal marking until the late 1910s, when it was overtaken by the round dimple pattern. Francis Ouimet won the US Open in 1913 with a bramble ball, but this design became less and less popular until it faded into obscurity in the 1920s. Surprisingly, however, in 1934 the Silvertown Company reintroduced the bramble pattern

for a couple of years on their popular Silver King ball.

By the late 1890s, with all the balls looking alike, players were finding it difficult to distinguish their golf balls from those of their playing partners. In order to determine ownership, balls had to be frequently lifted, looked at and replaced. In an attempt to 'break the mould' some interesting – and now very collectable – golf ball patterns were devised by the manufacturers between 1895 and 1909.

Strange and unusual patterns, designs and auction prices

Willie Park, a great golf ball innovator, designed and produced two exceptionally pretty golf balls. The first was the Diamond Mesh and the other the Park Royal. The Diamond Mesh design, made from superimposed ring markings, was registered on 22 October 1890 as No. 16862. As the name indicates, this beautiful-looking ball bears a pattern made up of diamonds.

The Park Royal design was registered as No. 11761 on 30 May 1896: 'Golf balls are formed with flattened parts or faces preferably of hexagonal shape as shown. The faces may be slightly hollowed or indented' – which was supposed to prevent the ball from 'running too easily on very keen greens or downhill'!

Sotheby's, London, 24 July 1984, Lot 87: 'An unusual hexagonal-faced gutta percha golf ball, the multi-faceted ball, painted white, 1⅝ in. in diameter.' Sold for £280.

Phillips, New York, 2 November 1996, Lot 191: 'An extremely rare Park

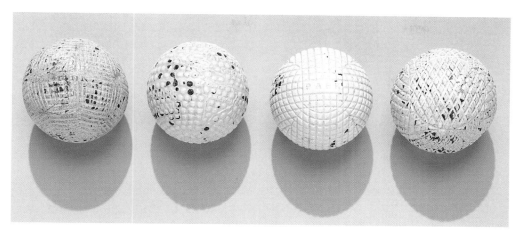

Royal Gutty with hexagonal faces, near mint, one facet exposed.' Sold for $US35,650.

On 7 January 1895 J. Sturrock introduced a canvas-covered ball, because 'standard' golf balls tended to suffer from too much loss of paint during play. It was not a success. Made the same year was the Henley ball, whose 'unusual triangular markings' comprising horizontal and diagonal lines were similar to Britain's Union flag. This product was intended for the domestic market, whereas Willie Dunn Jr's Stars and Stripes ball, launched in 1897, was aimed at the fast-growing American market.

Golf, 22 February 1895: 'This ball is different from other balls in as much as the nicking is entirely on novel lines. It is grooved in a series of rings divided into compartments and curiously interwoven with the happiest effect to the eye, as well as utility in scoring the longest flight. The name "Henley" is printed on two sides of the ball.'

Phillips, Chester, 16 July 1996, Lot 291: 'A Henley with cross pattern (near mint).' Sold for £5,000.

Towards the end of the nineteenth century Alexander Henry, a 'Gun and Rifle Maker' designed a grooved rifled pattern for a ball he called 'Henry's Rifled'. This design was patented as No. 4360 on 22 February 1898: 'Golf ball moulded with a series of curvilinear and angular grooves.' Henry applied the same rifling pattern to a rubber-cored ball in 1903, which he advertised as 'The fartherest, straightest, and swiftest flying ball in the market ... It flies like a bullet.' It is likely that Henry's Rifled ball was manufactured by Henleys.

J.P. Cochrane & Company of Edinburgh released an interesting bramble ball in 1908, called the Terrestrial Globe. It was reviewed in *Golfing* magazine of 18 June 1908: 'The "Globe" is of the popular bramble pattern, but in and out and round about the pimples is shown a map of the world in relief, the names of the continents, countries, oceans, etc., being also indicated by raised lettering.'

This exceptionally rare Henry's Rifled ball, c.1903, in pristine condition, unused but with a few flakes of original paint missing, was sold for £29,900 by Sotheby's in July 1998. The great rarity of these balls is probably attributable to the fact that they did not perform very well and not many were made.

Four more Terrestrial Globe balls, all in differing degrees of condition, have come to auction at Sotheby's and Phillips: in 1995 one sold for £10,500, in 1997 one sold for £6,800, and in 1998 two were sold – one for £4,600 and the other for £5,500.

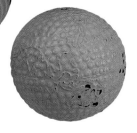

Patent application for the
Dympl ball, 1905.

Date of Application, 15th Sept., 1905
Complete Specification Left, 13th Mar., 1906 – Accepted, 26th Apr., 1906

PROVISIONAL SPECIFICATIONS

An Improvement in Golf Balls

I, William Taylor, of 57, Sparkenhoe Street, Leicester, in the County of Leicester, Engineer, do hereby declare the nature of this invention to be as follows:–
This invention relates to balls such as are used in the game of golf, and has for its object to improve the flight of the ball in the air, and its action when on the ground.
It consists essentially of an improved form of surface indentation or marking. The marking commonly used for such balls is in the form of numerous separate prominences resembling those upon the surface of a blackberry and named on this account the bramble pattern. Formerly the most common marking consisted of numerous grooves of even width intersecting one another and leaving between them separate polygonal portions of the spherical surface of the ball. It has also been proposed to make golf balls with circular indentations made by a centre punch. A further object of the present invention is to diminish the risk of slackening or bursting the shells of what are known as cored balls and to provide such a form of indentation that it will not readily collect dirt and can be easily cleaned.
I make the cells which form my improved marking either circular or approximately circular in outline or of polygonal form, the angles of which may be rounded. The mean diameter of the cells I make not less than nine, nor more than fifteen hundredths of an inch. The cellular indentations occupy not less than one quarter nor more than three quarters of the entire surface of the ball. The exterior surface of the ball between the cells may either retain its natural spherical form or be curved downwards about the margin of each cell as far as the lip of the cell proper which, however, I prefer to make somewhat acute. From this point the depth of the cell should not exceed fourteen thousandths of an inch. The sides or walls of the cell at its lip I make either parallel or to contain an angle less than ninety degrees measured in the axial plane common to the ball and the cell. The bottom of the cell may be flat and the section of the cell be of the form of a truncated cone, but I prefer to make the bottom somewhat concave and to round the re-entrant angle so that the section of the cell becomes semi-ellipsoidal or approximately so.

Dated this day 15th day of September, 1905.

Abel & Imray,
Agents for the Applicant

[Price 8d.]

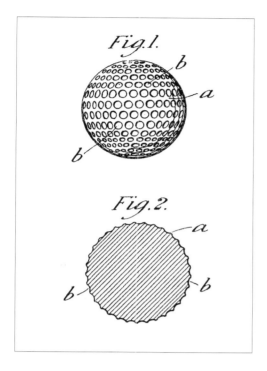

Fig.1.

Fig.2.

The Dympl was reviewed in *Golf Illustrated* on 6 December 1907:

… the feature of which is in the form of 'dimples' instead of 'pimples'. That is to say, the ball is pitted with small circular cavities instead of being covered with the usual bramble-like protuberances. We have tried these balls and found them satisfactory in every respect for driving approaching and putting; and contrary to expectation, we found that these did not clog with mud, but were actually easier to clean than ordinary balls.

For ball makers it was a more complicated procedure to make the dimple moulds than the bramble ones. Drilling holes into a smooth mould to make a bramble was relatively easy, whereas to make the dimple mould, and later the mesh mould, the indented dimples had to be lifted out: an expensive and labour-intensive operation.

In 1908 A.G. Spalding & Bros. bought the rights to Taylor's dimple pattern, and in 1909 they launched their first golf ball with round dimples, the Spalding Glory. By 1912 Spalding had added more dimple-patterned balls to their extensive range. These included the Domino; the Black & White, which was a small, heavy ball with ten per cent more dimples than the earlier Glory; the Spalding Dimple, of which 60,000 dozen were sold between 1912 and 1913; the Midget Dimple and the Baby Dimple. In 1915 Spalding's store news magazine wrote of the Dimple marking:

We have conclusively and scientifically proved that a ball marked in this way is at

Phillips, Chester, 22 January 1993, Lot 317: 'An extremely rare Terrestrial Globe bramble ball. The bramble ball moulded with the continents, the oceans, and North and South Pole… Only five of these balls are presently recorded.' Sold for £3,200.

The dimple pattern

William Taylor, an engineer from Leicestershire, patented in April 1905 a round dimple pattern, which was the reverse of the bramble pattern. Patent No. 18668: 'To improve the flight of a golf ball the surface of a covered or solid ball is formed with a number of shallow isolated cavities which are substantially circular … and evenly distributed.' The ball had 330 round dimples, each no deeper than 0.012 in. Taylor claimed his Dympl ball to be capable of a longer and truer flight than any other ball.

The beautiful Slazenger Cross, c.1915.

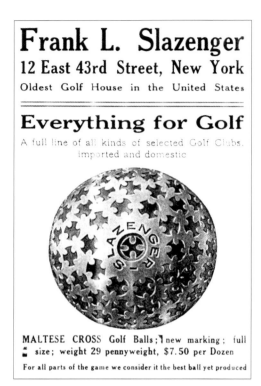

Frank L. Slazenger
12 East 43rd Street, New York
Oldest Golf House in the United States

Everything for Golf

A full line of all kinds of selected Golf Clubs, imported and domestic

MALTESE CROSS Golf Balls; new marking; full size; weight 29 pennyweight, $7.50 per Dozen

For all parts of the game we consider it the best ball yet produced

least five yards longer on the drive owing to the fact that the blow is nearer the rubber thread delivered on a flat surface... We point to our competitors who universally here and in England have attempted to construct balls on the same principle. To refer to a few – 'Zome Zodiac', 'Arch Colonel' ... the whole Goodrich and Worthington lines ... stars, crescents, diamonds, triangles and hexagons in the form of depressions on the surface of a golf ball.

Very quickly golfers came to prefer the round dimple pattern because it enabled the ball to be controlled in the air much better than the bramble and it put just as much, if not more, backspin on the ball.

Other ball makers brought out their own versions of the dimple, but for legal reasons could not call the pattern

'dimple'. A Spalding advertisement dated 7 February 1913 stated:

A majority of the 'Half Crown' Golf Balls on the market this year show 'recessed' 'depressed' 'sunken' 'indented' or other markings made to imitate in one way or another the original Spalding Dimple.

The Dunlop Company released several dimpled golf balls, including the Dunlop 29 and 31, which they described as being 'recessed'. In 1913 the Bird & Etherington Company released three balls with dimpled covers: the Bird, the Birdeth and the Wee Bird. Miller & Taylor called their dimple pattern 'Cymbal' on their Reliance ball released in 1913. Capon Heaton released the dimple-patterned Sunbeam ball in 1914. With the exception of Spalding, ball manufacturers had to wait until the 1920s before they could use the term 'dimple' in their advertisements.

The Scottish Golf Ball Company referred to their oval indentations as 'dent' markings. Phrases such as 'depressed markings' were coined by companies such as the Worthington Ball Company to describe their pattern of diamond shapes within raised discs. In 1913 the Goodrich Company also called their cover pattern of small sunken triangles 'depressed markings'.

Stars remained a popular alternative to dimples. In the late 1890s J.P. Cochrane & Company had made a gutty ball decorated with a series of five-pointed stars within larger recessed stars, called the Star Challenger. Even with the advent of the rubber-cored ball they successfully continued with this cover pattern. The Cromith

ball had a series of stars within hexagons. One of the most prolific ball producers at this time was St Mungo, which used the term 'sunken markings' to describe patterns of diamond mesh or crescent-shaped moons. The Craigpark Company made a ball in 1906 branded the White Flyer, which had a pattern of thickly rimmed circles, each one containing an indented cross.

The mesh pattern

There was one worthy rival pattern to the dimple and that was the mesh pattern, patented by A.E. Penfold in 1912 whilst employed by the Silvertown Company. This comprised parallel ridges that circled the ball at right angles to each other, with the square areas between the ridges recessed 0.013 in. The design of interlaced horizontal and vertical frets created an overall pattern of recessed square dimples that gave the ball an advantage of several yards over the bramble ball, but it did not travel as far as the dimple ball. In an interview published in *Golf Illustrated* on 2 November 1924, Penfold wrote:

The most satisfactory feature of the sunken marking is the very small surface change over a prolonged life. For consistency of

behaviour over several rounds and for durability the mesh marking has the bramble beaten every time.

The Silver King Black Dot, first made in 1913, was the first commercially produced mesh-patterned ball. In 1912 A.E. Penfold patented the lattice design. It was similar to the mesh pattern but the longitudinal ridges were slightly curved. When Penfold moved to the Dunlop Rubber Company in 1919, he launched the Dunlop MaxFli ball, which had a lattice-patterned cover.

Martin's Zome Zodiac in 1916 had strange-looking circles.

Worthington balls made in America.

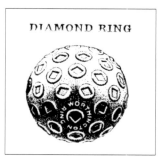

DIAMOND RING

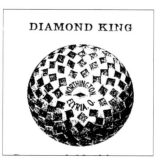

DIAMOND KING

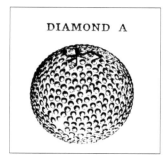

DIAMOND A

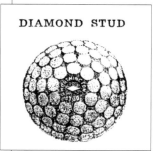

DIAMOND STUD

In an article titled 'The Implements of the Game' published in *Nisbet's Golf Year Book* for 1914, Ernest Lehmann wrote:

In the case of the balls, the Silvertown Co. brought out a ball with a novel marking called the 'mesh' marking. In the writer's humble opinion this marking seems the best of the 'compromise' markings, and approaches most nearly to a solution of the perplexing problem of combining the rough and the smooth.

The mesh pattern remained a popular alternative to the recess pattern well into the 1940s. It fell out of favour not only because dirt tended to collect in the corners of the square indentations, but because the ever-improving aerodynamics of the round dimple were quite obviously better.

The mesh pattern was popular on both sides of the Atlantic.

Golf course maintenance
A dog-leg around the greenkeeper's shed

Of course, when golf started there were no greenkeepers. Golf grounds were cut, mown and chewed regularly by the animals that roamed the links. As golf grounds were mainly public or common land, sheep, horses, cattle, rabbits and others fed from them daily!

One would think this medieval. However, there are still many courses that have animals grazing on a permanent basis, perhaps no longer cutting the greens, but certainly helping to keep the rough down. Rosapenna Golf Club in County Donegal, Eire, founded in 1895, has most of the first nine holes surrounded by an electric rabbit fence. Nevertheless, there are so many rabbits on this part of the course that it almost seems the idea of the fence is to keep rabbits in!

The rabbits commonly found in Britain originally came from northern Spain, where they lived in bushes above ground. The Roman clergy brought them to Britain because the Pope had decreed that they were 'fish on Fridays'. Many rabbits escaped – no doubt not wishing to be treated as 'fish' (i.e. eaten) – but they found the British climate too cold and consequently developed the habit of burrowing in order to keep warm underground.

The earliest reference to any form of greenkeeping at St Andrews dates back to 1805 and gives the name of Robert Morris, who probably just looked after the holes and caddied. There are earlier references to hole-cutting at Blackheath Golf Club in south London. The first five hole-cutters there are on record: William Holt was the first, recorded in 1787; Donaldson was a club maker and hole-cutter from 1788 to 1815; then came Ballantyne and Cockburn. The fifth,

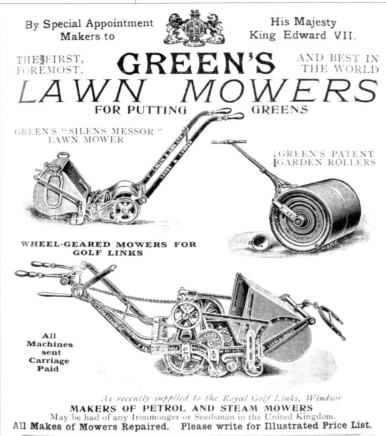

Above: Thomas Green &
Son advertisement, 1905.

Right: Thomas Green &
Son 'Multum in Parvo'
(Much in Little) 6-inch cut
cog-driven lawnmower,
c.1880.

Alick Brotherson ('Old Alick'; 1766–
1840), has become part of golfing
legend thanks to R.S.E. Gallen's early
nineteenth-century oil painting of him.

The first proper greens were cut
with a scythe, and a great art it was,
too. In the mid-1950s the two green-
keepers at Harpenden Common Golf
Club in Hertfordshire gave an exhi-
bition of cutting the greens with a
scythe. They 'said' that even the greens
at Gleneagles were cut by scythe up to
the Second World War.

The lawnmower was patented in
1832, and the single horse-drawn
mower for larger areas of grass came
into use around the middle of the nine-
teenth century. The horses wore golf

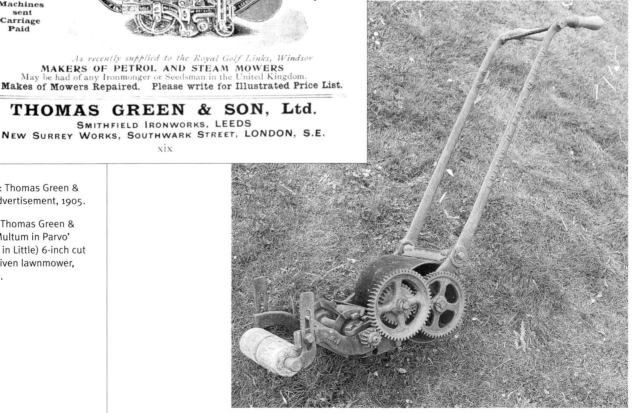

shoes! Or at least, leather boots with spikes. Gang mowers (three mowers in formation) did not come into use until the late nineteenth to early twentieth century and at this time steam had arrived. Steam-driven grass cutters!

One can imagine the varied contents of our greenkeeper's shed: dressings for the greens, stabling and hay for the horses, coal for the steam engine (or in later years petrol for the mowing machines), scythes, sickle, shears, spades, forks, hole-cutters, aerating tools, mole traps, weeders – and more than probably, on top of it all, a pack of sandwiches, a pipe of tobacco and a bottle of beer.

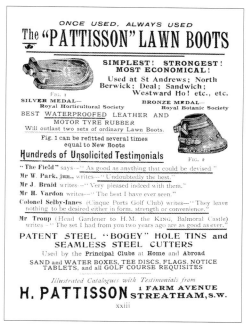

Pattisson's advertisement, 1905.

A group of 'mowers' resting after work.

Caddies
A short hole past the caddies' hut
Recollections from Kevin McGimpsey

When the aristocracy and nobility first played golf they had no need of a caddie, as such, since they had their own servants to carry their clubs and replacement balls. The modern-day usage of the word 'caddie' dates from the eighteenth century, when in Scotland (Edinburgh in particular) casual-labour servants such as messengers/errand boys and men who carried people around in sedan chairs were known as caddies. The word is thought to have derived originally from French 'cadet'; in the seventeenth century it had been used to mean a non-commissioned military trainee.

Caddies, often young boys but also adult men, found work on the links carrying the golfers' clubs. The caddie was expected to perform various duties and to know the names of the clubs he carried. He also had to be physically fit so as to be able to keep up with the players, needed good concentration and sharp eyesight, and had to watch every shot played to ensure that his employer did not lose a ball. Any damage to bunkers had to be repaired and at the start of every hole the caddie would carefully construct a sandy tee mound for his player. Should a blind shot be played, the caddie would become a fore-caddie and position himself on high ground to see where the ball went. The most common problems associated with being a caddie were the lack of regular employment and the temptation of alcohol.

By the 1800s a new type of caddie began to emerge: one who wanted to make a living out of golf. He may have been brought up near the links and probably played the game himself. Some would have been keen eventually to become greenkeepers, whilst others would supplement their income on a continuing basis by learning to make clubs and balls or by playing golf

The Young Caddie, watercolour by G.H. Jalland, late 19th century.

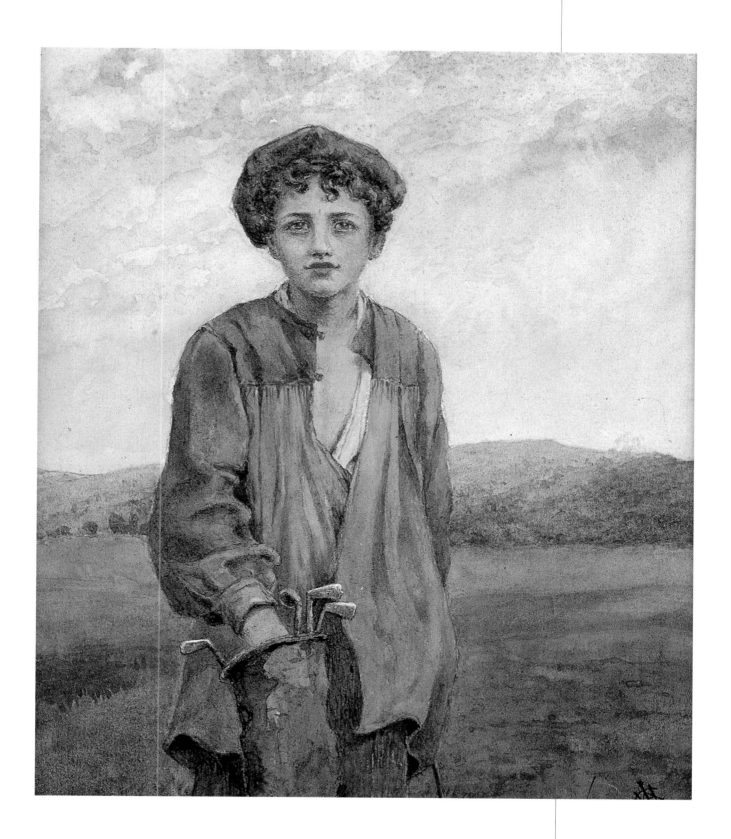

for money. Indeed, many a young caddie developed into a professional golfer or a golf coach.

In 1899 at a General Meeting of the Royal & Ancient, the committee, after liaising with 50 other golf clubs, drew up regulations for the employment of caddies. This had come about because more and more visitors to St Andrews were being accosted at the railway station and 'induced to employ the services of caddies at exorbitant rates'. Also, there were too many instances of the caddies abandoning their regular employers in favour of casual visitors who offered much higher rates of pay. From 1890 the R. & A. employed a caddie master, 'through whom the members of the club shall be requested to engage their caddies'. This officer had to maintain a register of caddies and of those who wished to become caddies.

He also kept a merit board of caddies on display that showed which caddies were best. A tariff for caddies was also agreed:

1s 6d for the first round

1s 0d for the second and every subsequent round

2s 0d for a round played during the spring and autumn medal weeks

2s 6d for a professional going out with a player in addition to his caddie's fees

2s 6d for a professional teaching the game for each round

A Benefit Fund was also established, 'for the help of deserving caddies, who are invalided and unable to carry...'.

JACK NICKLAUS – personal recollections from a caddie's perspective
by Kevin McGimpsey

In June 1985 my brother Garth won the Amateur Championship at Royal Dornoch. During the dinner after the final I heard someone say to him that one of the benefits of being Champion was that he would be invited to play in the Masters at the Augusta National Club, Georgia the following April. Unless your name is at the top of a waiting list and someone dies, you need a miracle to get a ticket just to watch the Masters! It had always been an ambition of mine to attend this prestigious event and so I asked Garth, if the invitation materialised, could I caddie for him?

In October Garth received what is undoubtedly the most sought-after invitation in golf and – unbeknown to Garth – our father, Hal, wrote to Jack Nicklaus asking if he would play a round with him before the Masters got under way. On Christmas Day an unopened letter tied up in ribbons was hanging on the McGimpsey tree. Talk about miracles: this letter was from Jack Nicklaus inviting Garth to join him and two leading American amateurs for a game on the Tuesday of Masters week. Jack Nicklaus, the greatest golfer who ever lived, had agreed to play with three amateurs as part of his build-up to one of the world's four major championships.

What sort of a man was he, and would his presence reduce these three non-professional golfers to a state of uncontrolled nerves? I shall always

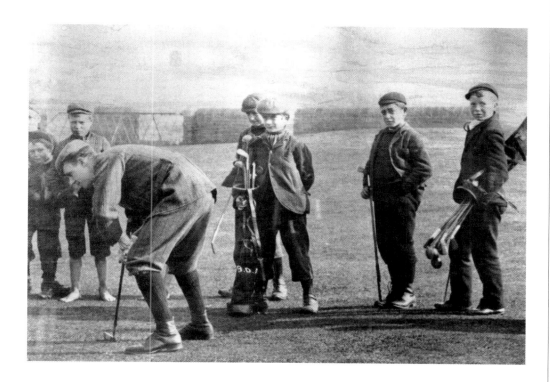

This photograph was probably taken at North Berwick in Scotland. One of the boys watching is barefoot!

remember that Tuesday afternoon and I have three specific memories of the man.

There were literally hundreds of fans crowded in the area between the clubhouse and the first tee. Suddenly a cheer went up. Jack had left the locker room and was on his way to the tee. Garth and I were on the practice putting green. He continued putting, although I knew that he wasn't concentrating too much on his putting stroke. When he thought the time was right, he told me to get the balls and his bag and follow him to the first tee. Never before had I seen so many people crowded around a tee. We pushed through the gallery, which was four or five deep, to find Jack Nicklaus talking with the other two amateurs, Peter Persons and Chris Kite. Garth politely

introduced himself to Jack and the two young golfers while I took myself to the side and stood beside Jackie Nicklaus, who was carrying his dad's bag.

As if to put them at their ease, Jack asked his three playing companions for their golf balls. He threw the four golf balls into the air, just as we all do on competition day to determine playing partners. The balls landed on Augusta's first tee and Jack paired off the balls; Garth was to play with young Persons against the mighty Jack Nicklaus and Kite. It just couldn't get better than this, or could it? Jack then asked the three whether they should play for a four-dollar wager.

My first specific memory is of Jack's determination to complete the round. I had read that his back had been giving him problems and he had no form

coming into the Masters. The weather in Georgia in April can bring tremendous storms, and after we had finished the fifth hole the skies opened and the party ran for shelter under the trees. There was lightning and rain and after some small talk amongst the four golfers I dreaded hearing Jack say that that was it and there was little chance of any more golf that day; but he never said it. The weather cleared and the game continued. Garth was playing well and seemed totally relaxed. More bad weather struck on the second nine and shelter was sought again. This time the weather was even worse and I thought this was it, the game was going to be cancelled. However, Jack asked if the other three players were happy to wait until the weather cleared. He was going to stay out there – he needed the practice!

My second memory is of an incident that happened on the 7th. I was the flag man and the hole had been completed. Whilst the others walked off the green Jack moved to about 60 feet (18 metres) from the hole and putted again. The gallery stayed to watch. Where was Jackie? The ball got closer and closer to the hole. I had lifted the flag out of the hole and the gallery was silent. Now the ball was only two feet away and it was slowing down, but it didn't count for anything. I don't know why, but I began to bend down and just as the ball was about to drop into the hole I stopped it with my hand and rolled it back to him. If looks could kill! The gallery gasped with disappointment. I realised there and then that Jack still thrived on the adulation of his fans and that, albeit from a practice putt, that ball should have been allowed to drop. It was what they had all come to see, and who was I to spoil their fun?

My third memory goes back to the game with Garth and the other two amateurs. They were playing the last of Amen Corner, the 13th hole known as Rae's Creek. All four golfers had hit good drives, but Jack was some 30 yards behind the amateurs. Standing by Garth's ball I looked back down the fairway at Jack. He was 46 years old. Jack struck a fairway wood that hooked viciously into the creek that ran along the edge of the fairway, then indicated that he was going to hit another. The same thing happened and I felt so sorry for him. He hadn't been playing particularly well, maybe he was just too old, and I remember saying to myself that maybe after all Jack should have retired a few years earlier. Little did I know that five days later he would win his sixth green jacket!

The gallery keenly followed the progress of the match. Suddenly it was all over. Garth and Kite had won the 16th and the match 3 and 2. The remaining two holes were played out and on the 18th green hands were shaken and thanks were exchanged. We saw the two American amateurs settling up.

As Garth and I walked back to the clubhouse Garth jokingly grumbled that Jack hadn't paid up for losing the game. I reminded him that he had just played with the best golfer ever and that was more than enough. Of course, he agreed. Meanwhile Hal caught up

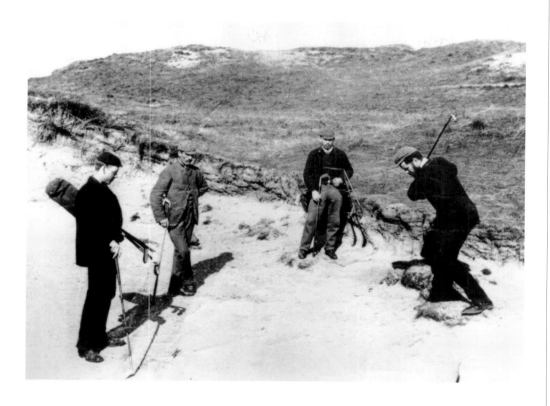

Bob Martin, winner of the Open in 1876 and 1885, playing in Hell Bunker, watched by George Lorimer, the famous club maker. One caddie has a golf bag whilst the other carries the clubs underneath his arm.

with Jack by the players' enclosure. After introducing himself he thanked Jack for inviting Garth to play with him and handed Jack a box of Irish linen handkerchiefs monogrammed with the letter 'J'. Hal recalled that Jack just couldn't have been nicer: a true gentleman and champion.

In the first round of the Masters Jack played well but could only manage a 74. He had a 71 in the second round and a 69 in the third. He told Jackie that a 66 would tie for first and a 65 would win it! That Sunday Jack completed the last round in 65 for a total of 279. Seve Ballesteros and Tom Watson had their chances to win, as did Tom Kite and Greg Norman, but it was the 46-year-old Jack Nicklaus who won the 1986 Masters.

Imagine this! The next day Jack found the time to write a note to Garth thanking him for the game. With it he enclosed a $4.00 cheque payable to Garth McGimpsey, 'for getting beat at Augusta'. Needless to say, Garth never cashed that cheque. Instead he framed it – and it has since taken pride of place above the fireplace in his lounge at home.

18th HOLE

Historical notes on golf and kindred sports
The home hole

It is very rare in historical research to find out precisely when something started. Golf is first recorded in 1457 when James II of Scotland complained that too many of his subjects were missing archery practice because of it. But the problem must already have been well established for him to go so far as to ban golf. So how much earlier, one wonders, had people been hitting globular objects into holes? It may have been many years before this that golf really began!

The age of golf

Golf is a game full of strange stories, weird folklore, and even occasionally serendipity.

It is well documented that the oldest golf clubs in Sussex are Royal Eastbourne and Seaford Golf Club, both founded in 1887. But wherever Scots went there was golf. Take Blackheath, for example. On this club's signboard it

is stated that 'Royal Blackheath' was founded in 1608. Nobody quite knows whether this is true or not, although we do know that Blackheath is very

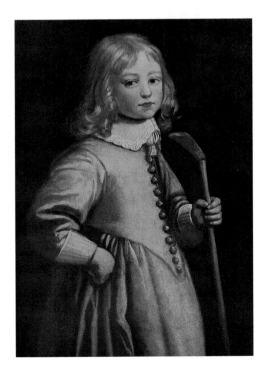

A small boy with a golf club, c.1600.

An article from *The Sporting Magazine* of December 1828

The Sporting Magazine

Vol. XXII N.S December, 1828. No. CXXXV.

THE GAME OF GOLF

Sir,

With reference to the observations on the ancient game of Golf in your Number for August last, under the initials D.A., I beg to correct one or two inaccuracies as detailed in that communication.

The club, to begin with, is properly enough described; but in place of two or three, there are at least eight or nine, carried by the attendant or caddy, of different shapes, as well of wood as of iron, to strike the ball in whatever situation it may chance to be found by the player, who, according to the rules of some societies, is never allowed to touch his ball till holed.

The ball is, as stated, stuffed with feathers; but the leather of which it is made is boiled before the feathers are stuffed into it, and not afterwards, in order that it may be softened to receive the thread with which it is fastened.

The game is correctly described; and in addition to the places mentioned where, principally, this game is played, I may state that every Saturday in the season it is practised at Blackheath, where there is a Golf Club of very old standing; and at Manchester there is one lately established.

I may just farther mention, that instead of the game being played on the Sands of Leith, St. Andrews, &c. it is on the Links at these places – certainly not far from the Sands.

By inserting this, any of your curious readers may have an opportunity of seeing the game played in the vicinity of London.

I am, Sir, yours, &c.

AN ADMIRER OF THE GAME

London, November 11, 1828.

old. An article published in *The Times* in 1835 stated that the Club had records going back to 1745, which could have been lost when The Green Man (their clubhouse) was demolished. Another article, published in *The Sporting Magazine* in 1828, describes Blackheath as a golf club of very long standing.

We know that Scottish golfers from Blackheath visited Sussex. This is illustrated by a handwritten poem in eight stanzas by R.C. Broughton, dated 1826, in a copy of Thomas Mathison's book *The Goff* belonging to Royal Blackheath. The title and the first four stanzas read as follows:

Broughton on the Brighton Club
From London some Sons of auld Reekie
 set off
To establish at Brighton a wee Club of Golf
The Downs near this place are just the
 right sort
For enjoying con gusts that elegant sport.

It's air so balsamic – Its Sea views so grand,
I'll defy you to find through our tight little
 land,
A spot better adapted for driving the Game
Not e'en on Leith Links so famous in fame.

Such velvet the Swards – such banks – Pits
 of Chalk,
To shew a Man's skill – such hazards, such
 baulks,
In short 'tis quite sure, tho' you search the
 Isle round,
No such circuit for Golfing can ever be found.

The Green on Blackheath is indeed pretty
 fair,
But Blackheath with Brighton can never
 compare

Envelope addressed to John Adam, Edinburgh, with the LEWES straight-line stamp (postage-free because he was a Member of Parliament!)

A letter from William Adam MP, marked Seaford, 28 October 1791.

'Mongst Scotia's brave Sons I scarcely
 need name,
"That Golf first of Sports stands foremost
 in fame".

We have now proved that golf was played in Sussex much earlier than had been thought, but that is not all! It becomes stranger and stranger. When the President of the Seaford Golf Club was addressing the ladies at a recent Open Day, he produced a letter from William Adam MP to his father John Adam, an architect, addressed simply 'John Adam, Edinburgh'. The President collects local postage memorabilia and this envelope, together with the letter, was one of his treasures.

The letter was dated 28 October 1791 and had been posted in Seaford then carried by river to Lewes, where it was stamped with the straight-line 'Lewes' stamp. This straight-line stamp is quite rare as it was only used in 1791, so the envelope and letter are a collector's jewel. However, it is the contents of the letter that are astounding to us. After divulging that he has 'had a bad bout of [his] bowels, but it is better now', William Adam writes that he is going to enjoy a 'fine day *golfing*' – in Sussex in 1791!

If golf demonstrably goes back to the eighteenth century in Sussex, how much older is it in the land that invented it? James I of Scotland banned only football in 1424, so it may be that at that time there were insufficient numbers of people playing golf to

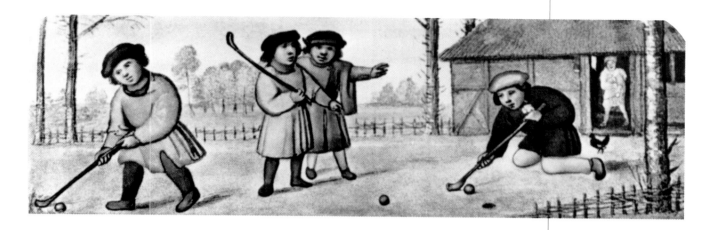

worry about them. Or perhaps it was just that it takes two teams of players for a football match.

And did the Scots 'invent' golf anyway? The game as we know it today, perhaps, but there is convincing evidence to show that this may have developed from the earlier Dutch game of 'colf'.

Golf in the Low Countries and France

The Scots and the Dutch have traded across the North Sea since time immemorial. According to Steven Van Hengel in his book *Early Golf*, the first game of colf probably took place on Boxing Day 1297 at Loenen aan de Vecht in the province of North Holland. Not only are the words *golf* and *colf* remarkably similar, but the fact that golf was played on the east coast of Scotland – nearest to Holland – and the first courses were at ports such as Leith, St Andrews and so on, is significant. Another significant fact is that golf on the west coast of Scotland did not commence until the middle of the nineteenth century.

There is no lack of spectacular images of the game of colf, which can often be found depicted on Delft blue-and-white tiles. There are many wonderful examples of these, but few better than the one pictured here.

There have been a multitude of stick-and-ball games similar to golf. In France the game of 'jeu de mail' ('mall game'), similar to English pall-mall (for which the London street called Pall

Golf in the Low Countries, enlarged from a miniature in a manuscript 'Book of Hours' of c.1500 in the British Museum.

A fine 18th-century blue-and-white Delft tile.

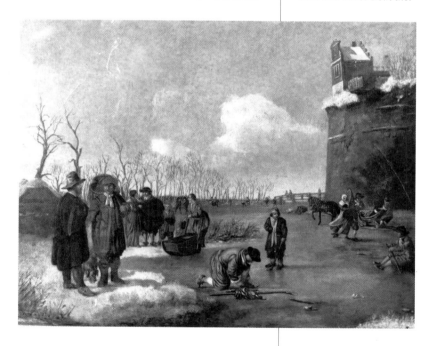

Above left: New rules for the game of 'mail' dated 1717.

Above: Playing 'jeu de mail'.

Left: 'Jeu de mail à la chicane', c.1850.

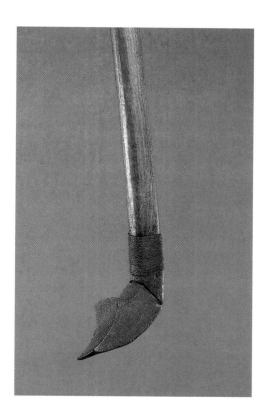

A chole club, c.1800.

Mall was once a court), went out of fashion in the eighteenth century, but the game 'jeu de mail à la chicane' continued to be played in France throughout the nineteenth century.

This game was played in the open countryside and particularly along roads to a definite target. It had certain features in common with golf – for example, the club used had one end lofted to cope with irregularities of the terrain. A description of 'Golf in France' is given in *Historical Gossip about Golf and Golfers* by George Robb, 1863:

The game is played along the bye-roads, in the neighbourhood of the town, sometimes with high banks on each side, sometimes ditches, at other places level, with fields, sometimes lined with hedges, but usually quite open. The surface of the ground is very variable. The goals are not very long, averaging perhaps half a mile. At the end of each is placed a touchstone, as it is called, which the players have to strike before the match is won, and he who can do it in the least number of strokes wins.

'Chole' is another ball-and-stick game not dissimilar to golf, which was played in the Flemish part of Belgium. It consists of a long game, played along roads, and a short game played indoors with a shuttlecock-like ball called a 'oiseau' (bird).

'Kolf' was played on a court, not unlike pall-mall. Finally, Rembrandt's 1654 etching *The Kolf Player* in fact depicts a different game, 'beugelen', which involved hitting the ball through a suspended hoop.

All in all, a number of different stick-and-ball games have been played on links – or 'hlink', an old English word for the rough land behind the seashore. But none of them has been quite like golf, which has of course developed into the greatest stick-and-ball game the world has ever known.

Appendix 1:

Golfing artists from the early seventeenth century to the present

Abbot, Lemuel Francis	Late 18th–early 19th century
Abell, William A.	Mid-20th century
Acton, Stewart	Early 20th century
Adam, Patrick William	Late 19th–early 20th century
Adams, Douglas	Late 19th–early 20th century
Aikman, George W.	Mid-/late 19th–early 20th century
Airey, F.W., RN	Late 19th–early 20th century
Aldin, Cecil	Late 19th–early 20th century
Alexander, R.M.	Late 19th century
Allan, David	Late 18th century
Ambrose, Charles Edward	Early 20th century
Anderson Bros (CynICUS)	Early 20th century
Armitage J.C. (IonICUS)	Late 20th century
Armour, George Denholm	Late 19th–mid-20th century
Armstrong, F.W.	Early 20th century
Atwell, Mabel Lucy	Early–mid-20th century
Austen, Joe	Late 20th century
Avercamp, Hendrick	Early 17th century
Ayton, Symington J.	Late 19th century
Barclay, John Rankine	Early–mid-20th century
Barker, Madeline Graham	Early 20th century
Barraclough, James P.	Early–mid-20th century
Barrie, Erwin	Early–late 20th century
Barrow, Julian	Modern
Bateman, Henry Mayo	Early–mid-20th century
Baumer, Lewis	Early 20th century
Baxter, Graeme W.	Modern
Bayros, Franz Von	Early 20th century
Beardsley, Aubery	Late 19th century
Belcher, George	Early–mid-20th century
Beldam, George (photographer)	Early 20th century
Bell, T.B.	Mid-20th century
Benger, Berenger	Late 19th–early 20th century
Bennett, Frank Moss	Early 20th century
Bensing, Frank C.	20th century
Berrie, J.A.A.	20th century
Berrisford, Frank E.	Mid-20th century
Bird, Cyril Kenneth (FougASSE)	Early–mid-20th century
Birley, Oswald	Early 20th century
Blabey	Early 20th century
Blacklock, Thomas Bromley	Late 19th–early 20th century
Blair, John	Late 19th–early 20th century
Blampied, Edmund	Early–mid-20th century
Blyte, Ward	Early 20th century
Bond, J.L.	Second half of 19th century

Bone, William Drummond	Early–mid-20th century
Bonnar, A.T.	Late 18th century
Booth, J.L.C.	Late 19th–early 20th century
Boyd, A.S.	Late 19th–early 20th century
Braur, Bill	20th century
Briggs, Clare	Early 20th century
Bril, Paul	Late 16th–early 17th century
Brock, Charles Edmund	Late 19th–early 20th century
Brooks, Henry Jamyn	Late 19th–very early 20th century
Brown, James Michael	Late 19th–early 20th century
Brown, Marg Hamilton	Early 19th century
Browne, Tom	Late 19th–early 20th century
Bruce, James Christie	Early 20th century
Buchanan, Fred	Late 19th–early 20th century
Buchel, C.	Early–mid-20th century
Bull, René	Early 20th century
Cameron, Mary	Early 20th century
Cameron, Duncan	Late 19th early 20th century
Carey, Joseph William	Early 20th century
Carter, R.C.	Early 20th century
Chalmers, Sir George	18th century
Chapman, C.D.	Modern
Chapman, Loyal H. 'Bud'	Late 20th century
Chorley, Richard	Modern
Christy, Howard Chandler	Early–mid-20th century
Clark, René	Early–mid-20th century
Clarkson, Robert	Late 19th–early 20th century
Cleaver, Reginald	Late 19th–early 20th century
Coleman, A.G.	Modern
Collier, The Hon. John	Late 19th–early 20th century
Cooper, G.C.	Late 19th century
Cooper, M.A.	Early 20th century
Cost, James Peter	Mid-20th century
Cox, Walter A.	Late 19th–early 20th century
Craft, Percy Robert	Late 19th–early 20th century
Crombie, Charles	Early–mid-20th century
Cuneo, Terence T.	Mid-20th century
Cutherbertson, William A.	Early 20th century
Cuyp, Aelbert	17th century
Cynicus: *see* Anderson Bros.	
Dadd, Stephen T.	Late 19th–very early 20th century
Davenport, I. Bromley	Mid-20th century
Davidson (also Davison), Jeremiah	Late 18th century
Davis, Lucien	Late 19th century
DeEgville, Harvey	Mid-20th century
De Geest, Wybrand Simonsz	17th century
De Hooch, Pieter	Early 17th century
Dickinson	Late 19th century
Dicksee, Fred	Late 19th century
Dixon, Arthur P.	Late 19th–early 20th century
Dollman, John Charles	Late 19th–early 20th century
Douglas, James	Late 19th–early 20th century

Doyle, Charles Altamont	Mid–late 19th century
Drake, Stan	Mid-20th century
Dryden, Ernest	Early 20th century
Duff, William	Early 20th century
DuMaurier, George Louis Palmella Busson	Mid–late 19th century
Duncan, John A.S.	Late 20th century
Dyer, S.	Late 20th century
Earle, L.C.	Early 20th century
Edmondson, C.J.	Late 19th century
Edwards, Lionel Dalhousie Robertson	Early–mid-20th century
Elliott, Harry	Early–mid-20th century
Ellis, Ray G.	Mid–late 20th century
Elmore, Richard	Mid–late 20th century
Emery, Leslie	Mid-20th century
Ewins, Michael	Modern
Farnic, Robert	Early 20th century
Ferrier, George Stratton	Late 19th–very early 20th century
Finn, Herbert John	Late 19th–very early 20th century
Fish, G. Drummond	Early 20th century
Fisher, Harrison	Late 19th–early 20th century
Flagg, James Montgomery	Late 19th–mid-20th century
Flower, Clement	Early–mid-20th century
Forbes, Bart	Late 20th century
Fougasse: *see* Bird, C.K.	
Fox, Fontaine	Modern
François, Geo.	Mid-20th century
Fraser, Eric	Mid–late 20th century
Frost, Arthur Burdett	Late 19th–early 20th century
Fuchs, Bernie	Late 20th century
Fuller, Edmund G.	Early 20th century
Fuller, Leonard John	Early–mid-20th century
Furniss, Harry	Late 19th–early 20th century
Gallon, R.S.E.	Early–mid-19th century
Galsworthy, Jocelyn	Modern
Gamley, Andrew Archer	Late 19th–mid-20th century
Gandy, H.C.	Early 20th century
Garland, Peter J.	Late 20th century
Garratt, Sam	Early–mid-20th century
Geddes, Ewan	Late 19th–early 20th century
Gibson, Charles Dana	Late 19th–mid-20th century
Gilbert, F.	Mid–late 19th century
Gill, Arthur	Early 20th century
Gillet, Frank	Early 20th century
Gordon, Sir John Watson	Early–mid-19th century
Grant, Sir Francis	Early–mid-19th century
Green, Valentine	Late 18th–early 19th century
Greenwood, Ernest	Mid-20th century
Gruber, Jacques	Early 20th century
Gustavson, Lealand	Early–mid-20th century
Guthrie, Sir James	Late 19th–early 20th century

Haddon, Arthur Trevor	Late 19th–early 20th century
Haley, H.	20th century
Hamilton, James	Late 19th century
Hardie, Alexander	Late 19th–early 20th century
Hardie, Charles Martin	Early 20th century
Hardy, Dudley	Late 19th–early 20th century
Hardy, Heywood	Late 19th–early 20th century
Harris, Ernest H.	Modern
Harris, Henry H.	Early–mid-20th century
Harrison, C.	20th century
Harrison, Terry	Late 20th century
Harte, Glyn Boyd	20th century
Hartough, Linda	Modern
Harvey, Bruce	Modern
Hassall, John	Late 19th–mid-20th century
Heade, Reginald C.W.	Early–mid-20th century
Heard, H. Percy	Late 19th–early 20th century
Held, John Jr	Early–mid-20th century
Henderson, Joseph Morris	Late 19th–mid-20th century
Henderson, Will	Late 19th–early 20th century
Henry, Everett	20th century
Heywood, Oliver	Late 20th century
Hickling, P.B.	Early 20th century
Higgins, T	Early – Mid 20th century
Hilturn, James	Early 20th century
Hindley, Godfrey C.	Late 19th–early 20th century
Hodge, Thomas	Mid-19th–early 20th century
Holt, Will	Early 20th century
Home, Robert	Late 19th–early 20th century
Hopkins, Francis Powell ('Major S.'; 'Shortspoon')	Late 19th–early 20th century
Hoskinson, Mark	Modern
Houghton, George	Mid–late 20th century
Houseman, G	Early 20th century
Houston, George	Late 19th–early 20th century
Howe, Hubert R.	Early–mid-20th century
Humphrey, Maud	Late 19th century
Hunt, Cecil Arthur	20th century
Hunt, Michael John	Late 20th century
Hutchison, Robert Gemmell	Late 19th–early 20th century
Hutchison, Sir William	Early–mid-20th century
Icart, Louis	Early 20th century
Innes, Fripp	Early 20th century
Ionicus: *see* Armitage, J.E.	
Irwin, J.F.	Late 19th century
Izatt, James Paterson	Late 20th century
Jack, Richard	Late 19th–mid-20th century
Jackson, Raymond ('Jak')	Late 20th century
Jacobs, Charles John J.	Late 19th century
'Jak': *see* Jackson	
Jalland, G.H.	Late 19th–early 20th century
J'Anoon, Charles	Early 20th century
Jelland, H.C.	(Worked for *Punch*)

Jenkins, Arthur Henry	Early 20th century
Jennings, F. Nevill	Early 20th century
John, C.R. d'Oyly	Mid-20th century
Johnston, Martin	Early 20th century
Johnstone, Eric D.	Modern
Jolley, Martin Gwilt	Late 19th–early 20th century
Jones, David	Mid–late 20th century
Jossett, Lawrence	Mid–late 20th century
Kay, James	Late 19th–mid-20th century
Kay, John	Late 18th–early 19th century
Keller, Arthur Ignatius	Late 19th–early 20th century
Keller, Reamer	(period active unknown)
Kemble, Edward W.	Late 19th–early 20th century
Kenyon, Ann Manry	Late 20th century
Kernan, J.F.	Early 20th century
King, Glynn	Early 20th century
King, H. S.	Late 19th century
Kinsella, E.	Early 20th century
Kinstler, Everett Raymond	Mid–late 20th century
Kirmse, Persis	First half of 20th century
Kubik, Kamid	Late 20th century
Lackway, L.T.	Late 19th–early 20th century
Lancaster, Percy	Early 20th century
Lander, Capt. Edgar	Mid-20th century
Lassells, James	20th century
Longlands, George A. Nasmyth	Late 19th–mid-20th century
Lavery, Sir John	Late 19th–mid-20th century
Laws, Stephen W.	Mid-20th century
Leckie-Ewing, J.G.	Early 20th century
Lees, Charles	19th century
Leigh, Conrad	Mid-20th century
Lessells, James	Late 19th–early 20th century
Leukart, Sandra T.	Late 20th century
Lewin, F.G.	Late 19th–early 20th century
Leyde, Otto Theodore	Late 19th century
'Lib': *see* Prosperi	
Likajoko	Late 19th–early 20th century
Lockhard, Barbara Sheene	Late 20th century
Lombard, Lambert	Mid-16th century
London, Doug	Late 20th century
Loraine, Nevison Arthur	Early 20th century
Lorimer, John Henry	Late 19th–early 20th century
Ludlow, Hal (painter and sculptor)	Early 20th century
Lunt, Wilmot	Early–mid-20th century
Lupo, Dom	Mid–late 20th century
Luxton, Doris	Mid 20th century
MacDonald, Alister	Early 20th century
Mackenzie, F.B.	Mid–late 20th century
MacMaster, James	Late 19th–early 20th century
'Major, S.': *see* Hopkins	
Malouze, Broward	Early–mid-20th century

Masson, Frank	Early 20th century
Maxwell, Jack	Mid-20th century
May, Phil W.	Late 19th century
MacLeod, W. Douglas	Early 20th century
McClymont, John I.	Late 19th century
McCracken, Cynthia	Mid-20th century
McIan, R.R.	Mid-19th century
McNiven, A.	Early 20th century
McQueen, Jim	Late 20th century
Meo, David	Mid-20th century
Miles, W.B.	Late 19th–early 20th century
Mills, A. Wallis	Late 19th–early 20th century
Mills, Ernest H.	Early 20th century
Mills, Reginald	Early–mid-20th century
Milne, John Maclauchlan	Early–mid-20th century
Milne, Joseph	Late 19th early 20th century
Mitchell, Charles D.	20th century
Mitchell, E.W.	Late 19th–early 20th century
Mitchell, J.M.: *see under* Saltfleet	
Monk, William	Late 19th–early 20th century (period active unknown)
Montgomery, John	Modern
Morgan, Brain (photographer)	Mid-20th century
Morland, G.	Late 20th century
Morland, J.	Late 19th–early 20th century
Morrison, Robert, Edward	Early 20th century
Morrow, George	Mid–late 20th century
Moss, Donald	Late 19th century
Murray, Charles Oliver	Late 20th century
Myer, David	
Neill, J.R.	Late 19th–early 20th century
Nesbitt, John	Late 19th century
Neville, A. Munro	Late 20th century
Nicholson, Sir William	Late 19th–mid-20th century
Nieman, Leroy	Mid–late 20th century
Oldfield, F.H.	Late 19th century
Orpen, Sir William	Early 20th century
Orr, James	Modern
Orr, Norman	Late 20th century
Outhwaite, Ida Rentoul	Early–mid-20th century
Owen, Will	Early 20th century
Palmer, William	Mid-20th century
Parr, Simon	Modern
Partins, F.H.	Early 20th century
Paterson, Gary	Modern
Paterson, James	Late 19th–mid-20th century
Paton, Frank	Late 19th–early 20th century
Patrick, James	Late 18th century
Patrick, James	Late 19th century
Patrick, James McIntosh	Mid–late 20th century
Partridge, Frank	Early 20th century
Partridge, Sir J. Bernard	Late 19th–early 20th century

Patterson, Gary	Late 20th century
Patterson, Malcom	Early 20th century
Pears, Charles	Late 19th–20th century
Peddie, Tom H.	Early 20th century
Pegram, F. (sculptor)	Late 19th–early 20th century
Penfield, Edward	Late 19th–early 20th century
Perry, Roy	Late 20th century
Pettie, John	Mid–late 19th century
Phillips, Charles Gustav Louis	Late 19th–mid-20th century
Phillips, Coles	Early 20th century
Phillips, Edward	Early 20th century
Pike, Sidney	Late 19th–early 20th century
Pimm, William E.	Late 19th–early 20th century
'Pipeshank', *see* Wallace, J.	
Popple, Edward	Early – Mid 20th century
Porter, Gibby	Modern
Pott, Charles L.	Late 19th–early 20th century
Prance, Bertram	Early–mid-20th century
Preiss, Frederick (sculptor)	Late 19th–early 20th century
Price, Allan	Late 20th century
Pritchard, Stanger	Late 19th–early 20th century
Prosperi, Liberio ('Lib')	Late 19th century
Purdy, Gerald	Mid–late 20th century
Pyne, Charles	Late 19th century
Rackham, Arthur	Early 20th century
Raeburn, Sir Henry	Late 18th–early 19th century
Raine, Barker Anthony	20th century
Ralston, William	Late 19th–early 20th century
Ramsbottom, A.R.	Early 20th century
Raven-Hill, Leonard	Late 19th–early 20th century
Ravielli, Anthony	Mid–late 20th century
Reed, Edward Tennyson	Late 19th–mid-20th century
Reed, Kenneth	Modern
Reid, Sir George	Late 19th–early 20th century
Reid, John Robertson	Late 19th–early 20th century
Rembrandt van Rijn	Mid-17th century
Rennie, George Melvin	(period active unknown)
Reynolds, Frank	Early–mid-20th century
Richards, F.T.	Late 19th–early 20th century
Ridgewell, W.L.	Mid-20th century
Robertson, C.H.	Mid/late 18th–19th century
Robinson, William Heath	Early–mid-20th century
Rockwell, Norman	Mid–late 20th century
Ross	Early 20th century
Rowland, Ralph	Late 19th–early 20th century
Rountree, Harry	Early–mid-19th century
Rumpold, Gilbert	Early 20th century
Rushbury, Sir Henry	Early–mid-20th century
Russell, Gene	Late 20th century
Sadler, W. Dendy	Late 19th–early 20th century
Saltfleet, Jean M. (née Mitchell)	Late 19th–early 20th century
Sandby, Paul	Mid-18th–early 19th century

Sanders, Christopher	Late 20th century
Savigné, Marie	Early 20th century
Scott, Septimus Edwin	Early–mid-20th century
Scott, Tom	Late 19th–early 20th century
Sealy, Allen Culpeper	Late 19th century
Shearer, Donald M.	Late 20th century
Shepard, Ernest Howard	Early/mid–late 20th century
Shields, Harry Gordon	Late 19th–early 20th century
Short, Frederick Golden	Late 19th–very early 20th century
'Shortspoon': *see* Hopkins	
Simpson, Charles Walter	Early 20th century
Smart, John	Mid–late 19th century
Smith, Archer L.	Early 20th century
Smith, A.T.	Early 20th century
Smith, Garden Grant	Late 19th century
Smith, Ken	Late 20th century
Smith, W. Granville	Early 20th century
Snape, Martin	Late 19th–very early 20th century
Soper, George	Early 20th century
Southam, H.	Late 19th–early 20th century
Speed, Lancelot	Early 20th century
Spencelayh, Charles	Late 19th–mid-20th century
Spiegle, C.	Late 19th–early 20th century
Spinder, J.H.	Late 19th century
'Spy': *see* Ward, Sir Leslie	
Stampa, George Lorraine	Late 19th–mid-20th century
Staples, Sir Robert Ponsonby	Late 19th–early/mid-20th century
Steen, Jan	Mid–mid/late 17th century
Steene, William	Early 20th century
Stevens, Thomas E.	Mid-20th century
Stevenson, William Grant	Late 19th century
Stewart, Allan	Late 19th–early 20th century
Stretton, Philip Eustace	Early 20th century
Studdy, George	Early 20th century
Swinstead, George Hillyard	Late 19th–early 20th century
Tarbet, J.A. Henderson	Late 19th–early 20th century
Temple, J.	Late 19th century
Tennant, C. Dudley	Late 19th–early 20th century
Tepper, Saul	Early–mid-20th century
Thackerey, Lance	Very late 19th–early 20th century
Thomas, Bert	Early 20th century
Thompson, G.H.	Early 20th century
Thorne, Diana	Early to Mid 20th century
Thorpe, James H.	Early–mid-20th century
Tippit, Jack	Modern
Tittle, Walter	Early–mid-20th century
Touraine, E.S.	Early 20th century
Townsend, Frederick H.	Late 19th–early 20th century
Tringham, Holland	Late 19th–early 20th century
Vallée, Dessin D'Armond	Early 20th century
Van de Neer, Aert	Late 16th–early 17th century
Van de Velde, Adriaen	Late 17th century

Van de Velde, Esaias	Late 16th–early 17th century
Van, Loo	Late 18th century
Venner, Victor	Early 20th century
Vogl, R.	Early 20th century
Vorhees, Donald	Modern
Wain, Louis	Late 19th–early/mid-20th century (period active unknown)
Wallace, Hugh R.	Late 19th century
Wallace, J. ('Pipeshank')	Modern
Walsh, Kevin	Early–mid-20th century
Walters, Evan	Late 19th–early 20th century
Ward, Sir Leslie ('Spy')	Late 18th–early 19th century
Ward, William (engraver)	Late 19th century
Wardlaw, A.H.	Modern
Watson, Frank	Modern
Watson, James Fletcher	Modern
Waugh, Bill	Mid–late 20th century
Weaver, Arthur	Late 19th–early 20th century
Weinman, Adolf	Late 19th–early 20th century
Wells, William	20th century
Wells, William	Late 19th–early 20th century
Wells, William Page Atkinson	Late 20th century
West, Douglas E.	Modern
Western, John	Mid–late 20th century
Whitmore, M. Coburn	Early–mid-20th century
Whydale, Ernest Herbert	Late 19th–early 20th century
Whymper, Charles	Early 20th century
Wilkinson, Henry	Early–mid-20th century
Wilkinson, Norman	Late 19th–early 20th century
Wilkinson, Tony	Modern
Williams, David	Late 19th–early 20th century
Williams, E.S.	Early 20th century
Williams, Harry	Late 19th century
Williams, John	Early–mid-20th century
Williamson, J.W.	Mid-20th century
Wills, Anthony J.	Late 19th–early/mid-20th century
Wilson, David Forrester	Mid-19th century
Wilson, James	Late 19th–early 20th century
Wimbush, Henry B.	Late 19th–mid-20th century
Wood, Frank W.	Early–mid-20th century
Wood, Lawson	Early–mid-20th century
Wood, Starr	Mid-20th century
Wood, Watson	Mid–late 20th century
Wotton, Frank	Late 19th–early 20th century
Wyllie, William Lionel	
Ysasi, Ricardo	Modern

Appendix 2:

Feather golf ball makers from the early seventeenth century to the end of the nineteenth century

ALEXANDER, THOMAS (active 1803–41), Musselburgh: Specialised in making big, heavy balls. One such ball sold at auction was a large feather ball weighing 32 dwt; it was owned by David Wallace, who lost on the last green at St Andrews to R. Chambers, winner of the first Matchplay Championship in 1858.

ALLAN: see ROBERTSON, ALLAN

ARNOTT, ROBERT (early 18th century), St Andrews: Known to have been an active ballmaker in 1704.

BALMINO, RICHARD (early 18th century), St Andrews: Learned his trade with Robert Arnott and was a ball maker in St Andrews 1704–10.

BERWICK, DAVID (mid-17th century), St Andrews: The son of William Berwick, who, with James Melvill, had gained a stranglehold on the making and selling of golf balls in Scotland at the turn of the century. David Berwick served his time (i.e. apprenticeship) under JAMES KID.

COSGROVE, ALEX (1821–67), Musselburgh

DICKSON, ANDREW (1665–1729), Leith

DICKSON, ANDREW (also known as Andro Dicksoun; mid-17th century), St Andrews: His son JOHN DICKSON also became a golf ball maker.

DICKSON, JOHN (mid-17th century), St Andrews: Son of ANDREW DICKSON (above); served his apprenticeship in St Andrews between 1653 and 1659 with Andrew Gibson, a shoemaker.

DICKSON, THOMAS & WILLIAM (early 17th century), Leith: In 1629 they won a complaint against James Melvill, who had confiscated nineteen of their 'gowffe ballis'. William was also known as William DICKSONNE.

DICKSONNE, JOHNNE (mid-17th century), Aberdeen: *Golf*, 2 November 1894: 'Thus, in venerable Aberdeen, in 1642, we find it enacted that one John Dickson should be permitted to exercise the trade of making Golf-balls.'

DUNCAN, T. (active 1720s), St Andrews

DUNN, JAMIE (1821–71) & WILLIAM (WILLIE) DUNN SR (1821–78), Musselburgh: Identical twins who served their five-year apprenticeship with the leading golf ball partnership of the time, W. & J. Gourlay.

GOSGROVE, ALEX (1821–67), Musselburgh

GOURLAY, DOUGLAS, SR (late 18th century), Bruntsfield: The Gourlays were a mighty golfing family stretching back several generations. Archie Baird (see Acknowledgements) has linked their origins back to the Dutch town of Goirle (pronounced Horley). In 1631 three ball makers in Goirle made and sold over 17,000 balls to merchants in the town of Maastricht. A 'Gourlay' was regarded as being the best type of feathery and was described as 'white as snow, hard as lead and elastic as whalebone'. Douglas Gourlay Sr arrived at the Bruntsfield Links in Edinburgh as a ball maker around 1780.

GOURLAY, WILLIAM, SR (1778–1836), Bruntsfield: Son of DOUGLAS GOURLAY SR and himself a well-respected ball maker. At the peak of his ball-making career in the early 1820s he was selling his 'best golf balls' for 1s 9d each. It is known that he usually sold his feather balls at the south-west of the city by the Bruntsfield links.

GOURLAY, WILLIAM (1813–44) & JOHN C. GOURLAY (1815–69), Bruntsfield: Grandsons of DOUGLAS GOURLAY SR and sons of WILLIAM GOURLAY SR, the Gourlay brothers were also related by marriage to the McEwan and Dunn club-making families. Feather golf

J.C. Gourlay,
ball maker.

balls made by this partnership were stamped 'W & J GOURLAY'. William died very young, just a year before the invention of the gutta-percha ball, and the business carried on under his brother John; balls made in the period 1844–69 were stamped simply 'J GOURLAY'. An account sent by the representatives of John Gourlay's estate to Douglas McEwan of Musselburgh Links in 1869 records that J.C. Gourlay charged 2 s 0d (10p) for his feather balls in the period 1844–60.

Phillips, Chester, 22 January 1988, Lot 253: 'W. & J. Gourlay of Bruntsfield: A feather ball apparently unused.' Sold for £1,700.

Christie's, Chester, 18 July 1991, Lot 192: 'A feather filled golf ball by W. & J. Gourlay, stamped W. & J. Gourlay and numbered 26.' Sold for £7,150.

Sotheby's, London, 21 July 1986, Lot 147: 'A good J. Gourlay feathery ball, circa 1840, the ball of stitched leather stamped . Gourlay, 4 cm (1½ in.) diameter.' Sold for £1,600.

GRESSICK, DAVID (1821–71), Musselburgh: Ball maker to the Royal Perth Golfing Society, for which he was paid £4.00 per year.

KID, DAVID (mid-17th century), St Andrews: Second son of PATRICK KID.

KID, JAMES (mid-17th century), St Andrews: Youngest son of PATRICK KID. Later his own apprentice was DAVID BERWICK, son of William Berwick.

KID, PATRICK, SR (early to mid-17th century), St Andrews: His three sons all initially 'served their time' as shoemakers.

KID, PATRICK, JR (mid-17th century), St Andrews: Eldest son of PATRICK KID SR.

LAW, GEORGE (early 18th century), St Andrews: The son of James Law, he served his apprenticeship under William Russell of St Andrews between 1707 and 1712. Law's son and grandson, both also called George (see below), in turn became ball makers.

LAW, GEORGE (d.1776), St Andrews

LAW, GEORGE (d.1827), St Andrews

LINDESAY, DAVID (late 18th century), St Andrews

LINDESAY, JOHN (early 19th century), St Andrews: Son of DAVID LINDESAY.

MARSHALL, DAVID (active 1830s), Leith:

Sotheby's, Chester, 15 July 1991, Lot 26: 'D. Marshall feather ball, circa 1830, stamped D. Marshall, approximate diameter 1.75 in., good condition.' Sold for £7,800.

Phillips, Edinburgh, 16 July 1995, Lot 289: 'A rare feather ball marked D. Marshall, with ink-written weight 27, and stamped R.H.B.' Sold for £17,000.

MILN, GEORGE (early 18th century), St Andrews: Active as a ball maker 1710–38. His son and grandson, both also George (see below), followed in his footsteps.

MILN, GEORGE (d.1755), St Andrews

MILN, GEORGE (d.1797), St Andrews

MORRIS, TOM, SR (1821–1908), St Andrews: The name Tom Morris is synonymous with the game of golf. The following extract about him is from *Golf*, 5 October 1894: 'He was apprenticed when quite a laddie to Allan Robertson, the famous golfer and ball maker. Balls were then made by compressing a hat full of feathers into a little pocket of bull's hide cured with alum. The operation involved pretty hard work: "Ye were just like a kind o' shoemaker, for after ye had filled them ye had to sew them." In 1850 Allan Robertson found Tom playing with a borrowed gutta-percha ball. Robertson regarded this as being an act of deceit and dispensed with Tom Morris's services. However, they remained good golfing partners.'

Sotheby's, London, 24 July 1984, Lot 83: 'A mint condition Tom Morris feathery golf ball, the stitched leather ball numbered "28" in black ink, 1½ in.; 4.1 cm diameter, *c*.1840.' Sold for £2,000.

PATERSON, JOHN (late 17th century), Leith

PIRIE, SANDY (active 1840s), St Andrews: Brother of WILLIE PIRIE.

PIRIE, WILLIE (active 1840s), St Andrews: Brother of SANDY PIRIE.

POTTS, THOMAS (1825–60), Perth

RAMSAY, JOHN (mid-19th century), Musselburgh

ROBERTSON, ALLAN (1815–59), St Andrews: Son of DAVID ROBERTSON; one of Allan's brothers, also David Robertson (b.1824), emigrated from St Andrews to Australia, where he became a successful merchant in Sydney. Professor Colin Tatz wrote in *The Royal Sydney Collection*: 'David Robertson was a sometime resident of Goulburn, NSW. In 1849 *Bell's Life* in Sydney wondered why this splendid game was overlooked in Australia. David replied, offering his assistance in developing the game. There was, he wrote, no want of suitable links: "Near town we have the Government paddocks, beyond the Benevolent Asylum, and a little further off we have Petersham and Homebush." ' The Royal Sydney Collection comprises clubs and balls made by Allan Robertson and used by him and his brother David, which were presented to the Club in 1912 by a family descendant. Allan Robertson went on to become the best golfer of his time – a true professional who made money winning countless head-to-head matches. In 1846 he beat Willie Dunn by two matches to one and became known as 'the best golf player extant'. Allan Robertson also made the finest feather golf balls, which he stamped not with his surname, as was the norm, but with his forename. Robertson is one of the most prolific names associated with the making of feather golf balls. The feather ball-making display in the St Andrews Golf Museum centres on an Allan Robertson mannequin.

Christie's, Glasgow, 20 July 1989, Lot 110: 'A fine and unused feather filled golf ball by Allan Robertson, stamped Allan and inscribed 29, circa 1840.' Sold for £14,850.

Phillips, Edinburgh, 14 July 1992, Lot 286: 'Allan Robertson: A feather ball inscribed "27" and indistinctly ink written the following inscription: "One of the earliest kind of golf ball made of leather and stuffed with feathers used for the last 200 years. This ball was made and used by Allan Robertson, golf maker, St Andrews 1849." ' Sold for £3,800.

ROBERTSON, CHARLES (early 19th century; d.1810), St Andrews: Son of a Peter Robertson; became a ball maker and caddie at St Andrews. On his retirement in 1805 he was succeeded by Thomas Robertson.

ROBERTSON, DAVID (1775–1836), Bruntsfield: Father of ALLAN ROBERTSON. Worked as an agent for the McEwans during the 1820s.

ROBERTSON, DAVID (d.1864), St Andrews: A ball maker who became the landlord of the Golf Links Hotel in 1863.

ROBERTSON, GEORGE (early 19th century), Bruntsfield

ROBERTSON, JAMES (19th century), Leith

ROBERTSON, WILLIAM (1720–1820), Leith

ROBINSON, WILLIAM (active 1850s), St Andrews: A caddie who carried clubs on the St Andrews links, he made his feathery golf balls in Allan Robertson's shop. Was commonly known by his nicknames 'Long William' or 'Long Willie'.

Sotheby's, London, 2t July 1987, Lot 52: 'A feather golf ball, Scottish, dated 1841, the stitched leather name stamped indistinctly with maker's name, possibly W. Robinson, and in black ink "St. Andrews Made by Long Willm 1841." 1½ in.' Sold for £2,200.

RUSSEL, CHARLES (mid-18th century; d.1788), Perth: Active as a ball maker from 1744. He was also known as Charles Russal.

RUSSEL, WILLIAM (early 18th century; d.1755), St Andrews: Active as a ball maker from 1706. His son CHARLES RUSSEL also became a ball maker.

SHARP, JOHN (active 1850s), St Andrews: Feather ball maker to the Royal Perth Golf Society in succession to DAVID GRESSICK, for which he received an annual wage of two guineas.

Sotheby's, Glasgow, 17 July 1989, Lot 271: 'A "Sharp" feathery golf ball, Scottish circa 1850, stamped indistinctly, good condition.' Sold for £2,600.

STEWART, THOMAS (mid-19th century), Musselburgh

TOD, JOHN (mid-18th century), St Andrews: Active as a ball maker 1730–43.

WALLWOOD, JOHN (late 17th century), St Andrews: The second son of a St Andrews merchant, he served his time with William Berwick 1690–5.

WATSON, GEORGE (mid-17th century), Edinburgh

Tom Morris.

Appendix 3:
Gutta-percha golf ball manufacturers, makers and retailers in the nineteenth and early twentieth centuries

Agrippa Golf Ball Co., 6 Much Park Street, Coventry (golf ball manufacturers)

Alexander Aitken, 174, Morningside Road, Edinburgh (golf club and ball maker)

Anderson, Anderson & Anderson, 35 St Paul's Churchyard, London E.C. (rubber products suppliers, including golf balls)

D. Anderson & Sons, St Andrews, Fife (golf club and ball makers)

The Argus Golf Ball and Requisites Manufacturing Co., 17 Mount Pleasant, Rosebery Avenue, London E.C. (ball manufacturers)

D. & W. Auchterlonie, Albany Place, St Andrews, Fife (golf club and ball makers)

C. Bain, 36 St Patrick Square, Edinburgh (ball maker)

Bettoruss Ltd, 35 & 36 Rathbone Place, Oxford Street, London W.1 (ball manufacturers)

Boston Belting Co., 236 Devonshire Street, Boston, MA, USA (ball manufacturers)

James Bradbeer, Ivythorn, Glastonbury, Somerset (club and ball maker)

Joseph Braddell & Sons, Belfast, Ireland (club and ball manufacturers)

Charles Brand, Carnoustie, Angus (club and ball maker)

Bridgeport Gun Implement Co., Bridgeport, Connecticut, USA (club and ball manufacturers)

Brodie Breeze, 182 Trongate, Glasgow (sports goods retailer)

G.D. Brown, St Andrews, Fife (club and ball maker)

Bryce & Robertson, Glenpark Road, Glasgow (ball manufacturers)

George Bussey, 36 & 38 Queen Victoria Street, London E.C. (manufacturer and retailer of sports goods, including golf balls)

J. & D. Clark, Musselburgh, Edinburgh (golf club and ball makers)

Clydesdale Rubber Co., Glasgow (ball manufacturers)

J.P. Cochrane, 27 Albert Street, Edinburgh (ball manufacturers)

Cockburn, London (ball maker)

Craigpark (Telegraph Wire and Cable) Co. Ltd, Townmill Road, Dennistoun, Glasgow (rubber products and ball manufacturers)

William Cunningham, 35 Leven Street, Edinburgh (ball maker)

William Currie & Co., Caledonia Rubber Works, Dalry Road, Edinburgh (rubber products and ball manufacturers)

J.& A. Dickson, Edinburgh (ball makers)

J.D. Dunn, Bridgeport, Connecticut, USA (golf club and ball makers)

W. Dunn Sr.: *see Appendix 2*

W. Dunn Jr., London & Musselburgh (golf club and ball maker)

W. Forbes & Co., 20 Endell Street, Long Acre, London W.C. (ball makers)

R. Forgan & Sons, St Andrews, Fife (golf club and ball manufacturers)

Forth Rubber Co., 6 George Street, Edinburgh (ball manufacturers)

Paynne Gallway, Thirsklesby Park, Thirsk, Thornton-Le-Street, Yorkshire (ball maker and inventor)

Charles Gibson, Westward Ho, Devon (club and ball maker)

B.F. Goodrich, Akron, Ohio, USA
(tyre and ball manufacturers)

J.T. Goudie & Co., 25 Prince's Street,
Edinburgh (ball manufacturers)

John C. Gourlay: *see Appendix 2*

James B. Halley, 76 Finsbury Pavement,
London E.C. (club and ball manufacturer)

A. Haskins, West Derby Golf Club, Liverpool,
Merseyside (ball maker)

Haskins & Sons, 76 Market Street, Hoylake,
Lancashire (ball makers)

W.T. Henleys Tyre & Rubber Co.,
27 Martins Lane, Cannon Street, London E.C.
(tyre and ball manufacturers)

Alex Herd, Fixby Hall, Huddersfield, Yorkshire
(golf club and ball maker)

Ramsay Hunter, Sandwich, Kent
(golf club and ball maker)

J.H. Hutchison, North Berwick & Muirfield
(golf club and ball maker)

Hutchison, Main & Co., Cowlairs, Glasgow
(ball manufacturers)

The Hyde Imperial Rubber Co., Trianon Mills,
Woodley, Cheshire (rubber and ball
manufacturers)

The Improved Golf Balls Co., Locksley Street,
Limehouse, London E. (ball manufacturers)

J. Jaques & Son, 192 Hatton Garden, London
E.C. (manufacturers and retailers of sports
goods, including golf balls)

Frank A. Johnson, 29 Paternoster Row,
London (club and ball retailer)

J. Lillywhite, Frowd & Co., 24 Haymarket,
London S.W. (sports goods retailers)

Donald Lowne & Co., 86 Chancery Lane,
London (ball makers and retailers)

T. & G. MacKenzie, 25 Nicolson Street,
Edinburgh (ball makers)

David McEwan, Royal Birkdale, Lancashire
(club and ball maker)

William Millar, 40 Finsbury Circus, London
(sports goods retailer)

Charles Miller, 117 Bothwell Street, Glasgow
(retailer)

Mitchell & Co., 50 Market Street, Manchester
(sports goods retailers)

T. Morris: *see Appendix 2*

North British Rubber Co., Castle Mills,
Fountainbridge, Edinburgh (ball
manufacturers)

A. & D. Padon, Edinburgh (ball makers)

R.A. Paterson, St Andrews, Fife (ball maker)

W. Park & Son: *see Appendix 2*

A. Patrick: *see Appendix 2*

G. Pullford, Hoylake, Liverpool, Merseyside
(ball maker)

A. Robertson: *see Appendix 2*

B. Sayers, North Berwick (club and ball maker)

J. Sharp: *see Appendix 2*

The Silvertown Co., Wharf Road, City Road,
Silvertown, East London (rubber products and
ball manufacturers)

Archie Simpson, Carnoustie, Angus
(golf club and ball maker)

Slazenger & Sons, 6 East 15th Street,
New York, USA (sports goods equipment
manufacturers and retailers)

William Smith, Musselburgh (ball maker)

A.G. Spalding & Bros., Chicopee Falls, MA,
USA (sports goods equipment manufacturers
and retailers)

St Mungo Manufacturing Co., Broomloan
Road, Govan, Glasgow (rubber products and
ball manufacturers)

Telegraph Wire & Cable Manufacturing,
Queen Victoria Street, Helsby, Cheshire
(rubber products and ball manufacturers)

Thornton & Co., 78 Princes Street, Edinburgh
(retailers)

The Viper Golf Ball Co., 14 Clarence Street,
Southend, Essex (ball manufacturers)

John White & Co., 193 St Andrew Street,
Edinburgh (ball makers)

Whitman & Barnes Manufacturing Co.,
Akron, Ohio, USA (ball manufacturers)

Robert. B. Wilson, St Andrews, Fife
(club and ball maker)

J. Wisden & Co., 21 Cranbourne Street,
Leicester Square, London W.C.
(ball makers and retailers)

Wood Milne, Preston, Lancashire (rubber
products and ball manufacturers)

Bibliography

BADDIEL, Sarah, *Beyond the Links*, Studio Editions, London, 1992

CRAWLEY, A.E., *The Book of the Ball*, Methuen, London, 1913

EAST, J. Victor, *Better Golf in Five Minutes*, 1956

FURJANIC, Chuck, *Antique Golf Collectables*, Krause Publications, Winsconsin, 1997

GASCOIGNE, Bamber, *How to Identify Prints: A Complete Guide*, Thames & Hudson, London, 1986

HARRIS, Robert , *Sixty Years of Golf*, Batchworth Press, London,1953

HENDERSON, Ian & David Stirk, *Golf in the Making*, Winchester, 1979

HENDERSON, W.C., *Decisions by the Rules of Golf Committee, 1909–28*, St Andrews University Press, St Andrews, 1909

JOHNSON, J. & A. Grentzner, *The Dictionary of British Artists, 1880–1940*, repr. Antique Collectors Club, Woodbridge, Suffolk, 1980

MARTIN, John S., *The Curious History of the Golf Ball: Mankind's Most Fascinating Sphere*, Horizon Press, New York, 1968

OLMAN, John & Morton, *The Encyclopedia of Golf Collectables*, Books American, Cincinnati, 1985 (out of print)

OLMAN, John & Morton, *Olmans Guide to Golf Antiques*, Market Street Press, Cincinnati, 1992

PETER, H. Thomas, *Reminiscences of Golf and Golfers*, James Thins, Edinburgh, 1890

The Shell International Encyclopaedia of Golf, Ebury Press and Pelham Books, London, 1975

STIRK, David, *Golf History and Tradition*, Excellent Press, Ludlow, 1998

VAN HENGEL, Steven J.H., *Early Golf*, Drukkerij Tesink, Netherlands, 1982

WATERS, Grant M., *Dictionary of British Artists: working 1900–1950*, Eastbourne Fine Art. Eastbourne, 1975

WOOD, Harry B., *Golfing Curios and the Like*, Sherratt & Hughes, London, 1910

Index

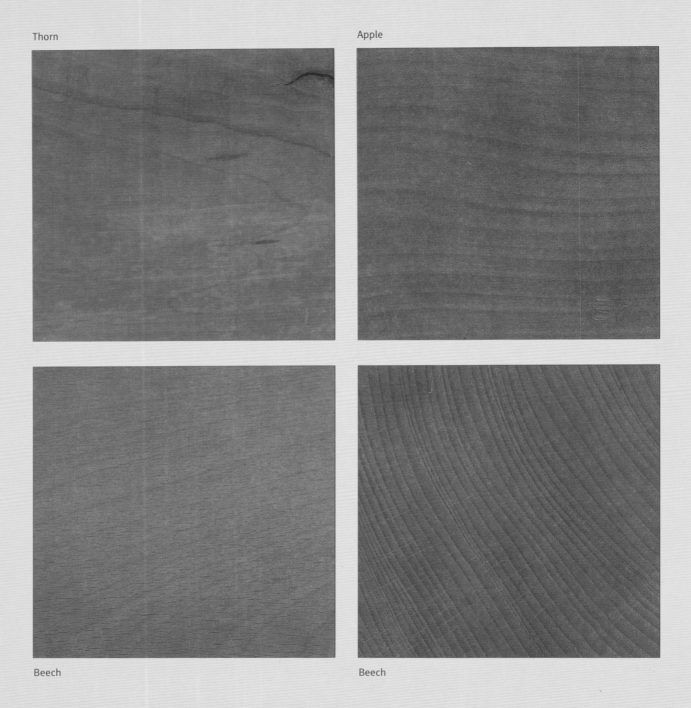

Thorn

Apple

Beech

Beech

Index

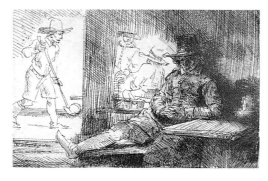

Rembrandt's etching *The Kolf Player*, 1654.

Thorn

Apple

Beech

Beech